DIVERSITY COUNTS

Diversity Counts

Gender, Race, and Representation in Canadian Art Galleries

ANNE DYMOND

McGill-Queen's University Press
Montreal & Kingston • London • Chicago

© McGill-Queen's University Press 2019

ISBN 978-0-7735-5672-0 (cloth)
ISBN 978-0-7735-5673-7 (paper)
ISBN 978-0-7735-5782-6 (ePDF)
ISBN 978-0-7735-5783-3 (ePUB)

Legal deposit second quarter 2019
Bibliothèque nationale du Québec

Printed in Canada on acid-free paper that is 100% ancient forest free
(100% post-consumer recycled), processed chlorine free

This book has been published with the help of a grant from the Canadian
Federation for the Humanities and Social Sciences, through the Awards
to Scholarly Publications Program, using funds provided by the Social
Sciences and Humanities Research Council of Canada.

Funded by the Financé par le
Government gouvernement
of Canada du Canada

Canada Council Conseil des arts
for the Arts du Canada

We acknowledge the support of the Canada Council for the Arts, which
last year invested $153 million to bring the arts to Canadians throughout
the country.

Nous remercions le Conseil des arts du Canada de son soutien. L'an dernier,
le Conseil a investi 153 millions de dollars pour mettre de l'art dans la vie
des Canadiennes et des Canadiens de tout le pays.

Library and Archives Canada Cataloguing in Publication

Title: Diversity counts: gender, race, and representation in Canadian art
 galleries/Anne Dymond.

Names: Dymond, Anne, author.

Description: Includes bibliographical references and index.

Identifiers: Canadiana (print) 20190049472 | Canadiana (ebook)
 20190049480 | ISBN 9780773556720 (hardcover) | ISBN 9780773556737
 (softcover) | ISBN 9780773557826 (ePDF) | ISBN 9780773557833 (ePUB)

Subjects: LCSH: Museums and women—Canada. | LCSH: Museums and
 minorities—Canada. | LCSH: Art museums—Curatorship—Canada. |
 LCSH: Art museums—Social aspects—Canada.

Classification: LCC N908.C3 D96 2019 | DDC 708.11—dc23

This book was typeset by Marquis Interscript in 10.5/13 Sabon.

Contents

Tables and Figures

TABLES

FIGURES

Preface

This book began with the question: Are Canadian arts institutions gender equitable? There was good reason to be optimistic. After all, it had been more than forty years since women started protesting for greater representation in museums. Women have comprised more than 50 per cent of artists and 60 per cent of the art faculty in post-secondary institutions since the early 1990s, and women now occupy the majority of Canadian museum curator and director positions. Moreover, since gender issues have been so central to contemporary art practice, gender awareness seems a requisite part of any arts professionals' job. Mere numeric equity seems like an issue that the art world should have put to rest decades ago. We have shifted our focus to more complex considerations of sexual identities and politics, as indicated by the paucity of museum studies literature that seriously considers gender equity and by the focus on sexual identity rather than gender in much recent work.[1]

Despite my initial focus on gender, I quickly realized the necessity of considering wider issues of representation in the study. Questions of racial or ethnic diversity have been important in both museum studies literature and museum practice since the 1980s. In Canada, the rethinking of diversity issues has been most productive with respect to Indigenous art, as reinstallations of the Art Gallery of Ontario (AGO) and the National Gallery of Canada (NGC) indicate. Innovative practices and a considerable body of scholarship have led to changes in many museums' relations with Indigenous peoples; yet the process of decolonizing museums and art galleries has not gone far enough. Despite years of study, many conferences, and symbolic gestures, the numeric record on Indigenous and other racialized artists remains

underwhelming in many institutions. Moreover, as my project reveals, a resistance to statistical information has meant that there is little factual knowledge about how equitable art galleries and museums are; and too often it seems that if representation of one minoritized group increases, another decreases.

In the initial project, we set out to quantify the gender balance of art exhibitions in Canada. To do so, we examined the gender of contemporary artists who had solo shows at public Canadian art institutions between 2000 and 2010. We focused on contemporary art, where we hoped historical biases would be less persistent. With comprehensive data from nearly 100 public museums, galleries, and artist-run centres from across Canada that exhibit contemporary art, our analysis came up with some fascinating results, which form the basis of the first chapter.

The initial study did not account for other forms of identity for a variety of reasons – not least of which were practical ones around classification. Despite increasing social awareness of genderqueer and non-binary identities, binary gender categories remain clearly coded in both English and French. In every case we looked at, artists were identified as either he or she. Sexual orientation was clearly an important identity category for some artists but was inconsistently recorded and impossible to quantify with any certainty. Similarly, with racialized identities the nomenclatures were not consistent or clear. For example, artists are often identified by birthplace or colour or race; in Canada, it is common to elide differences between such categories. More inhibiting was my wariness of applying a form of cultural identification that artists did not themselves condone. Moreover, there are important critiques of the concept of diversity as something that can reify constructed categories as natural and whitewash the power relations that sustain the constructed hierarchies.[2] In addition, the terms *visible minority*, *ethnicity*, and *race* are all problematic and limiting for a variety of reasons. I decided, however, that not examining them was more problematic than doing so, no matter how inadequate the terms. Not acknowledging gender or racialized identities results in an inability to discuss the invisible category, and I did not want to partake in the ongoing "whitewalling" of the gallery space, to use Aruna D'Souza's apt phrase.[3] I use the term *racialized identity* to highlight the constructed nature of such categories and to point to the problematic nature of fixed categories as ignoring the diasporic, hybrid, evolving, or contingent nature of identities. I also use terms

found in different reports and analyses that elucidate the evolving nature of our thinking and practice. So I am wary, too, that terms that may seem respectful in current parlance are too often co-opted or revealed to be themselves racist; for any such categories, I apologize. For all these reasons, and not unproblematically, my analyses of racialized identities are on a smaller scale and limited to specific institutions that I consider in more depth in later chapters.

Stimulated by this initial quantitative project, *Diversity Counts: Gender, Race, and Representation in Canadian Art Galleries* takes an interdisciplinary approach to examine the state of affairs with respect to gender, diversity, and the visual arts in Canada. The first chapter of the book explains the initial project in detail and thus focuses on gender. It explains the project's methodology and situates it in response to the widespread resistance to metrics that I encountered. It provides a broad overview of gender equity in solo contemporary art exhibitions at galleries in Canada from 2000 to 2010 in order to explore the interrelated factors that contribute to equitable and inequitable gender practices, such as institutional type, size, and location. It considers the vast number of institutions with relatively equitable practices as a foil to those considered in the following chapters, where the focus is on less equitable institutions.

The subsequent chapters examine specific institutions and their contexts. Each chapter includes some statistical analysis but broadens and deepens the numbers with a more qualitative assessment that seeks to understand how these practices have evolved in particular circumstances. In general, I felt compelled to look more closely at institutions that had poor gender records, particularly if I considered these institutions "significant." My assessment of significance was based on my sense of the reputation of the gallery, the size of its audience (either in person or in reviews or catalogues), and the effect that the institution's support would have on an artist's reputation, all of which tends to correlate with large budgets in big cities. Thus, the coverage is uneven, but responds in the first instance to an institution's record in my initial gender count. From there, the data and the context in each city led me to different ways or modes of exploration: each chapter raises different questions about the politics of representation and, perhaps more importantly, the ways in which quantitative data might be used in museum studies.

The second chapter looks in depth at the NGC from its first solo show of a female artist to 2016.[4] As the numbers reveal, the NGC

does very poorly with respect to gender and other kinds of diversity. From 2000 to 2009, less than 20 per cent of its solo contemporary shows went to female artists. In contrast to its poor record on gender equity, it has improved its representation of Indigenous peoples. This chapter compares histories of inclusion and exclusion by considering how various markers of difference (female, First Nations, Inuit, Indigenous) have been conceptualized over time. The relatively recent inclusion of Indigenous cultures in the national art museum makes it clear that the previous narrative told by the gallery's exhibitions was predicated on a hierarchical model of culture that privileged the white Canadian establishment. I argue, however, that the conceptual shift represented by recent rehangs of the permanent collections – a breaking down of traditional privileging of Euro-settler power – has not been carried through with respect to gender and that the transformations up to 2016 had not gone deep enough. Indeed, as my research shows, the numbers of female artists exhibited have decreased in recent years. When questioned, the NGC's director, Marc Mayer, has invoked the issue of "quality," claiming that the gallery is "blind" to any other issues. However, their numbers indicate a strong bias in favour of white male artists, suggesting that rather than being blind to gender or race, they might more aptly be described as blinkered.

Chapter 3 focuses on the intersection of ethnicity and gender in Vancouver institutions. The Vancouver Art Gallery (VAG) and the University of British Columbia's Museum of Anthropology (MoA) have both been at the forefront of the heartening shift in cultural diversity that has animated museum practice since the 1980s. Yet their records on gender equity are among the worst in the country. The chapter gives an overview of galleries in the city but focuses on the situation at the VAG. It explores the VAG's demonstrated commitment to improving its representation of artists of colour, arguing that the VAG is markedly better in this respect than similar large institutions, like the AGO or the NGC. But it also shows that outcomes can be inconsistent and that a progressive attitude toward representational equity with respect to one group can obstruct other groups. The examination of other institutions in the city reveals different concerns, such as the effect of the curator's gender on an institution's diversity record. The chapter also considers intersectionality by looking at the gender record of the MoA, illuminating some significant occlusions.

Chapter 4 looks at galleries in Toronto. It draws out some of the differences between historical, collecting institutions and contemporary,

non-collecting galleries, and reveals the importance of patrons' and curators' perceptions of audience expectations. Using data gleaned from interviews with practitioners, the chapter explores some of the obstacles to greater equity such as the layers of bureaucracy in larger institutions with multiple levels of administration. It questions the very different records on gender and racialized identities in the exhibition records of the AGO, the erstwhile Museum of Contemporary Canadian Art (MOCCA), and the Power Plant.

Chapter 5 turns to consider two major institutions in Montreal: the Musée d'art contemporain de Montréal (MACM) and the Montreal Museum of Fine Arts (MMFA). Like many of their counterparts in other provinces, these institutions do not have good equity records in their exhibitions of contemporary art. In Montreal, these issues intersect with linguistic identities in ways that create a different context than that of other places. The chapter reveals other differences as well. Whereas the lack of public protest was notable in much of the rest of the country, in Montreal the art community has been actively engaged in events at the MACM, particularly around issues of personnel. Spurred by these interventions, as well as rapid changes in leadership at the MACM and recent changes at the MMFA, in this chapter I consider closely the correlation between specific individuals and the exhibition record. Numbers here led me to investigate the influence of museum boards, as well as the effects of power and influence more generally.

The final chapter draws some conclusions about persistent beliefs and practices around gender, diversity, and the politics of representation in the Canadian art scene. It relates the data in more theoretical ways to the body of literature in museum studies and curatorial theory. It makes recommendations, drawing on the preceding analyses to draw out a preliminary and tentative list of best practices as well as practices to be avoided. In contrast to the widely held view that statistics and good curatorial practice are antithetical, the conclusion makes the case that knowing our numbers with respect to gender and other forms of diversity is crucial to making real transformations in the ways of thought that shape the field.

This book began as a numeric record of gender distribution in contemporary art exhibitions. While I see much value in this enumeration, my intention shifted to something I consider more significant. The project expanded to become an intersectional consideration of issues of representation and diversity, of the different ways institutional

responsibilities to representation have been conceptualized and struc-
tured over time, and of the different ways in which specific institutions
have worked with categories of inclusion and exclusion. In the end,
it is a condemnation of the resistance to numeric analysis, because
I see such resistance as tacit support for institutions that function
primarily to marginalize. The book is, ultimately, a plea for more
consciously equitable exhibitions, which will only happen when insti-
tutions look critically at their records on diversity and equity. In asking
what we can gain from collecting systematic data on exhibitions, this
book reveals the absolute necessity of that information.

Acknowledgments

I am deeply grateful to the inspiring students in my first Gender, Art, and Art History class, particularly Jennifer Vanderfluit and Tyler Stewart, who became collaborators at the earliest stages of this project, and later students Ashley Fulton and Kaitlynn Smart, with whom I co-authored the first chapter. I also thank Amy Parks for her careful and insightful reading of the manuscript. I am grateful to my colleague Mary Kavanagh, who first convinced me of the need for a gender course, without which this project would not have happened. Devon Smither provided invaluable insight at several crucial moments, as did Christine Clark, whose expertise with data visualization was essential. Olu Awosoga answered more statistics questions than would be fair to ask of any professor, and Olakunle Jones assisted with much of the statistical analysis: I thank them both but also must apologize to these statisticians whose advice I sometimes disregarded. Jason Laurendeau helped me recognize that social scientists and statisticians might legitimately differ on certain statistical issues.

I am also extremely grateful to the many museum and gallery workers who completed surveys and especially those who agreed to be interviewed, including but not limited to Heather Anderson, Kate Armstrong, Kathleen Bartels, Nan Capogna, Shawna Dempsey, Dana Kletke, Rosemary Donegan, Josée Drouin-Brisebois, Karen Duffek, Sandra Dyck, Anna Hudson, Reena Katz, Andrea Kunard, Greg Hill, Melanie O'Brian, Jenifer Papararo, Sadira Rodrigues, Kitty Scott, Jonathan Shaughnessy, Sarah Robayo Sheridan, Matthew Teitelbaum, Georgiana Uhlyarik, Scott Watson, and others who wished to remain anonymous. I am appreciative of the generous assistance of Cyndie Campbell, head of the National Gallery of Canada Library and

Archives; Rhys Stevens at the University of Lethbridge Library; Catherine Crowston and Rochelle Ball for information from the Art Gallery of Alberta; Terry Graff and Sarah Dick for information from the Beaverbrook Art Gallery; and to Joyce Zemans for sharing her ongoing research with me and for her leadership in the area.

I am also appreciative of the financial assistance of the University of Lethbridge, which supported this project in a variety of ways, including study leaves, a Faculty of Fine Arts research grant, and the Chinook Summer Research Awards, which funded student research.

At McGill-Queen's University Press, I am grateful to Jonathan Crago, who has patiently guided me through this process. I thank especially copyeditor Correy Baldwin and the peer reviewers, whose comments were incredibly insightful and improved this book immensely.

I also owe a debt of gratitude to my sister, Cindy Dymond, who has been a sounding board and an inspiration. Feminist friends are essential and too many to name, but in relation to this project, I am grateful for Lisa Kozleski's journalistic skills and generosity, which contributed many relevant newspaper articles.

As for my three favourite guys, there are no words that could express my appreciation of their presence in my life: Thomas and Daniel bring me so much joy and much hope for a better future. My greatest appreciation goes, as always, to Phil.

DIVERSITY COUNTS

1

Counting Gender: A Statistical Overview of Gender in Solo Shows of Contemporary Art in Canada, 2000–10

Anne Dymond, Jennifer Vanderfluit, Tyler Stewart,
Ashley Fulton, and Kaitlynn Smart

And, when people ask if I see myself as a female artist, or whether my work has a part in feminist history, I don't think I'm political in that sense. I see myself as a sculptor and as an artist and I think that my mother, her mother and their grandmothers worked incredibly hard for my generation to be able to do what we do.

<div align="right">Rachel Whiteread</div>

In the late 1990s, some twenty-five years after Linda Nochlin's infamous question, "Why have there been no great women artists?," sculptor Rachel Whiteread expressed a popular view: that she should be considered an artist, without any concern for gender, and that such concerns – however appropriate to her mother's generation – were no longer relevant. Like many before and after her, Whiteread understandably did not want to be defined as a "woman artist" or for her art to be gendered.[1] Many artists, academics, curators, and museum directors agree. Her statement recognizes the historical reality that there was a problem, it pays tribute to the work of feminist artists and activists and women forebearers, and it suggests that those problems have been effectively laid to rest. Indeed, Whiteread's success – she was the first female winner of Britain's prestigious Turner Prize in 1993 – is taken as proof by many that, more than two decades ago,

we reached a state of equity and that gender is no longer a relevant factor in contemporary art. But is this true?

This book began as a teaching assignment created to encourage students to evaluate their belief that, in the realm of art, gender bias was only a historical issue, not a contemporary one. In the face of students' increasing discomfort around gender issues as we approached the period in which they themselves lived, I asked the class to keep track of the gender of those included in any "site of knowledge production regarding contemporary art." They tabulated all kinds of things: articles in contemporary art magazines, exhibitions at specific institutions in the last year, reviews of exhibitions in newspapers, speakers in a visiting artist series. Most chose to count exhibitions. As we discussed and tabulated the results in class, it became clear that the project was far more important than just as an exercise for my students. It was bigger and more necessary than I had expected or wished. I will admit it: I did not want to undertake this project. It would be very difficult and very unpleasant to enumerate how far from equity we are. Yet, urged by students in the class, two of whom became my research assistants and collaborators (Jennifer Vanderfluit and Tyler Stewart), I concluded that it was necessary.

When I spoke about the developing project to colleagues, they had mixed reactions, although they were almost always impassioned. Some who would identify as feminist argued vehemently that we were past mere numbers, and that I should consider instead issues of "greater complexity," such as the content of the work. Some felt I was reinforcing gender bias by solidifying the categories. Less frequently, people would suggest that gender bias was not the thing I should study and would give examples of other kinds of omissions, like ethnicity, that they found more pressing. Some of these issues, particularly the systemic whiteness of Canadian institutions, I felt were crucial to address in subsequent chapters. By far the most common response, however, was to dismiss the value of statistics themselves.

If the value of statistics has been questioned, if they have been considered able to be manipulated – typically dismissed as "lies, damned lies, and statistics" – their usefulness has nowhere been more vehemently decried than in the art world, from feminists and non-feminists alike. When I began this project in 2011, resistance to metrics was rife throughout the art world. Recently, there have been indications that this is changing, from Micol Hebron's popular web project Gallery Tally, begun in 2013 and which similarly accounts for gender

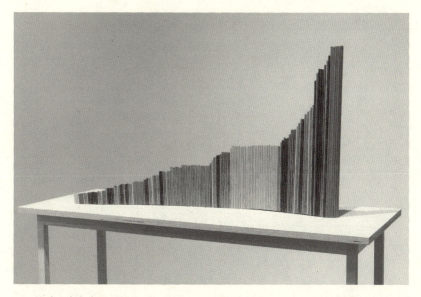

1.1 Richard Ibghy and Marilou Lemmens, *Real GDP per Capita and Share of Global Population (2011)*, from the series *Measures of Inequity*, 2016. Photo courtesy of the artists.

inequities, to art that visualizes data, such as the *Measures of Inequity* series by Richard Ibghy and Marilou Lemmens (see figure 1.1).[2] Museum personnel, however, seem particularly resistant. To some extent, I understand why. In a survey that I sent out to curators and museum directors across the country, many respondents expressed concerns about the basic premise of collecting statistics. Some suggested statistical information was of little or no use, and many drew (or jumped to) conclusions as to how they might be used: one respondent expressed their skepticism to the collecting of numbers, fearing they would be used to dictate programming: "There are obvious problems with attempting to program according to demographics."[3] While certainly true, does this mean we should not have the data that the statistics can give us? The bureaucratization implied by the gathering of statistics makes many curators fearful: it has the potential to kill the creativity and the personal expression that is necessary for excellence in their creative fields. There are many other objections: that statistics lie; that statistics simplify an extremely complex issue; that they unfairly compare very different situations; that they do not account for the more meaningful issues, such as the content of the

art or the artist's sexual identity; that they rely on an essentialized notion of gender identity; that they place blame without providing answers, or lay blame at the wrong feet, or are dated, unhelpful, "merely sociological," or out of date, like the identity politics of the 1990s with which they are most associated. Often lurking behind these expressed fears is concern about what use the statistics will be put to: will the very fact of the numbers lead to mandated quotas? Undoubtedly there are many more criticisms to be made of statistics, and I try to address these in various ways throughout this book.

Despite my own reservations about statistics, I have come to the position that their benefits outweigh the drawbacks. I agree that statistics alone are not enough to understand the complexity of the issues involved in the triad of museums, representation, and diversity. Yet I would counter that without knowing the numbers, we cannot even begin to assess the situation. Having worked with the numbers for many years now, I am confident that when you read about some of them, you too will see the value of "mere counting." In the presentations I have given on this research, I have been engaged in vigorous and thought-provoking debate, by far the fiercest response to art historical projects that I have encountered, not least from avowed feminists who strongly objected to the entire project. So, I know I am wading into important, and loaded, territory to which excellent people are deeply and rightly committed. I do so with trepidation, but also with a sense of necessity. If there is ongoing bias that favours specific groups in Canadian arts institutions, this is a critical issue, one that we should all be deeply concerned about. If there is not, the numbers, sensitively interpreted, should demonstrate as much, and we can rest easy. So rather than foregoing any kind of metrics, I argue that we need to have them as a starting point to understand the situation so that we may consider improving it. To that end, this book begins with an overview of the statistical project we undertook in 2010.

THE PARAMETERS OF OUR STUDY

My research assistants Jennifer Vanderfluit and Tyler Stewart, and later Ashley Fulton and Kaitlynn Smart, and I set out to quantify the issues by determining the gender balance of exhibitions of contemporary art in public institutions from 2000 to 2010. We collected data from 130 public museums, galleries, and artist-run centres (ARCs) from across Canada that exhibit contemporary art. Our primary

source of information was institutional websites. If these did not list their exhibitions, however, we turned to other sources like online annual reports, or in some cases, library archives. However, for the most part, our data relies on information in the public sphere, typically provided by the institutions' websites. This data thus has several limitations. First, if institutional websites were incomplete, it meant our data would also be incomplete. At the time of our large-scale data collection, in 2011, we worked from the premise that this publicly available information was a valid source for consideration. If omissions were random, we thought, it would not overly affect the data; that is, one would expect any omissions or oversights to be in rough proportion to the overall numbers of shows by male and female artists. If it was not random, well, that would beg other questions.[4] Indeed, as further research revealed, the website data did not always appear to be random, but that is a concern taken up in greater detail in chapter 2 on the NGC. Second, the start and end dates used for each institution are not identical, because they depended on the available data at the time. Statistically, this should not affect our conclusions in this chapter.

We wanted to be as fair as possible, and we recognized that the numbers would naturally vary from year to year. So, to be included in the study, we set some minimums in place: institutions had to have at least five years of available data, more than ten solo shows of contemporary art in the period, and no evident gaps in the available information. After looking at nearly 5,000 exhibitions, we ended up with data that we considered reliable on 97 institutions and 4,684 exhibitions.

The parameters had to be further defined for consistency. Although we may all recognize "contemporary art" when we see it, the term has no clear or objective definition across institutions.[5] At some institutions, contemporary art is defined as art created since 1970; at others, it is given a rolling date of twenty-five years before the present; at others, twenty years before the present. To quantify this category, we limited our study to artists living at the opening of their exhibitions. It is not a perfect definition, but it is one that can be consistently applied.

We focused on contemporary art for multiple reasons. Most importantly, a common justification for unbalanced exhibitions is that they are merely the legacy of historical gender inequity. In any historical show, it is often assumed (with little evidence) that in this

earlier time – any earlier time – male artists far outnumbered female, which is an issue broached in our longitudinal study of the National Gallery in chapter 2. We decided to sidestep this explanation by focusing on the contemporary. By 1999, the beginning of the study, it had been at least thirty years since women had begun protesting for equity in museum and art gallery representation. Women had comprised more than 50 per cent of those working as Canadian artists as early as 1988, a dozen years before the start of our survey.[6] Determining the percentage of artists who are female is complicated by Statistics Canada's categorization. The most obvious employment category is "Painters, sculptors and other visual artists"; however, depending on how participants categorize themselves, they may be listed elsewhere, for example as "educator" if they are employed at a college or university. Regardless, estimates of the percentage of working female artists in Canada in the 2000s range from 53 per cent by Hill Strategic Research to 56.9 per cent by Michael Maranda in his excellent study *Waging Culture*, and in Quebec, Guy Bellavance has concluded it to be as high as 58 per cent.[7] It is reasonable, given these more comprehensive assessments, to assume that slightly more than 50 per cent of artists in Canada were, and are, female, and that this has been true since before 2000, the beginning of the study.

Importantly, the fact that men and women were roughly equally represented in the artist population during this time was not only true of young or emerging artists. In the 1996 census, women made up more than 60 per cent of the faculty members in the relevant disciplines, suggesting that they had already achieved significant professional status and recognition.[8] Moreover, even in Statistics Canada's category of artists over the age of seventy-five, almost half the artists were female (47.8 per cent), which suggests that any holdover of a purely historical bias in favour of males in the area should have been declining. Consequently, we assumed that by 1999, the category of "living artists" was sufficiently resistant to the historical effects of this previously male-gendered profession, and that women made up more than half the artists, including older ones, in Canada for the duration of the study.

In the initial study, we limited the data to solo shows for several reasons. We suspected that group shows might be more likely to have a hidden gender bias, in either direction, built into them by the choice of theme (see the discussion of the exhibit *Wack!* in chapter 3). Moreover, solo shows are less likely to be curated from the collection,

and we speculated that they would be less affected by the gender bias that plagues both donations to galleries and the commercial art market.[9] Most importantly, solo shows are a significant marker of artistic success in Canada, and yet are common enough to represent a broad range of practices.[10] Thus, we consider them a key marker of equity. Nevertheless, many people suggested that feminist artists value collaboration and eschew the kind of hierarchies associated with success in the mainstream art world, rendering the criteria of the solo show less relevant to them, and possibly skewing the results. Although I am leery of this explanation, in our more focused examinations of specific institutions we also looked at gender representation in group exhibitions, and the results of these are presented in subsequent chapters; however, for the large survey, I believe the category of solo shows remains a useful measure.[11]

We also focused on exhibitions. While many curators and museum professionals see the building of the collection as the most significant component of their job, acquisitions seemed like a less useful category in terms of assessing the state of gender and other kinds of representation in Canadian arts institutions. Foremost was the recognition that many arts institutions in Canada are not collecting; focusing on acquisitions would leave out ARCs and many galleries that focus solely on contemporary art. Moreover, collecting institutions typically exhibit more established artists, and would be less representative of younger or emerging artists. In addition, acquisitions are subject to the vagaries of collectors and donors, and they vary considerably from year to year, making them a less intentional or controllable component of museum practice. Finally, while collections create the most significant record over the long term, in terms of present-day audiences, exhibitions are what the public sees, and thus what affect the entirety of the process, from collectors to historians. Consequently, in terms of the importance of seeing ourselves represented in the powerful, constructive, and social space that a gallery or museum is, exhibitions are a meaningful measure.

Another factor that we considered was whether the analysis by gender would reinscribe and thus inadvertently strengthen gender binaries or fall into the category of biological determinism or essentialism. This is an all-too-common dilemma in feminist practice, which has been deconstructed elsewhere; however, from my perspective it is necessary to recognize that to deny the category as relevant prevents analysis, and may allow a pervasive gender bias to go unchecked.[12]

I argue that the data makes clear that gender is still a relevant category of analysis; if it were not, my numbers would show that. However, we did not want to essentialize. Consequently, to determine the gender of artists, we looked to exhibition information and publicity or to readily available information online about the artists. Because binary gender categories are built into our language, official materials relating to the exhibition or in the public sphere almost always identified an artist's gender. In fact, of the nearly 5,000 exhibitions examined, only one was by an artist whose gender was not identifiable (and that exhibiting institution's data did not fit our criteria of a minimum of five years of available data and thus had to be excluded). In early iterations of the illustrations accompanying our analysis we used three gender categories: male, female, and other genders, although this last category consistently had no representation. For visual simplicity, I eventually removed the category from the charts. Griselda Pollock has used the pointedly awkward term "artist gendered female" to make clear that the gendering of the artists is a social construct. It is that social construct we set out to study, not to reify. In later chapters, the same reasoning guided our consideration of racialized identities. As the Black Lives Matter and Idle No More movements have made clear, when you claim not to see the category, it means you are also ignoring discrimination against it.

The complexity of the social construct of gender raises other challenges for the project. It is important to recognize that there are limitations to using statistics, or mere numbers. They minimize differences of content that some might consider more significant than an artist's gender. For example, a gallery that exhibited a male artist who consistently problematized gender binaries should be applauded, one curator suggested, while another showing a lot of art by women who were not feminist could be worse in terms of feminist politics. While this hypothetical scenario may be true (although I would be hard pressed to find examples), it misunderstands this project. The initial project set out to determine whether gender equity existed in arts institutions. For my feminist politics, I believe art galleries should be striving to reach gender equity in their programming, regardless of content. As a feminist, I might want more interesting content; as a theorist, I might want works that deal with more complicated gender identities; as a viewer, I might want only "excellent work"; but as a researcher, I wanted to see whether galleries were showing equal numbers of male and female artists before I considered other

components. I did not set out to research whether the content of art shown represents a theoretically sophisticated approach to gender issues or is feminist, nor did I set out to show that galleries *should* be showing equal numbers of male and female artists; I set out to quantify whether they were. Once that data is collected and analyzed, I argue, we can begin to discuss the more interesting questions that necessarily follow. I look forward to a more nuanced discussion around content, the complexity of gender as a construct, and the barriers that exist to certain kinds of art and certain artists, but I believe it is still worth knowing if artists who are gendered female are equitably exhibited, regardless of whether their content is feminist.

A SIDEBAR ABOUT STATISTICS

Statisticians, and I am definitely not one, commonly use a binomial pair test to determine whether the frequency of a variable (such as gender) is *significantly* different than expected, given the population or group being considered, when the data is limited to only two categories. So, in our case, what population we are considering is important. If we think of the example of flipping a coin, where you would expect half heads and half tails, and we had ten coin tosses producing six heads and four tails, the binomial test would tell us whether that was a "statistically significant" difference from the expected norm of five of each. If we had more than two categories, we would run a different kind of test, but as none of the galleries in the sample showed any artists who were not identified as either male or female, this was the study we used. As I have mentioned earlier, in our research of just over 5,000 shows, one gallery that we looked at had a non-gender-identified artist; however, that gallery did not have a large enough sample to meet the criterion for inclusion. In our example, however, of six heads and four tails of a coin toss, the binomial test would tell us that six to four is not a statistically significant difference from expected equity – that is to say, it could happen often enough that we would not be able to conclude there was something funny going on with our coin. In fact, statistics would never tell us there was something wrong with the coin; it would tell us only that the numbers were significantly different from the expected, and we could either draw appropriate inferences or realize that we would need to do other kinds of investigations to make the data meaningful. To continue with the coin analogy, if we had 1,000 throws, even if the ratio were the

same (600 to 400), the binomial test would tell us that the probability of getting 600 or more heads is less than 0.001 in a hundred, a figure known as the p-value. Any p-value of less than 0.05 is usually considered significant. So, the binomial test tells us that 600 out of 1,000 is a statistically significant difference from the expected equality, whereas six out of ten is not. I must point out that in terms of the writing of our shared history, exhibitions are not coin tosses.

THE RESULTS: OVERALL

When we look overall at the numbers for solo shows of living artists from 2000 to 2010, it seems that Canadian arts institutions do reasonably well. Of the 4,684 shows we included in the study, 47.4 per cent were by female artists. The appendix includes a list of all the institutions included in the study and the associated data. Even though it may intuitively seem "good enough" to many of us, in statistical terms this is extremely unlikely to have happened if men and women were equally likely to get exhibitions.[13] Given how many more artists are female only compounds the problem; overall, there are more female artists, but they receive fewer solo shows.

If we group galleries by the percentage of their solo exhibitions given to female artists, the scale of the problem becomes clear. In our count, there were sixty-three galleries with more than 50 per cent of their exhibitions by male artists, and less than half of that, thirty galleries, with more than 50 per cent of their exhibitions by female artists. Breaking down the data into greater detail further underlines how skewed the exhibition record is.

Figure 1.2 groups the galleries by the percentage of their solo shows given to female artists. If genders were given equal representation, we would expect a symmetrical distribution around the central dark grey bar. This central bar indicates that thirty-one galleries in our study had roughly equitable gender distribution, with 45 to 54 per cent female solo exhibitions. It is the biggest category, which shows that most institutions do relatively well with respect to gender equity. Overall, the chart makes clear that there are many more galleries on the bottom half, representing those that give a greater percentage of their shows to male artists. If it were an equitable distribution, we would expect the sets of paired bars on either side of the centre to be roughly equal throughout. Moving out from the centre dark grey bar, the next two bars, represented as vertical stripes, indicate that nearly

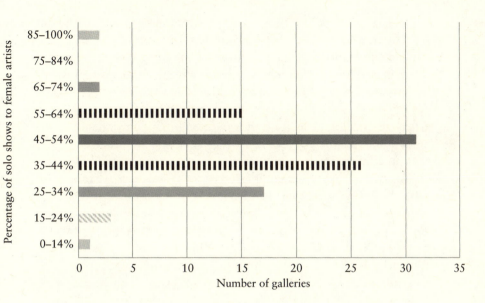

1.2 Distribution of Canadian art galleries by the percentage of their solo contemporary exhibitions by women, 2000–10. The central dark bar indicates galleries with roughly gender equitable exhibits. That the lines below this central axis are consistently larger than their counterparts above the central axis reveals just how many more institutions have more shows by male artists than female artists.

twice as many galleries exhibit somewhat fewer women (twenty-six, the striped bar below the centre grey line) than exhibit somewhat more women (fifteen, the striped bar above the centre grey line). The solid mid-grey bars further out represent institutions that exhibit 65 to 74 per cent female (upper) and 25 to 34 per cent female (lower). In these even more unequal categories, we find that only two galleries show a lot of female artists, and four times as many galleries show a lot more male artists. The next category, represented by diagonal stripes, does not include any institutions with more women (so the 75 to 84 per cent bar is empty) but includes three with a much higher proportion of males. The last bars on either end represent the few galleries that represent almost all male (one) and almost all female (two) artists. Figure 1.2 makes it clear that the question of how many solo shows go to male or female artists needs to take account of how skewed the picture is overall, but also to account for the records of specific institutions, which vary considerably.

The issue of how to define equitable representation is worth considering in further detail. It raises important issues around the extent to which institutions should be actively trying to right social injustices. If you believe that galleries should represent the population of working artists, you would expect the mid-line (or expected value) to be at 55 per cent, since it is the best estimate of the percentage of working artists gendered female. If we moved the centre point of figure 1.2 to match the number of working artists – that is, if we bracketed 5 per cent on either side of 55 instead of 50 – the picture would look significantly less equitable than it already does. However, we might not want the galleries to replicate the population for a variety of reasons. While you might be opposed because of the restraints on selection, you might also be opposed because mirroring the percentage of working artists will reproduce systemic problems already present in the art world. While you might think this is fine with respect to gender, you might think it would not be a progressive way of dealing with issues around ethnicity. For example, if there are very few black artists in a region, a more activist stance would be to want to combat this, rather than just accept it. In any case, while this issue of where the centre line should be does make a significant difference in our assessment of equity, the more pressing concern for me is around the institutions farther from the centre point.

It is important to keep in mind, however, that the percentage of exhibitions given to a particular gender is not the best indicator of equitability, because it does not account for sample size. A better measure is the two-tailed p-value of the binomial test, which tells us which institutions exhibit statistically fewer women than men. Consequently, table 1.1 presents a list of institutions that have significantly fewer female solo shows, in statistical terms, than male solo shows.

As table 1.1 outlines, eighteen of the ninety-seven galleries in our initial study had statistically significantly fewer solo shows by female artists. Most of these featured female artists in fewer than 30 per cent of their solo shows, while only two galleries featured female artists in 70 per cent or more of their solo shows. Moreover, when we look at the reputations and reach of these institutions, those that show far more male artists tend to be very significant institutions, with large national and international audiences, whereas the two galleries that exhibit more than 70 per cent female artists are smaller, more regional institutions. These ends of the spectrum are discussed in greater detail below.

Table 1.1
Institutions with statistically significantly fewer women in solo exhibitions, 2000–10.
Probability is calculated using the binomial test, which assesses difference from an assumed outcome. We assumed two genders were equally represented. A probability of less than 0.05 tells us that our assumption, that each gender is equally likely to be represented at a gallery, is extremely unlikely to be true; that is to say, that this result is significantly different from equitable. Probability values below this threshold are highlighted.

15

	Solo shows male artists	Solo shows female artists	Total shows	% of shows to female artists	Probability this is explained by random variation
National Gallery of Canada	41	10	51	20	0.000
Museum of Anthropology – UBC	18	1	19	5	0.000
Vancouver Art Gallery	39	12	51	24	0.000
Art Gallery of Ontario	46	22	68	32	0.002
Winnipeg Art Gallery	44	21	65	32	0.003
Nickle Arts Museum – U Calgary*	33	14	47	30	0.004
Kitchener Waterloo Art Gallery	44	22	66	33	0.005
Museum of Contemp. Canadian Art*	26	10	36	28	0.006
Beaverbrook Art Gallery	32	14	46	30	0.006
Plug In Gallery*	40	20	60	33	0.007
Musé d'art contemporain Montréal	44	23	67	34	0.007
Montreal Museum of Fine Arts	13	3	16	19	0.011
Art Gallery of Hamilton	27	12	39	31	0.012
Art Gallery of Alberta*	34	17	51	33	0.012
Dalhousie Art Gallery – Dal. U	29	14	43	33	0.016
Kenderdine Art Gallery – U Sask.	22	10	32	31	0.025
Contemporary Art Gallery Vancouver	38	22	60	37	0.026
U of T Art Centre*	12	4	16	25	0.038

* = name changed since end of study

a p-value less than 0.05 is usually considered statistically significant

Nevertheless, it is worth celebrating that the largest number of institutions showed between 40 and 59 per cent female artists. Even though some galleries are significantly less than equitable (in statistical terms), the range indicates that, in general, Canadian galleries have a large pool of female artists from which to draw, since the majority of galleries at least approach equitable numbers.

In future pages, I will examine the ends of the spectrum in more detail, but in broad strokes, the research suggests two important things: first, and most importantly, it is clearly possible to obtain gender equity in the exhibition of contemporary art in Canada, as indicated by the substantial number of institutions that do; second, some of our most important institutions fall far short in this regard.

INSTITUTIONS BY TYPE

Our data indicated that institutional type has a significant effect on the likelihood of gender equity in exhibitions. Consequently, we further analyzed the data by institutional category. We followed the Canada Council for the Arts funding categories, which differentiate between nonprofit ARCs and nonprofit public art museums and galleries. We further separated out of this latter category university-affiliated galleries, which have different audiences, locations, and funding models than other public galleries.

Artist-Run Centres

Of the three categories, ARCs had the best record on gender equity in solo shows. Overall, the twenty-four ARCs we examined had an average of almost 55 per cent female solo shows, which is roughly equal to our estimate of female artists in the population. Mapping the percentage of female solo shows at ARCs produces an almost normal distribution, slightly skewed towards more women, but not by a statistically significant amount. Another way of conceptualizing it is that ARCs had the smallest variation and the fewest outliers, with 75 per cent of ARCs landing in the middle section of the graph, with 40 to 59 per cent of their artists being gendered female. In contrast, only half of public galleries were in this middle ground (see figure 1.3).

Even more noteworthy, none of the ARCs made the list of galleries with statistically significantly fewer female solo shows than male solo shows.[14] On the other hand, four of the twenty-four ARCs included

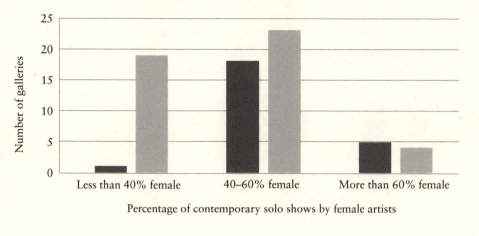

Percentage of contemporary solo shows by female artists

■ ARC ■ Public gallery

1.3 Gender distribution of artists with solo contemporary shows in Canadian ARCs and Canadian public galleries, 2000–10

in the data set had significantly more women. In contrast, no university galleries showed significantly more women, and only one public gallery did.

There are many reasons why ARCs typically have better records on gender equity. First is their history as alternative spaces created to run counter to the traditional museum model. This made them more open to younger, emerging artists, who, in the early days, were increasingly female.[15] Additionally, since ARCs do not rely on collections, they avoid any of the bias that can come from the preferences of donors. Their exhibition selection process may also lead to greater gender equity: at most ARCs in the past, selections would typically be made by a committee from a pool of applicants.[16] One would expect that a wider range of preferences and interests would be voiced within a committee than from the single person curator model used by many institutions; however, given that ARCs are increasingly employing curators, this is changing.

Most importantly, however, many ARCs have made a commitment to diversity in their mandates. In this, the mandate of the Winnipeg-based ARC aceartinc. might be typical: "aceartinc. is dedicated to cultural diversity in its programming and to this end encourages applications from all contemporary artists and curators including

those identifying as members of GLBT (gay, lesbian, bisexual and transgendered), Aboriginal (status, non-status, Inuit and Metis) and all other culturally diverse communities."[17] It is important to note that this mandate does not specifically mention gender; indeed, most institutions that I looked at did not mention gender as part of their diversity criteria. Nevertheless, the avowed support of diversity suggests an awareness of the need for gender-equitable representation. In this overview of institutions, I was not collecting information on race or ethnicity; consequently, the question of whether or not ARCs measure up to these goals remains an important one to be studied.

Of the twenty-four ARCs included in our study, four had significantly more exhibitions of female artists than male artists. Interestingly, no public galleries had significantly more female shows than male shows. Of these ARCs showing significantly more women, only La Centrale Galerie Powerhouse in Montreal had a history that specifically focused on gender. It was created in 1973 as the first women's gallery in Canada, and the second in North America. In 2007, it modified its mandate to be open to artists of any gender. As Leila Pourtavaf describes it, the new mandate is more consistent with contemporary feminist thought, which:

> recognizes that discourses focusing on a monolithic singular identity such as "women" have been sufficiently undermined at this point by the multiple narratives that situate the specificity and the differences of the bodies that occupy and push the limits of such a categorical identity. Instead, La Centrale's programming is now informed by a definition of feminism which questions relationships of power in our society and concerns itself with a broader range of societal issues, including the implications of gender regulations, regimes of sexuality, class, race, capitalism, and imperialism.[18]

While I agree with this characterization of contemporary feminist thought and support the deconstruction of binary gender difference in favour of a more comprehensive reconfiguration of gender dynamics, I am not at all confident that we have surpassed the strategic necessity of female positive spaces. I see the numbers represented throughout this book as indicating that the binary gender regime still exercises an inordinate amount of power in most larger Canadian galleries. It bears repeating that none of the institutions in our data

set included any artists who were not widely identified as either male or female. I hope that if I looked at the numbers for more recent years that will have changed.

The other three showing significantly more women – Harcourt House in Edmonton; ARTSPLACE in Annapolis Royal, Nova Scotia; and Artspeak in Vancouver – do not have specifically feminist mandates. However, when I asked about their strong female showings, ARTSPLACE's gallery director, Sophie Paskins, emailed, "There is nothing specified in our mandate to encourage female artists, we choose proposals based on merit alone – the fact we have represented more females may be a larger reflection of the role women play in the arts." Artspeak also does not specifically select with gender in mind, although the current director, Kim Nguyen, professes a consideration of diversity issues. She also suggested that the large number of women they exhibit might be explained by the fact that Artspeak has had few male employees. While this may be a contributing factor, the data does not consistently link employee gender with the gender of artists. Nevertheless, one curator I interviewed, who early in her career had worked at an ARC with a high proportion of female artists, suggested it would be bad for her career if it were to become known that she had shown so many female artists. She laughed as she said it, but I did not think she was joking.

Public Institutions: University Galleries

University and public galleries overall performed less well in terms of gender equity than ARCs, as was expected for a variety of reasons. Given the demographics in contemporary university art programs and the reduced necessity of generating gate revenue or even pleasing a wider public, we hypothesized that university galleries might produce results more in line with ARCs than with other public galleries. We were wrong. More than a third (37 per cent) of the university galleries gave less than 40 per cent of their solo contemporary shows to female artists, and a surprising 80 per cent showed less than 50 per cent female artists.

With the notable exception of the University of British Columbia's Museum of Anthropology (MoA), which I discuss in more detail in chapter 3, no university galleries showed less than 25 per cent female artists, although several were between 25 and 30 per cent: from 2000 to 2010, according to their websites, the University of Toronto Art

Centre, the Belkin Satellite Gallery at the University of British Columbia, and the Nickle Arts Museum (now the Nickle Galleries) at the University of Calgary all devoted less than 30 per cent of their solo shows to female artists.

There are multiple reasons for such numbers. Many university curators and directors who I spoke with suggested that the primary reason was financial. University galleries tend to have small acquisition budgets and rely heavily on donations that, anecdotally, have a significant gender bias in favour of male artists. Curating from the collection means they are selecting from a gender-biased pool, which many of the curators I spoke with felt they had little power to change. Yet this is less true for contemporary shows, which are often not chosen from the collection, and it would also be less true for the better-funded university galleries. Nevertheless, it is important to point out that if donor bias is the reason the collections are skewed toward male artists, and consequently why the shows are skewed toward male artists, this would make the resulting preferential loop for male artists even more difficult to break. We might ask whose job it is to break the cycle. Should we expect donors to do so? If the very programs in which our future curators are inculcated accept what seems to be the inevitable, change will be slow indeed.

Public Galleries

The least equitable category overall – and, concomitantly, the most visited – was public institutions excluding university galleries. Overall, they averaged 44 per cent of solo shows going to female artists. As with the other categories, it included many institutions that exhibited between 40 and 60 per cent female shows; however, public galleries had the lowest percentage in this middle ground at only 50 per cent of public galleries approaching equity. Public galleries had the highest proportion of institutions showing less than 40 per cent female artists, as indicated by figure 1.3. Even more disturbing, five public galleries in the study showed fewer than 30 per cent female artists, whereas none exhibited fewer than 30 per cent male artists. The Museum of Contemporary Canadian Art (MOCCA), the erstwhile Triangle Gallery, the Vancouver Art Gallery (VAG), the National Gallery of Canada (NGC), and the Montreal Museum of Fine Arts (MMFA) all exhibited less than 30 per cent female artists in their solo shows of living

artists.[19] That is to say, some of our most important contemporary galleries have the worst records on gender equity.

BY CITY

Because regional identity has been so important in the discourse around representation in Canada (see the discussion regarding the NGC), we also wanted to look at regional variation. We broke the data down according to the following cities: Vancouver, Calgary, Edmonton, Regina, Winnipeg, Toronto, Ottawa, and Montreal, leaving all remaining sites as one large category. Overall, the regions outside the major cities had a larger representation of men than women, but it was not statistically significant. In contrast, Montreal, Edmonton, Regina, and Calgary all had larger representations of female than male artists, but none were so much larger that they were considered statistically significant. However, Toronto, Vancouver, Winnipeg, and Ottawa did have statistically significantly fewer female artists, but it is difficult to assess how much of this is due to the dominance of specific problematic institutions in each centre. Overall, the data did not suggest that the city was the most significant factor.

THE ENDS OF THE SPECTRUM

If we focus more closely at the ends of the spectrum, two institutions had 70 per cent or more of their solo shows by female artists: ARTSPLACE in Annapolis Royal and La Centrale Galerie Powerhouse in Montreal, both ARCs discussed above. At the opposite end of the spectrum, the category of statistically significantly fewer solo shows by female artists than male artists (using data available in 2011, considering exhibitions from 2000 to 2010 as listed on institutional websites) is much larger, as table 1 shows. It includes nineteen institutions: five university galleries and twelve public galleries, with the least equitable in statistical terms at the top. In contrast to ARTSPLACE and La Centrale, many of these are appreciably more important as institutions, in terms of audience size, the likelihood of being reviewed in the national press, or the likelihood of leading to international recognition or sales. Perhaps most importantly, these large institutions are more likely to have archives that will become the basis of our

future history. The NGC, the VAG, the Art Gallery of Ontario (AGO), the Winnipeg Art Gallery (WAG), MOCCA, the Musée d'art contemporain de Montréal (MACM), and the MMFA, among others on this list, are by any measure major Canadian institutions. What does it mean when this many major institutions exhibited less than 30 per cent female contemporary artists from 2000 to 2010?

It can be easy to start making excuses and justifications for these numbers out of hand. Indeed, I have found it fascinating that most people with whom I casually discuss these issues immediately seek to explain the numbers in myriad ways that do not include gender bias or patriarchy. When I saw the VAG's results, my first thoughts were, "Well, but they showed *Wack!*, and they also have to contend with the Vancouver school, which has so many male stars." I excused and justified in equal measure. Whatever our collective explanations, I believe such numbers merit further consideration, which is the subject of future chapters.

Even in their broadest shape, as they are discussed in this chapter, we can draw some conclusions from this statistical project. We will need to provide nuance to this consideration through further investigation, but at a minimum, I believe these numbers show the following:

- First, that many Canadian art institutions are doing well with respect to gender equity in their solo shows.
- Second, that some are doing quite poorly.
- Third, that some of the least equitable are our most important and influential institutions.
- Fourth, the fact that some institutions do very well in terms of gender equity does not excuse others from doing poorly. In fact, the large number of galleries that are relatively gender equitable indicates that gender equity is not an issue of quality, since many curators are finding excellent work to exhibit by both male and female artists. The large number of institutions that are gender equitable only highlights how problematic the more inequitable institutions are.
- Fifth, that the results from UBC's MoA seem to confirm what we know from other literatures: that gender never stands alone as an issue; it is always intersectional. Race, ethnicity, gender identity, regional concerns, age, and many other less quantifiable factors can multiply disadvantages for specific groups.

- Sixth, that the relative silence on gender identity issues in the museum and curatorial studies literature is a significant issue that needs to be rectified.
- Seventh, that such statistics, despite their shortcomings, allow us to see the state of affairs in clear terms, and thus have value.

Cumulatively, these initial results make a strong case for further study – longitudinal, qualitative, discursive – of issues around representation.

2

"We're Only Interested in Excellence. We Don't Care Who Makes It": Thinking Through Diversity at the National Gallery of Canada

The strength of the National Gallery of Canada lies in its collection of art, especially Canadian art, and accessibility to the public across the country ... Through its collections, onsite and travelling exhibitions, loans program, educational programs and publications, professional training programs, and outreach initiatives, the Gallery aspires to be a model of excellence in furthering knowledge of the visual arts, both at home and abroad.

National Gallery of Canada Annual Report 2010–11

The NGC is, by many estimations, the most significant art gallery in Canada. It plays an important role in shaping the contemporary Canadian art scene through its ambitious collections and exhibitions. It has the largest travelling program, one of the country's largest acquisitions budgets, and the most impressive historical collections. Its role in promoting the international reputation of Canadian artists is unmatched. Any doubt about its importance is cast aside by looking at the success of those artists it has celebrated in the past: its ongoing support of an artist or group almost inevitably makes them a part of Canadian art history. Its purpose as set out by the Canada's Museums Act is: "to develop, maintain, and make known, throughout Canada and internationally, a collection of works of art, both historic and contemporary, with special, but not exclusive, reference to Canada, and to further knowledge, understanding, and enjoyment of art in general among all Canadians."[1] While the Museums Act lays out the larger governing principles, the Gallery augments these

in statements about its vision, mandate, and essence in its annual reports, which typically stress that the importance of Canadian art for the fulfillment of the Gallery's purpose: to strive "to provide Canadians with a sense of identity and to foster pride in Canada's rich visual-arts heritage."[2] Despite this seeming clarity of vision, thorny issues about its role in creating or shaping our collective heritage remain.

Because of its pre-eminence, the NGC has been the subject of many important analyses and critiques. I am certainly not the first to raise questions about how it fulfills its mandate – about *which* Canadian identities it names, produces, or promotes – nor even the first to discuss its mandate with respect to gender and statistics.[3] There are even art projects engaging with similar material. Figure 2.1 is a detail from Maria Flawia Litwin's artist book *The National Girl.* Her analysis of the subject matter and materials of NGC acquisitions concludes: "prefers photography ... in a manageable medium size ... nature above all ... abstraction above politics or the self." Yet despite the risk of some repetition, the statistical model used here allows us to explore certain trends in exhibition history that can be occluded by more detailed views of single exhibitions, installations, or categories of art. The statistical methods allow us to paint a bigger picture and come up with an overarching structural analysis of the National Gallery's record on gender and diversity, drawing on and extending the important work done by Joyce Zemans and others. In this chapter, however, I deepen this analysis: first, by extending it over time, which allows us to trace larger patterns to see how they are related to changing cultural expectations around diversity and representation; and second, by comparing the ways different diversity categories have been considered and treated. Examining the NGC's occasional use of the category "women artists" and their more frequent resistance to any gender recognition allows us to assess what Anne Whitelaw aptly called "statistical imperatives." It also allows us to bring to light the generally unspoken strategies for inclusion and exclusion that have guided the gallery's programming and consequently produce the story of Canadian identity that they promote.[4] In looking back to the earliest solo shows of living female artists, to group shows of "women" artists, and to more recent considerations of gender, the first sections of this chapter will tease out both the practice and the underlying ideology at work in order to assess how the NGC's various strategies for inclusion have functioned.

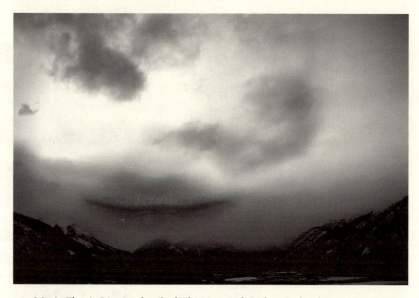

2.1 Maria Flawia Litwin, detail of *The National Girl*, artist book project, 2012.
Photo courtesy of the author.

The second half of this chapter compares how different diversity
categories have been conceptualized at different times and how they
have been structurally administered at the NGC, and then assesses
the resulting numbers of exhibitions. I wanted to collect data that
would allow me to interpret whether different strategies and ideolo-
gies had different levels of effectiveness. The categories examined
here – gender and indigeneity – are not identically situated within
the larger culture, and I do not want to suggest false equivalencies.
Rather, I want to consider the numbers in relation to the discursive
and structural constructs around the terms. The question of inter-
sectionality – of the relations among these categories of exclusion
and inclusion – is a vital component of any consideration of divers-
ity and representation.

METHODOLOGY

As described in the methodology section of chapter 1, in the first
instance my research team assessed solo shows of living artists at the
NGC that opened between 1 January 2000 and 31 December 2009
(a ten-year span). There are at least three ways (and probably several

more) to objectively classify what counts as a solo show at the NGC, although as it turns out, each produces similar results. Although what counts as a solo show at some institutions is easily quantified, the data from the NGC is often contradictory. We looked at the annual reports, the library and archives database, and the gallery website. We only included exhibitions at the Ottawa site, organized by the date of the opening. The first question that arose was whether or not to include the exhibitions organized by the Canadian Museum of Contemporary Photography (CMCP). Prior to 2006, the CMCP was in a separate building and was listed separately in the annual reports and on the website, so it seems clear that before 2006 it needs to be considered separately. The distinction seems less valid after that date, since its separation from the NGC would not have been very meaningful for most gallery visitors, given that CMCP exhibits were held in the main building. Nevertheless, we decided to follow the division as maintained by the website and the annual reports, and did not include CMCP exhibits.

Other decisions had to be made to minimize inconsistencies in the data. For example, exhibitions organized by the NGC library are usually listed as exhibitions in the database and on the website but are not included in the annual reports. This affects two exhibitions in our data set – Micah Lexier's library show in 2004 and Garry Neill Kennedy's in 2007. While undoubtedly of lower profile than a major retrospective in the Special Exhibition galleries, library exhibits still have some prominence, arguably more than some exhibits that are listed in the reports but not on the website, so we included these shows in the larger data set.[5]

The most vexing inconsistency for research, however, is how small shows are classified: until the 2002–03 reporting year, the annual reports did not differentiate between small installations of works in the permanent collection and larger shows – except implicitly by naming the gallery location. In 2003, the NGC entered into protracted negotiations and ensuing litigation with Canadian Artists' Representation/Le Front des artistes canadiens (CARFAC) and Regroupement des artistes en arts visuels du Québec (RAAV) over artists fees, including over the issue of how artists should be paid for exhibitions of works in the permanent collection, and implicitly whether an installation that is owned by the gallery is considered a solo show. That same year, the NGC began to subdivide the exhibitions list in its annual reports to include a category called Installations of

Selected Works from the Permanent Collection (ISWPC).[6] These shows are typically in the contemporary galleries and are lower profile than those in the temporary exhibition spaces; but they are not categorized in a consistent manner, which causes difficulties for a data-driven project. For example, the 2003–04 annual report includes *Brian Jungen: Recent Acquisitions* (shown in the Contemporary Galleries from 17 February to 14 April 2004), which was also listed on the NGC website and is listed in the archives as an exhibition. However, when I spoke with curators at the NGC in 2013, they did not perceive this show as a solo exhibition, and shortly after our conversation it was removed from the website.

Such inconsistencies are compounded by a change to the method of archival record keeping. Exhibitions held before May 2005 are searchable in the Library and Archives online catalogue by EX number; however, EX 2149, which opened in May 2005, was the last to be categorized that way. Given the errors on the website and in the annual reports that I encountered, I enquired about later exhibitions, only to be referred to the Past Exhibitions tab on the website. Many of the exhibitions listed in the annual reports as ISWPC are not listed on the website, although some are. Simply excluding all the ISWPC works is one means of regularizing the data, however it is not really adequate. This method would, for example, include the first exhibition of Janet Cardiff's *Forty-Part Motet* (twice exhibited in the Rideau Chapel, it is a large and very popular installation that was given considerable space and press, and was advertised on the website as an exhibition), but exclude the second exhibition of the work because it dates after the ISWPC categorization. Even more problematic, and as discussed in greater detail below, for the period 2013 to 2015, whether exhibitions of ISWPC works are listed on the website strongly correlates to gender.

Consequently, we have run the numbers in multiple ways. First, we included all the exhibitions listed in the annual reports and on the website. We also ran the numbers excluding both those listed as ISWPC in the annual reports and the Library and Archives exhibitions. In a third analysis, we included only the exhibitions that were in the Special Exhibitions rooms.

THE NUMBERS, OBJECTIONS, AND RECOUNTS

In the most inclusive count, we tallied fifty-one solo shows of living artists opening between 1 January 2000 and 31 December 2009;

forty-one were of male artists and ten of female artists. Statistically, that is less than 20 per cent female, and it is an extremely significant deviation from the expected outcome of numeric gender equity (see the first column of figure 2.2).[7]

My first opportunity to present my results was at a Universities Art Association of Canada conference session entitled "Contemporary Art, Gender, and Institutions," held, ironically, in a cloakroom of the National Gallery.[8] Although the audience was deeply engaged, they also had many suggestions about how we might re-examine certain issues to produce a more representative count. Indeed, suggestions stemming from the idea that the data is somehow not a fair representation, even if it is accurate, are one of the most common reactions I get to the information. People, myself included, want to be able to dismiss the data. In the next sections, I will try to unpack this resistance to the idea that the numbers are a result of gender bias by looking closely at the NGC and following some of the suggestions of that original and important audience. But first, I will sort through some of the other ways of counting solo shows, out of recognition that different kinds of shows indicate different levels of support.

If we reconsider the numbers and remove all the exhibitions that were categorized as ISWPC, as well as the two exhibitions located in the library that were not included in the annual reports, the percentage of female artists rises. The total becomes thirty exhibitions, with eight female artists and twenty-two male artists, which is still a statistically significant deviation from expected equity (see the second column of figure 2.2).[9] This surprised me, because I expected bigger shows to have less gender equity. Consequently, I decided to look at the big exhibitions, those held in the Special Exhibitions space. Of these, six were male and two female, which puts us back at 25 per cent female, although because the numbers are so small it is not considered statistically significant (see figure 2.2). I also looked separately at the smaller, less expensive shows (those in the library and the ISWPC), and the numbers here were the most surprising to me. In this category, there were twenty-one exhibitions, of which nineteen went to male artists (see figure 2.2). Less than 10 per cent of these small shows went to female artists. I would have guessed that small shows would be more equitable, but in this instance the reverse is true. This may point to a consistent problem I heard from smaller institutions that work mainly with the permanent collection: If collections are heavily oriented towards male artists and you are curating

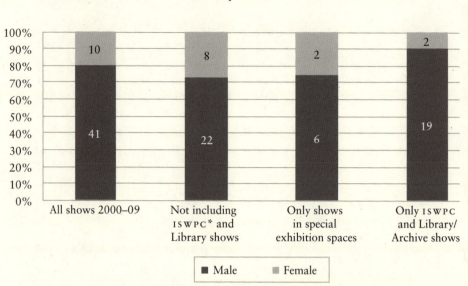

2.2 Gender distribution of artists with solo contemporary shows at the NGC, 2000–09, by type of exhibition. This figure reveals that regardless of what type of solo exhibition is counted, the representation of female artists is consistently poor.

*Installation of selected works from the permanent collection.

from the collection, curating equitably becomes very challenging. The same works by a few female artists get shown over and over again. Given that of the eight shows of female artists in the most inclusive data set, two are Janet Cardiff's *Forty-Part Motet*, the importance of equitable collecting is clear. Any way you count it, the National Gallery falls far short of gender equity.

Despite these facts, I heard many other theories besides gender bias that sought to explain, if not necessarily excuse, the numbers (as is also discussed in chapter 1). Undoubtedly, the most common dismissal of gender bias as an explanation is the suggestion that the numbers might actually be representative, because there may not be many senior female artists yet. That is, people suggest that 20 per cent could, in fact, be representative of the number of senior female artists. It is not. By 1979, female students outnumbered male students in Canadian university art programs, at a ratio of sixty-eight to thirty-two.[10] According to Statistics Canada data, since 1988, the number of female artists in the employment category "5136 – Painters, Sculptors and Other Visual Artists" has consistently outnumbered male artists. In 1988 it was 5.5 to 4.1; by 2016 it was 9.9 to 5.1.[11]

In the face of this evidence, the next most frequent objection comes from the seemingly reasonable idea of a seniority lag. That is, it suggests that although female artists might account for half of the working artists today, they must not have represented such an even amount until very recently, and since the NGC typically exhibits senior artists, perhaps these artists are being selected from a different pool. Assessing seniority is somewhat more difficult and less precise, but this assumption is premised on the idea that gender bias is a historical artifact, something left over from the admittedly gender-biased practices of earlier decades. This is belied by the fact that in Canada, women represent *more* than half the working artists, and this has been true since at least the 1980s.

Another of the common ways people have excused these numbers is by suggesting that no matter how bad things are, gender representation must be getting more equitable. Many people I have spoken with about the project agree that gender bias was a significant problem in earlier periods, but are reluctant to admit that it is ongoing. To assess this possibility, we did a comparative look at the solo shows of living artists at the NGC by decade, relying on the exhibitions listed on the NGC website. Despite our expectations, the results were even more worrisome.

In the 1980s, the percentage of solo shows of living artists gendered female at the NGC was 18 per cent; in the 1990s, this figure rose to about 30 per cent; and, as we have seen, from 2000 to 2009, it fell back to around 20 per cent (see figure 2.3). By the measure of solo shows of living artists at the NGC, gender equity is getting worse.

Despite what my research shows, I continue to hope that there will be a substantial improvement at the NGC, so I was excited to read a 2015 article in *Canadian Art* that implied significant improvement on gender representation, if not ethnic diversity.[12] It was an important study for *Canadian Art* to publish, as this magazine has not been a beacon of gender equity. The authors counted solo shows of living artists, so I expected our numbers to be comparable. In trying to reconcile my numbers with theirs, some interesting issues came to light. First, their findings underline the dangers of looking at a short time span (less than two and a half years in this case); relying only on percentages, especially when small numbers are used; and, most importantly, relying on an institution's website for data. Included in their study of the NGC were shows listed on the gallery website: Janet Cardiff, Mary Pratt, Vera Frenkel, Candice Breitz, Robert Burley,

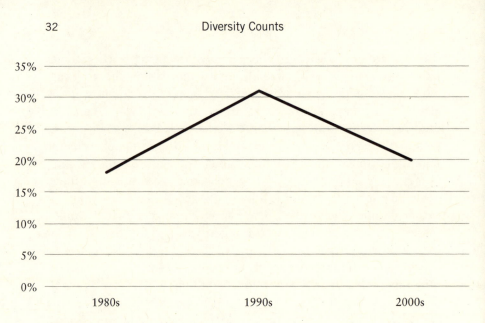

2.3 Percentage of solo contemporary shows by female artists at the NGC, by decade

Michel Campeau, Don McCullin, Pierre Huyghe, and Martin Creed, which gave rise to their number of 44 per cent female solo shows.[13] However, in trying to align my research numbers with their, I found that the data they relied on – that available on the NGC's website – significantly misrepresents the solo shows: it skews the data toward more shows by female artists.[14]

Comparing the data in the annual reports with the website data reveals that the difference between them is gendered. Exhibitions categorized in the annual reports as ISWPC are sometimes, though not always, counted as solo exhibitions on the website. So, using the website, the numbers from 1 January 2013 through 3 April 2015 were, as correctly reported in *Canadian Art*, nine solo shows. Of these, four were by female artists and five by male artists. However, if we use the data from the annual reports for the same time period there were many more shows and installations of selected works. What is disturbing, however, is that ISWPC installations by female artists are three times more likely than those by male artists to be listed as solo shows on the gallery website. Of the four solo exhibitions of female artists in the article, three were ISWPC. Of the five solo exhibitions by male artists, only two were ISWPC. I do not have access to the rationale for why some ISWPC exhibitions are included as exhibitions

on the website while others are not, but regardless, the data on the website for these years is inadequate, and it substantially over-represents female artists as having had solo shows that were in fact installations of works from the collection, when such exhibitions by male artists are unlikely to be classified as solo shows.

There are several ways to correct what a sociologist would classify as bad data. One would be to exclude all the ISWPC shows. That would result in four total shows, one of which is by a female artist (25 per cent female). Another way is to count all the shows listed in the annual reports, including both non-ISWPC and ISWPC, which would result in fifteen shows by women out of forty-seven total shows. That is to say, in the most inclusive count of this short time frame, the percentage of shows given to female artists is 33 per cent (see figure 2.4).

Any fair way you count it, the numbers are still significantly different from expected equity, significantly worse than the numbers reported in *Canadian Art*, and significantly worse than those listed on the NGC website, on which the article, reasonably enough, relied.

Another way to look at the data is to define major exhibitions as being those that have an accompanying catalogue. In their important work, Joyce Zemans and Amy Wallace looked at exhibitions of Canadian artists and considered those with catalogues and those without: "Overall, from 1998 to 2011, the NGC mounted 22 solo exhibitions by living Canadian male artists and 13 by living Canadian female artists. Of the 22 solo exhibitions by male artists, 18 (82 per cent) were accompanied by a catalogue, and 9 (69 per cent) of the 13 exhibitions by female artists had a catalogue."[15] Female artists are less likely to receive the substantial investment represented by a catalogue. More significantly, they do not receive the entry into the historical record as happens with a catalogue.

There has not been an unimpeded progression towards greater equity, nor has the NGC suddenly improved its record on gender equity. Such wishful thinking does not stand in the face of the evidence. Given that the NGC's representation of women in solo shows has fallen significantly in the first decade of the new millennium, we can conclude that gender inequity in the art world is not going to simply wither away. Delving more deeply into the times when the gallery has opened up its exhibitions to more women, when it has made marked improvement around diversity and representation, and understanding

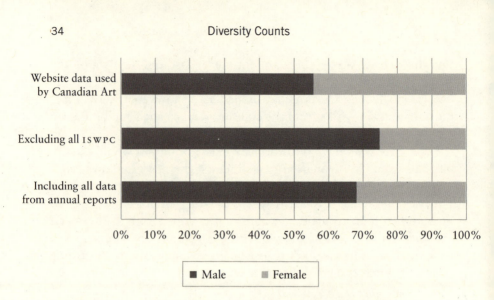

2.4 Percentage of solo contemporary shows at NGC by gender, 2013–15.
The number of shows listed as solo exhibition on the gallery's website is not
consistent with the numbers in the annual reports. The website numbers have been
used to suggest that the gallery's record on gender equity has improved; however,
any consistent method of categorization does not show much improvement.

when there has been a retrenchment may allow us to draw some
conclusions about best practices.

REPRESENTING WOMEN IN THE 1970S
AND EARLY 1980S AT THE NGC

The NGC had no solo shows of living female artists until 1971. Fast
on the heels of the *Royal Commission on the Status of Women Report*
in 1970, however, there were important breakthroughs. In May 1971,
the NGC's Extension Services began an extended tour of two simul-
taneous exhibitions by Vera Frenkel (*Vera Frenkel: Printmaking Plus
I & II*), which began at opposite coasts and travelled to twenty-two
venues. Although they did not show in Ottawa, these exhibitions
indicate a major commitment to a rising Canadian artist, who was
by then receiving significant international recognition for her print-
making.[16] In the fall, American artist Nancy Graves's exhibition
Shaman opened, curated by Brydon Smith. Sandwiched between her
1969 solo show at the Whitney and her prominent position at *docu-
menta 5* (1972), Graves's Canadian exhibition gave further inter-
national recognition to the rising star. As we will see, it was also

significant for the NGC to take on an international artist who was a woman.[17] Undoubtedly the most renowned exhibition of 1971 was the one that opened on what is now known as Canada Day: Joyce Wieland's exhibition *True Patriot Love*. Often characterized as a "feminist milestone,"[18] the exhibition attracted much attention. Like Graves, Wieland had an established and international reputation: inclusion in the Expo 67 exhibit *Painting in Canada*, film screenings at the Museum of Modern Art in 1968, a retrospective at the VAG that same year, and a retrospective at the Glendon College Art Gallery in 1969 had all established her as a major Canadian artist with an international reputation.[19] Given the international reputation of these three artists, the support they were given by the NGC should not have been noteworthy. However, because of both the dramatic increase in female representation and the prior lack of representation, it seemed to indicate a fundamental reconfiguration of the status of women in the National Gallery in 1971.[20]

The Wieland show caused some furor, ostensibly because of its subject rather than the gender of the artist.[21] Yet gender issues around this show remain controversial. Comments at the show's fortieth anniversary by its curator Pierre Théberge, latterly director of the NGC, typified one of the ways in which artists gendered female were thought about and positioned in the intervening years: "I have always thought it was such a stupid thing to characterize the exhibition [as a feminist milestone] ... To me, Wieland was an artist first, not a woman first. She did not hide her sexuality at all. But that was not the exhibition's point."[22] Théberge's statement is difficult to parse: Is he saying that an artist's gender is irrelevant? That some artists' gender is irrelevant? That if the exhibition's point were more (obviously) related to gender then the artist's gender would matter, but if the show was not about gender then the artist's gender does not matter? That there are artists who transcend their gender/sex but also artists who do not? Whatever it lacks in precision, his comment evinces a desire for gender to be an irrelevant category. As a strategy, it seems sound; we might find it cautionary, though, that the next solo show at the NGC by a living female artist did not occur for more than a decade.

After the heady days of 1971 through the remaining years of the decade, female artists were hard to find at the National Gallery. There was a Diane Arbus show in 1974, three years after her death, and the same year as an exhibition by the duo Bernd and Hilla Becher.[23] The next solo show of a female living artist at the NGC was Paraskeva

Clark's exhibition, which opened in November of 1982 (discussed below, see also table 2.1). Given how the rest of the 1970s played out, those solo exhibitions in 1971 are even more striking.

If solo shows did not fulfill the promise of 1971, were groups shows in the 1970s any better? Since 1971, the NGC has generally shied away from overtly promoting gender as a category that should be considered or celebrated. However, in 1975, a year the United Nations had designated International Women's Year, the gallery held a significant group show of female artists, promoted for reason of their gender: *Some Canadian Women Artists*, curated by Mayo Graham. These were the years in which the first feminist and women-only artist spaces, such as the Powerhouse Gallery and Studio, which began exhibiting in 1973, were created in both Canada and the USA.[24] In many respects, *Some Canadian Women Artists* represents the NGC's efforts to respond to and be a part of a significant international trend in both contemporary art and contemporary art galleries. The exhibition catalogue's preface situates the project in relation to the United Nations' International Women's Year, yet also stipulates that the show had earlier origins. Graham attributed its origins to two different sources, the first being an idea proposed in 1972 by Joyce Wieland in a letter to gallery director Jean Sutherland Boggs: "I have been thinking for a long time about an historic show of Canadian women artists ... It's just a powerful thought at the moment and something some of us feel really eager to see."[25] Weiland's proposal for a historic show seems to have supported the second source Graham claims: her own area of expertise in contemporary Canadian art. Regardless of the initial motivation, we can situate the exhibition within the wider surge of "women's year" activities taking place internationally and rising out of the growing women's movement.

Hailed by the *Globe and Mail* as one of the most important exhibitions of the decade,[26] *Some Canadian Women Artists* was an enormous undertaking. Accounts of the exhibition stress that Graham, who was then assistant curator of contemporary Canadian art, visited roughly 200 female artists from across the country. This number is cited in almost every article about the exhibition, and I read its frequent repetition as evidence of a desire to validate the breadth of women's art practice. In Canada, there were three other major exhibitions of female artists that year and numerous smaller ones. In Kingston, at the Agnes Etherington Art Centre, Dorothy Farr and Natalie Luckyj curated *From Women's Eyes: Women Painters in*

Canada; the WAG exhibited *Woman as Viewer: An International Women's Year Project*, a project that critiqued the simultaneous show *Images of Women*; and Montreal was home to the multi-venue event *Art Femme '75*.[27] Unlike with these exhibitions, however, the NGC sought a tighter focus, exhibiting only seven artists. Yet the NGC's elevated position and its ideology of "excellence" made its overt selection criteria fraught from the outset.

The ambivalence over the fundamental premise of the exhibition is made clear in many facets of the exhibition materials. The exhibition catalogue begins by tackling the most persistent question head on: "Why have an exhibition of women artists?"[28] Graham uses statistics to support her observation that, "Until very recently, women artists have been almost invisible."[29] After mentioning the rising interest in "women's art," Graham claims: "This new awareness about artists/women only underlines their previous invisibility and shows that there are *or have been* specific problems of recognition" (emphasis mine).[30] We need to note the optimism, if that is the right term, in the phrase "there are or have been": as early as the gallery's first group show of female artists, people were assuming that problems around gender bias could be discussed in the past tense. Graham concludes her justification with a two-pronged argument: first, she maintains that the works stand on their own in terms of quality; and second, she suggests that the category itself allows us to see some shared concerns, which she sees as being based on both biology and different social experiences. Consistent with some feminist trends in the 1970s, Graham refers repeatedly to biology as one factor influencing female production – seeing, for example, seriality as potentially biologically inspired by the "female biological system, at once both sequential and cyclical."[31] Yet it would not be fair to dismiss her argument as merely biological, as she clearly does not situate biology as the only factor. She concludes by expressing an optimism that we, as a society, will move toward androgyny, implicitly understood here to be a state in which gender no longer plays a determining role in peoples' lives.

Although reception of the exhibition was generally positive, much of the public discourse revealed a discomfort around gender as a category, including responses from the gallery itself. Despite her defence of the show's premise, Graham's ambivalence about the "women artists" category was palpable. Sylvia Sleigh, who had been active in the feminist art movement in New York since the early 1970s, reported that "The curator of the National Gallery of Canada

and organizer of *Some Canadian Women Artists* seems to have had some doubts about her subject and is apologetic for having an all-woman show."[32]

The institutional ambivalence implied by Graham's defensive positioning was even more clearly revealed by Boggs's response to an article by Charlotte Gobeil in the *Ottawa Citizen*. Boggs stated categorically that she would not "disavow" any exhibition at the NGC. She went on to explain that

> the basis for the suggestion in relation to our exhibition of Seven [*sic*] Canadian Women Artists, which I thoroughly enjoyed, may be that I do not believe works of art should be judged on the basis of geography, the language the artist speaks, the colour of the artist's skin, or sex. Nevertheless, exhibitions often bring together works of art on an arbitrary basis – in this case because the artists are women. I would never however argue that they are gifted artists – which I believe they are – *because* they are women.[33]

Like Graham, Boggs was at pains to distinguish the organizational principle, which she called arbitrary, from the quality of the work. Gathie Falk also admitted to disliking the idea of being included in a women-only show – and suggested that all the women included felt similarly.[34] Boggs's and Falk's distrust of the premise might explain Graham's attempt to defend it, but the larger controversy around the show speaks of the fundamental concerns of the time around naming the categories of inclusion.

Other critics objected to Graham's suggestion that biological concerns were evident in the work. Robert Fulford, for example, took issue with Graham's suggestion that her research allowed her to identify some distinctly feminine concerns, such as texture and seriality.[35] Fulford read this as a kind of biological essentialism, which he argued was reductive. Georges Bogardi in the *Montreal Star* objected most strongly to the exhibition's premise. He saw the exhibition as insulting to women, and described the premise as sexist and an example of mere tokenism.[36] His review criticized what he saw as Graham's biological essentialism and resultant reduction of the individuality of the women to shared experiences. His position seems, in many ways, supportive of female artists. "What emerges from this diagnosis is the basic, 'sexist' view of women as prisoners of biology and social conditioning; delicate, emotional creatures who are,

however, clever with their hands," he writes. "Not a flattering portrait and not one that describes the women artists this writer is acquainted with." But Bogardi also took issue with the quality of the work, stating that only Sherry Grauer and Colette Whiten were ready for this level of exposure. He urged the NGC to refrain from such tokenism and suggested instead that they should give artists such as Whiten and Grauer full solo exhibitions. His criticism seems founded on principles of equity. Yet the limits to his understanding of feminism and feminist art practice become clear when he describes the artists' statements as having "a great deal of irritating prattle about the house, kids, husbands, boyfriends, and precious little about art."

Yet, while several objected to and all noted the exhibition's principle of gender, no reviewers objected to the other criterion in the title: "Canadian."[37] Despite Boggs's recognition of the arbitrary nature of constructed categories, she only speaks of it in terms of gender, not nation. Moreover, as we have come to expect, there was some complaint about regional representation: Virginia Nixon of the *Montreal Gazette* noted that there were no Prairie or Quebecois artists. Yet the biggest omission of all went unrecognized. No critics decried the other underlying categories of inclusion: all the artists are white, and all worked in the Euro-Canadian tradition. That is to say, many of the categories of inclusion and exclusion are never made apparent, and remain unrecognized.

The gallery's first foray into the category of "women artists" and the variety of responses to it revealed many of the issues that I would argue are still at play in any discussion of representation: "quality" versus selection criteria; inclusion being (or being seen as) tokenism; the theme obscuring individual works; the "arbitrary" nature of categories; and the foregrounding of the artist over the art. Then as now, however, what was called out also occluded many of the issues that continue to be at play in questions around representation. For example, when shows support the status quo, it is not typically decried as activist, although perhaps it should be. The unspoken premises underlying other exhibitions may not be obvious to most people, and thus are not subject to the same scrutiny. For example, every other exhibition at the NGC in 1975 was by a male artist, suggesting that gender was an underlying, yet unrecognized criterion. Indeed, these unrecognized criteria may be equally arbitrary categories, the de facto but unspoken categories of race, gender, class, media, and so on that continue to inhibit diversity today.

In the subsequent forty-odd years, I found only two more exhib-
itions that explicitly foregrounded gender – both examining the con-
tributions of female artists to video. In 1989, *Rebel Girls: A Survey
of Feminist Videotapes, 1974–1988* was curated by Susan Ditta,
then-video curator at the National Gallery. Ditta's exhibition, although
exhibiting only female artists, was organized around the category of
feminist artists, not necessarily female artists.[38] Consequently, she
avoided the charge of biological essentialism. Indeed, the following
year, her feminist video series *Double Exposure* featured mainly
female feminists but also included work by Michael Snow, thus refut-
ing the category of "woman artist" and embracing an idea of feminism
as a political position rather than biologically determined category.
The next NGC exhibition to foreground gender would come five years
later, in 1994, when *The First Generation: Women and Video, 1970–
75*, which originated at the US National Museum of Women in the
Arts, travelled to the National Gallery.[39]

But for these three exceptions, the category of "woman artist" was
not normally a focus for the NGC: works by female artists were
mainstreamed, and attention was seldom drawn to artists' gender,
except insofar as was required by the English language. Even in these
few cited instances, there was resistance to the category, and calls for
a focus instead on "quality." Exclusively male exhibitions did not tend
to receive such attention.

Other group shows made slow progress on the equity front through
the early part of the 1980s, despite claims that women-only shows
were not required. The 1980 exhibition *Pluralities* – purportedly a
survey of new Canadian art – included seventeen male artists and two
female artists.[40] Despite some significantly inequitable representation
in this and many other group shows, gender has almost never been a
cause for overt protest at the NGC, and most often the inequity has
not been noted at all. One rare exception I found was a review by
Virginia Nixon, art critic for the *Montreal Gazette*:

> The four guest curators … will undoubtedly be criticized for
> their selection. There are seventeen men and only two women!
> Only a single painter! No video or performance art at all, and
> most of Canada's best-known contemporary artists are not
> included! But no single exhibition has room for everybody, and
> nobody's claiming that these nineteen are the only significant
> artists in Canada. The curators simply took the very reasonable

approach of choosing a workable number of artists whom they considered exceptional.[41]

So although Nixon pointed out inequitable gender representation as a complaint people might make about the exhibition, it was only to dismiss such a complaint as unreasonable.

Despite the belief already commonly held in the 1970s and 1980s that institutions were not biased against female artists, actual data on the experiences of female artists suggests otherwise. Their experiences were the subject of a study supported by the Status of Women Canada and led by Sasha McInnes-Hayman in 1980. It documented specific problems, such as the fact that of 229 jury positions on Canada Council visual arts juries from 1972 to 1978, only twenty-eight were held by women.[42] The report also noted the increase in the 1970s of female art faculty at Canadian universities, from 16 per cent in the early 1970s to 19 per cent in the late 1970s. The report did not mince words:

It is evident, indeed glaring, that Canada's arts related women have been and are being discriminated against in a variety of ways. The art of a large number of women has, in proportion to that of men, been given short shrift in the Canadian cultural context. The symbolic universe representing the unique female experience does not breathe equally on the walls of our galleries or on the staffs of our cultural institutions.[43]

After surveying more than 300 female artists from across Canada, the report made nine recommendations to the secretary of state. Status of Women Canada should undertake to "develop funding policies which include incentives to encourage publicly funded granting organizations to sponsor special programmes for women artists;" encourage publicly funded institutions to develop special education programs for women artists; develop policies to ensure equal representation of women in managerial, administrative, and policy-making decisions; create short-term funds targeted at women; and encourage, through special incentives, exhibitions of women's art.[44] Nevertheless, the report noted that while 47 per cent of the artists surveyed supported funding that was targeted towards women, 43 per cent opposed it. The report ended on what now seems to be a very optimistic note: "The artistic expression of women needs not only to be nurtured but

actively promoted. Through proactive government policies, the inequities which have restricted women artists can be swept away, allowing the full force of their vision to publicly blossom, enhancing the environment for all Canadians."[45] One thing that is striking from today's perspective is that the report does not mention ethnicity at all, although the questionnaire does ask about "ethnic origin." The report makes it clear that despite the public rhetoric of exhibition reviews and public stances, many feminists and female artists were aware – painfully aware even – of how far the rhetoric was from the reality.

CHANGING TIMES: THE LATER 1980S AND 1990S

If the early 1970s were marked by a sense of necessity to begin collecting and exhibiting work by women, the 1980s were marked by a sense of necessity to begin representing Indigenous cultures fairly, a subject that is taken up in the subsequent section. Despite the sense that the women's movement had succeeded and that the National Gallery had more pressing needs to attend to, in the 1980s the National Gallery held only four solo exhibitions by living female artists: Paraskeva Clark (1982), Vera Frenkel (1985), Barbara Steinman (1988), and Betty Goodwin (1989). Eighteen men had solo shows in the same decade, which works out to 18 per cent female artists, a statistically significant deviation from expected equity. The Clark exhibition was organized by the Dalhousie Art Gallery, which implies that less commitment was required by the National Gallery than a show curated in house. Moreover, while Clark fits my criterion for defining a contemporary artist as one living at the time of the exhibition, in 1982 she was hardly contemporary. Indeed, just how far she was from the contemporary scene is alluded to in the exhibition records, which tell us that the show was "complemented by the film 'Portrait of the Artist as an Old Lady.'"[46] She was well into her eighties at the time of the exhibition and well past the height of her engagement with contemporary art.

The National Gallery's ongoing support for Frenkel is more significant. When a gallery invests in an artist over the length of their career, it changes the historical record. Collecting in depth is unusual when it comes to galleries collecting works by female artists, and this differs sharply from how many galleries collect male artists, as Christine Conley has shown.[47] Frenkel's 1985 show, *Vera Frenkel: The Videotapes*, provided an overview of her recent video production; it

included a catalogue, and was organized by assistant curator Robert McFadden. Steinman's *Cenotaph* was an installation of a work that had been purchased by the NGC in 1986, organized by Susan Ditta, rather than a larger retrospective, and it did not have significant documentation. However, the NGC would support Steinman again in its 1989 biennial. Goodwin's show, *Steel Notes*, was Canada's entry to the twentieth São Paolo International Biennial, and as such was an example of highly visible support for a senior female artist. Yet the exhibition was not organized by the NGC, although the entry was later shown at the gallery. Can we draw any conclusions about these four exhibitions in the 1980s? All are white and from either Toronto or Montreal. Whereas in the 1970s there had been a significant West Coast presence, these artists are from a narrower geographic range. More significant is the fact that the gallery only organized two of the shows; except for the Goodwin show, these were relatively modest investments on the part of the NGC for one reason or another.[48]

Even as late as the mid-1980s, Graham's 1975 exhibition was still being cited as evidence of the NGC's commitment to women artists and gender equity. Anne Innis Dagg, who published the polemically titled *The Fifty Percent Solution: Why Should Women Pay for Men's Culture?* in 1986,[49] is one of few to publicly criticize the National Gallery's representation of female artists. In a 1984 article, she lamented that on the third floor of the NGC, only one living female artist was exhibited (Joyce Wieland).[50] Charles Hill, the gallery's curator of Canadian art, responded in a letter in which he dismissed her points, implied that she had not looked at the entire gallery, and misrepresented her position.[51] His final sentences strike a familiar note: "We are truly committed to the collection and presentation of the work of Canadian artists, both men and women." Yet his response did not address in a serious way any of her critiques: that the history of women artists was being obliterated, and that the gallery only exhibited works by six (Hill says seven) female artists working in the interwar years. Hill's justification of the contemporary scene was scarcely any more convincing. In the gallery's defence, he held up a recent exhibition of twenty years of recent acquisitions, which, he writes, included contemporary work by "Gathie Falk, Leslie Reid and Ayn [*sic*] Whitlock." He explains that Liz Magor was not currently on display because she was one of two artists representing the NGC at the Venice Biennale that summer.[52] While this last event is no small measure of support for women's art, the listing of only four women

in twenty years of acquisitions suggests to the attentive reader that Dagg had a point. Sasha McInnes-Hayman responded to Hill and took Dagg's argument further: she noted that in 1981 to 1982, less than half of one percent of the NGC's acquisition budget was spent on work by female artists.[53]

Not until the second half of the 1980s do we begin to see equitable representation of female artists in group shows at the National Gallery. The 1986 exhibition *Songs of Experience*, curated by Jessica Bradley and Diana Nemiroff, had more female than male artists, as did the 1989 biennial.[54] As Anne Whitelaw has shown, the most significant criticism of *Songs of Experience* centred around inadequate regional representation and inadequate francophone representation (a linguistic category that relates, though is not identical, to a regional one). As Whitelaw pointed out, this theoretically sophisticated project was concerned with issues animating the contemporary art world, and feminist practice that was concerned with the experience of gendered subjectivities had been a dominant concern for more than a decade.

In these same years, well-founded concerns over other diversity and representation issues arose in the Canadian museum and gallery world. As I will discuss in detail below, the lack of representation of First Nations, Métis, and Inuit artists rightly became a central concern of much critical museum studies in the period. Yet First Nations artists continued to be underrepresented in group shows. Only one of the twenty-five artists in the 1989 biennial was Indigenous: Edward Poitras, a member of the Gordon First Nation. Nemiroff's curatorial record indicates that she was deeply concerned with curating excellent art that represented the diverse practices found in Canada and that, for her, this included work by women and First Nations artists. Indeed, by the 1989 biennial, the 1992 landmark exhibition *Land, Spirit, Power* would likely have been on the NGC's horizon and the gallery itself had made significant shifts to its collecting practices (discussed below). Nevertheless, representation of Indigenous practice as a component of the contemporary national scene was not much in evidence at the 1989 biennial.[55] While the complex issues around Indigenous representation in the gallery animated academic museum studies discourse, in more popular and public forums regional representation continued to raise more discussion than gender or ethnicity. In some ways, this may seem natural given the National Gallery's mandate. The Museums Act of 1990, the law governing the NGC, explicitly addresses the gallery's purpose in the following terms: "The purposes

of the National Gallery of Canada are to develop, maintain and make known, *throughout Canada* and internationally, a collection of works of art, both historic and contemporary, with special but not exclusive reference to Canada, and to further knowledge, understanding and enjoyment of art in general among *all Canadians*" (emphases mine).[56] In this single sentence, Canada is referred to four times, and the reiteration of the necessity of reaching all Canadians, throughout Canada, makes clear how important the idea of breadth in terms of regional representation is to the NGC's project. Yet, the gallery's governing legislation makes no mention of any need to represent the diversity of makers.

In the later 1980s and 1990s, while Bradley (until her departure in 1987) and Nemiroff were curating the contemporary exhibitions, representation of both female artists and First Nations artists increased. While there are many factors besides the interests of the curator that lead to an institution's overall profile, in this case the role of strong, progressive curators in shaping the direction of the programming is evident.[57] As mentioned, in the 1990s, the NGC reached its highest percentage of solo shows by female artists: 30 per cent. It may also come as no surprise that with such significant representation of female artists in group shows beginning in the 1980s, the widespread sense that the issue of gender had been dealt with began to be accepted. Indeed, the sense that the gallery paid attention to statistical data was roundly critiqued.[58]

If we look closely at the website's list of solo shows of contemporary female artists in the 1990s, some interesting things stand out. The artists were Geneviève Cadieux (1990), Trinh T. Minh-ha (1990), Jana Sterbak (1991), Spring Hurlbut (1992), Sara Diamond (1992), Panya Clark[59] (1995), the American Lynn Hershman[60] (1995), Betty Goodwin (1996), Joyce Wieland (1996), Vera Frenkel (1996), Irene Whittome (1996), Catherine Richards (1997), Jamelie Hassan (1997), Jan Peacock (1998), Char Davies (1998), and Liliana Berezowsky (1998). The international show of Minh-ha's work, organized by Sue Ditta, marks a significant shift. After Nancy Grave's exhibition in 1971, Minh-ha's would be the next international solo female show. Moreover, hers was the first solo show of a living female artist of colour at the gallery. Although it did not have a catalogue and was not a major exhibition, it was nevertheless an important milestone. Cadieux's exhibition reprised her 1990 Venice Biennale show, which had been organized by *Parachute* magazine. The next three artists

were all well established on the international contemporary scene and their shows had varying levels of commitment from the NGC. Sterbak's show, curated by Nemiroff, was the most significant, with a catalogue, whereas Hurlbut's and Diamond's shows were smaller affairs. After this flurry of activity, there was a two-year break, with no female solo shows until 1995. Clark was an unusual and interesting choice for Nemiroff; she was less established at the time of her show than most other NGC artists, but the installation, *Re Appearances*, was striking a chord in the Canadian scene. It had been in a group show at the VAG in 1993, and then went to the AGO before it showed at the NGC.[61] The work explicitly engaged with Clark's relation to her grandmother, Paraskeva Clark, whose work the gallery had long collected, and which may have helped spark the gallery's interest in the then-emerging artist. Jean Gagnon, an assistant curator, had been responsible for Diamond's show and also curated Hershman's show.

The following year, 1996, is fascinating for several reasons. It was the first year in which there were equal numbers of male and female solo shows (four each). But the female artists (Goodwin, born in 1923, Wieland, born in 1931, Frenkel, born in 1938, and Whittome, born in 1942) were all senior, mature artists with long-established practices, and all save Whittome had been given significant prior support from the NGC.[62] If we average the birth years of the four men and four women, the women's average age is eight years older.

The following year, 1997, the gallery only mounted three solo shows, and two went to women, the first year since 1971 in which more women than men had solo shows. Gagnon also curated Richards's show. Hassan's show left little trace; it seems to have arisen out of a touring show originating at the Art Gallery of York University. Jan Peacock's video art exhibition was small, but its presence is suggestive of the support that feminist video continued to receive, perhaps due to the interests of Ditta or Gagnon. Davies's show represented more of a commitment, as it included a catalogue by Gagnon and Dot Tuer. Berezowsky's show was another smaller show with no catalogue.

What can we conclude about solo shows at the NGC in the 1990s? Once again, the female artists were overwhelmingly white, which was also true of the male artists. None were Indigenous. Most were Canadian and well established. Geographically, there is a strong tie to Toronto and Montreal, with less support for other centres. Although the curator of smaller shows with no catalogues is not always

traceable, it appears that the male curator Gagnon was responsible for the greatest number of these shows: four of sixteen. We might also want to take note that while some years were equitable or even favoured women, there are several years in which no women at all were given solo exhibitions (1993, 1994, 1999), and that the percentage for the decade was just over 30 per cent (30.7 per cent), which is considered a very statistically significant deviation from equity, despite being the most equitable decade in the gallery's history.

While there was a marked improvement in both solo and group exhibitions, the type of explicitly female or feminist group shows that occurred sporadically in the 1970s and 1980s disappeared completely in the 1990s. They seemed to belong to an earlier age, to a kind of feminism that would be increasingly caricatured as essentialist and thus dismissible. Angela McRobbie has described the 1990s as the post-feminist era, when cultural rhetoric "positively draws on and invokes feminism as that which can be taken into account, to suggest that equality is achieved, in order to install a whole repertoire of new meanings which emphasise that it is no longer needed, it is a spent force."[63] Even amongst those of us who did not dismiss the earlier movements, there was a sense that we were past merely counting and had moved on to more sophisticated and more theoretical analyses of gender and representation issues. As Christine Conley has written of the period:

As my academic and other work moved along with the more theoretical frameworks for feminist analysis, I assumed that institutional support for women artists was somehow improving, and that we had somehow moved on from those issues of bodies – of body counts. Of course, there was a complex set of arguments that were taking place around art and feminism that I will get to, which was part of what led me to believe this. I assumed that the matter of counting gendered bodies in museums was no longer an issue, especially as there were clearly more women curators moving into galleries with collections and other visible markers of interest in women's art, such as academic courses and publications. I was wrong.[64]

If issues of representation around gender no longer seemed central, other kinds of questions around the NGC's duty to represent the nation began to take on greater urgency.

WORKING TOWARD INCLUSION:
INDIGENOUS ART ENTERS THE GALLERY

Feminist scholarship has long asserted that the construct of gender is but one mechanism of patriarchy's power, and that identity is always inflected and constructed in multiple ways. Other categories interact with gender to affect the unspoken terms of inclusion and exclusion, and so need to be analyzed alongside it. I would like to deepen this analysis by considering the NGC's record on other diversity issues, particularly around Indigenous representation. This is certainly not meant to assert an equivalency between the structural place of "women" and Indigenous peoples in contemporary culture. Nor do I want to assert a priority; instead, I want to suggest that concerns about a lack of diversity are shared, and that by examining the strategies of exclusion and inclusion for differently situated groups we may gain some important insights into the discourses around representation at the NGC and in museum studies more generally.[65] Consequently, the second half of this chapter turns away from issues of gender to consider in detail the changing discourses around Indigenous representation at the NGC, and sets this in relation to the discourses around gender representation.

In terms of strategy, as the first sections of this chapter indicate, with rare exceptions, gender has not been marked at the NGC. Since the 1980s, it has generally been seen as demeaning to female artists to note their gender or to group them according to it. In 2013, I interviewed close to forty curators across the country, and arguments such as this were voiced repeatedly, and almost universally. As one said, "Is it about the ideas being presented or is it about the bodies?" It seems, however, that there has been a shift on this issue since that time, which I consider in the final chapter of this book. Nevertheless, for most of the period of time under consideration, gender has been a category that curators have been loath to invoke.

The wider discussion around the obligations of cultural institutions toward representing their communities forms an important context for the understanding of the NGC's attitude toward gender. The NGC's exhibition record is part of a larger national narrative justifying a settler history. Part of this story has relied on an art/artifact binary, which has been applied (inconsistently, as I will argue) to maintain hierarchical relations between cultures and genders. In these terms, we might want to be cautious when interpreting the outcomes of

recent changes in NGC policy toward the representation of work by Indigenous peoples. If the settler narrative in its initial iteration focused on art by Euro-Canadians, and simply excluded from the category of art anything produced by Indigenous peoples, how does the insertion of Indigenous art into the national narrative reconfigure the narrative? And can we separate the settler narrative from a patriarchal one? How does (apparent) progress in one domain relate to the state of the other categories? And, more unsettlingly, to what extent are recent changes merely absorbed into the narrative, without fundamentally altering the terms of debate: do recent reconfigurations of both gender and ethnicity allow the fundamental story of a patriarchal white settler culture to remain unchanged?

To contemplate these questions, I want to consider the category of "Indigenous art," using the term currently employed by the National Gallery. At the time of writing, the NGC uses the term "Indigenous art" as a collective noun, which includes such sub-categories as "Inuit art," "Aboriginal art," and "international Indigenous art."[66] This examination allows us to trace an alternative set of strategies and positions to those used in the discourses around art produced by women, one that more consistently "marks" artists' bodies.[67] As Eilean Hooper-Greenhill and others have argued, categorization often purports to be universal and unchanging, which lends legitimacy to the constructs.[68] However, as we will see, the complexity of the categorization around difference reveals the categories' malleability, as they are made and remade, marked and remarked, over time.

Prior to the mid-1980s, the NGC showed little interest in collecting or exhibiting work by First Nations, Métis, and Inuit artists. However, as Greg Hill has shown, and as the NGC website is at pains to point out, the gallery had earlier acquired some art by Indigenous peoples. Although the 1986 purchase of Carl Beam's *North American Iceberg* is often described as its first contemporary Native art purchase, since 1927 the occasional piece had made its way into the collection.[69] There had also been occasional exhibitions of Inuit and Native art in the gallery's history, but these had typically been initiated elsewhere. Since the 1950s, the NGC had accessioned several Inuit sculptures and prints, and works by a few a non-Inuit, First Nations, and Métis artists had also made their way into the collection.[70] For the most part, as we will see, Inuit art has been set apart from other categories of Indigenous art, with consequences both positive and negative. Regardless of these exceptions, the general understanding of the

division of responsibilities within federal museums was that cultural production by all Indigenous peoples was to be collected elsewhere. As but one example of the mindset around Indigenous art expressed even relatively recently, a 1970 article by Jean Sutherland Boggs discussed the National Gallery's collection in terms of Canada's two founding peoples – meaning the French and the English – with nary a mention of First Nations, Inuit, or Indigenous arts, in a manner inconceivable in the art world two decades later.[71] Whatever else, it is fair to say that Indigenous art had not been a significant part of NGC programming or acquisitions. By the late 1970s and early 1980s, however, it was clear that the general division between the National Museum of Man (now the Canadian Museum of History), which collected works by Indigenous artists, and the NGC, which did not, was widely regarded as problematic.

Although explanations from insiders and the gallery itself tend to emphasize the administrative desire for change from within the gallery, the historical record suggests that outsiders, particularly those with valuable collections, have exerted the most significant and effective pressure. The first major donation in recent times to include some Indigenous art was announced late in 1979: the Henry Birks Collection of Canadian Silver. This collection, which focuses on early settler silver production, included several non-silver pieces made by First Nations artists. This acquisition did cause controversy, although not because of the Indigenous pieces, which were not publicly noted at the time and remained almost invisible. The most vocal public outcry was, as it so often is with respect to the NGC, regional. Since the collection centred around historical silver from Quebec, the relocation of the collection from Montreal to Ottawa was taken by some as a depletion of "*la patrimoine québécoise* in favour of the Canadian patrimony."[72] There was also significant concern over process: the *Globe and Mail* reported that the gift did not follow the normal acquisitions process and was reportedly forced upon the gallery by the National Museums Corporation. When complaints arose, the director, Hsio-yen Shih, "complained that she has basically been put into the position of the 'fall guy.'"[73] This controversy encapsulates many of the gallery's challenges in these years. Struggles for power and autonomy dominated the relationship between the National Museums Corporation and the National Gallery; relations were frayed between the director and her curatorial staff; the Elgin building had fallen into disrepair and the ongoing efforts for a new building were

stalled; and significant budget cuts left important positions such as archivist and chief librarian empty.[74] When it became clear that the Birks gift came with many strings attached, including a new curatorial position in silver decorative arts, many questioned the wisdom of the acquisition.[75] A few questioned the significant shift in collecting practices this decorative arts collection necessitated, but these were not the loudest voices. This silver acquisition breached the supposed divide between fine and decorative arts, a hierarchical categorization that is part of the process that validates the exclusion of much work by Indigenous peoples and women from the collections of the National Gallery. Yet this previously inviolable category at the NGC turned out to be malleable enough when it came to expensive "treasures" with a prestigious provenance, and perhaps also when a Quebecois collection could be folded into the national one.

It seems to have gone unremarked at the time that the collection also included sixteen Indigenous pieces. Virtually hidden within the larger gift, this stealth mode of inclusion has parallels with other Indigenous acquisitions, such as the works of Rita Letendre and Robert Markle, whose works were collected by the NGC.[76] With these paintings, the absence of an Indigenous label made the work collectible by the gallery. However, without further internal interest in the Indigenous works in the collection, the acquisition of these works did not lead to significant research on or exhibition of this First Nations and Métis art. Indeed, even today, the Indigenous objects in the Birks collection are just beginning to be researched.[77]

By 1980, it was clear to many that practice around the display and collection of contemporary Indigenous art had to change. At a board of trustees meeting of the National Museums of Canada in December 1980, the NGC and the National Museum of Man issued a joint policy addendum clarifying that the primary responsibility for the acquisition, collection, and care of "Native arts" in Canada rested with the National Museum of Man. However, the statement alluded to the possibility of NGC purchases of Indigenous materials: "The National Gallery of Canada in collaboration with the National Museum of Man will continue to purchase for its collection or borrow for display contemporary and historic native art when these objects demonstrate the highest level of aesthetic achievement or are deemed exemplary in the development of Canadian native art."[78] Following on these changes, several important policy reports appeared in the early 1980s, including the 1982 *Report of the Federal Cultural Policy Review*

Committee, often called the Applebaum-Hébert report, and Jean Blodgett's 1983 *Report on Indian and Inuit Art at the National Gallery of Canada*. Both called for change.

Although the sixteen Indigenous objects in the 1979 Birks gift were virtually invisible, the next major Indigenous acquisitions would be much more conspicuous, and, like the silver, they also emanated from federal government agencies outside the NGC. Significant donations of Inuit art in 1984 and 1985 drastically altered the narrative the National Gallery told, and predated the much-discussed acquisition of Beam's *North American Iceberg* in 1986.[79] The unique way that Inuit art was positioned within the National Gallery is important to understand because it provides an instructive counterpart to the history of display of other Indigenous peoples, and to the relative powers of various interests. Particularly important were the role of the Department of Indian Affairs and Northern Development (DIAND) and the arm's length Canadian Eskimo Arts Council (CEAC).[80] Although the complex role of the federal government in supporting and creating markets for Inuit art has a more complex history than I need cover here, what is clear is that its decision to become more remote from both production and marketing was instrumental in the changes to the NGC policy around Inuit art in the mid-1980s. That DIAND stopped acquiring Inuit art in 1985, just as the NGC began acquiring it, is no coincidence.

Briefly, DIAND began collecting Inuit art in 1954 and, by the early 1980s, had a collection of roughly 5,000 Inuit artworks.[81] Their role in developing a market for Inuit art in the South, and the concomitant instrumentalization of Inuit cultural production in asserting Canadian sovereignty in the North, has been well told elsewhere. Yet this story is essential to understanding how diversity began to appear at the NGC. Through DIAND, the federal government supported the development and growth of the Inuit art market in the South in order to foster Canadian sovereignty in the North. This endeavour stemmed from multiple motivations, but these certainly included the Cold War desire to assert a national presence in the North, as well as to support the removal of Inuit peoples from their land and traditional ways of life. Shifting Inuit off the land to urban centres and into a Western money economy was one component of colonization.[82] The use of cultural production in general, and art galleries in particular, in support of such colonization and assertions of national identity is by now well-established, if it has not always been well known. In the words of

Heather Igloliorte, "the federal government successfully established Inuit art as a national Canadian art form through numerous development strategies, marketing initiatives, and collecting practices, which satisfied both political and economic motivations."[83] Because of the government initiatives and the Canadian public's primitivizing fantasies, "Inuit arts and culture became both claimed and acclaimed as a distinctly Canadian artistic tradition from a uniquely Canadian primitive people."[84] In many respects, it is surprising how late the NGC was in entering this deeply problematic game, given their continued assertion of a unified Canadian heritage associated with ideas of connection to northern lands. Nevertheless, until the mid-1980s, they had collected very few Inuit pieces.

By the early 1980s, DIAND was beginning to believe that they had been successful in their goal to create a sustainable model of Inuit art production and a viable southern market that might allow them to remove themselves from these activities. The department had already been pushing the marketing of Inuit art to a more arm's-length position and, as early as 1961, had supported the founding of the CEAC to help with the southern marketing and to raise "artistic" standards for Inuit prints.[85] The CEAC made lobbying for change at the NGC a priority. They actively courted the gallery by inviting NGC staff members to sit on the board, and in earlier years, both director Alan Jarvis and later curator Kathleen Fenwick had done so (Fenwick also purchased Inuit prints for the gallery in the 1960s, although after her retirement in 1968 Inuit acquisitions largely ceased). By 1982, their lobbying efforts were coming to fruition, as it was reported that plans for the NGC's new building included a permanent exhibition space devoted to Inuit art.[86] Shortly thereafter, the CEAC would revive their relationship with the NGC through the appointment of Rosemarie Tovell, the NGC curator of Canadian prints and drawings, to the CEAC board. Given the promise of space at the new building, CEAC was actively soliciting collectors to pledge donations to the NGC.[87]

Forces aligned in 1983 and 1984 to create a series of events that would dramatically shift the conversation at the NGC. First, as was noted above, Tovell joined the board of the CEAC in 1983. Second, at a meeting with the NGC, the CEAC officially requested that the NGC begin collecting and exhibiting Inuit art and create a permanent exhibition space for it in the new building (to be designed by architect Moshe Safdie).[88] While the 1980 policy addendum had made clear that the acquisition of Indigenous art was permitted if the art were

of appropriate aesthetic quality, the NGC did not purchase any works by non-Inuit Indigenous artists in the intervening years, as there continued to be concerns over perceived overlap with the National Museum of Man.[89] Third, an Inuit art curator, Jean Blodgett, was hired to report on the issue, and not surprisingly, her 1983 paper, written on the heels of the Applebaum-Hébert report, strongly supported the NGC collection of Indigenous art.[90] Fourth, the Friends of the Gallery established a small Inuit art acquisition fund, and fifth, Tovell organized an exhibition of acquisitions from this fund to celebrate the twenty-fifth anniversary of both the Friends and the Cape Dorset graphics program.[91] Sixth, a significant Inuit donation was accessioned into the NGC collection, with forty sculptures and prints from the collection of M.F. (Budd) Feheley accepted in December 1984 (Dorothy M. Stillwell's gift would follow in 1985). Feheley would have been well aware of the ongoing negotiations between DIAND and the National Gallery, as he was a founding member of the CEAC and a commercial Inuit art dealer.[92] This momentum was consolidated by the creation of a new curatorial position in Inuit art at the NGC: beginning in January 1985, Marie Routledge began a secondment from the minister of DIAND to the National Gallery, a development the CEAC had recommended as a solution to the NGC's lack of expertise in the area.[93] DIAND would pay Routledge's salary for the next two years. Just how integral the work of DIAND and the CEAC were to the NGC's acquisition of Inuit art has not been foregrounded in the larger narrative of the NGC collection history, even though their vision for Inuit art would have a significant impact on the continuing display of Indigenous art.

Negotiations over the transfer of the DIAND collection would continue throughout the second half of the 1980s. Staff of the Inuit art section of DIAND increasingly began to believe that "we ... had worked ourselves out of a job ... museums and galleries had started to show Inuit art everywhere ... I felt that the federal government ought to withdraw from the responsibility [of collecting]."[94] By this time, members of the department believed that their efforts had sufficiently raised the profile of "Inuit handicraft as a credible art form suitable for national and international museum and gallery venues,"[95] and that they could now step back their own efforts.

They recognized, however, that "the involvement of the National Gallery in the collection and exhibition of Inuit art is important to elevate the profile of Inuit art."[96] The NGC had accessioned Inuit art

into the collection in 1984, and almost immediately, more ambitious plans were afoot. In 1985, the vice-chair of the National Museums Corporation, Léo Dorais, proposed that DIAND's Inuit art collection be transferred to the NGC, and the department supported his proposal.[97] Precisely where this art should be housed took several years of negotiations to determine, but eventually, in 1989, the NGC acquired a substantial component of the DIAND Inuit art collection.[98] The negotiated agreement governing the collection transfer is significant for the ongoing history of categories of inclusion and markers of difference at the NGC. The agreement specifies that:

3.4 The National Gallery of Canada shall:
3.4.1. continue its program of installing and displaying Inuit art, devoting to it at least the same space, with the same prominence, as it does now;
3.4.2. make best efforts to host special Inuit art exhibits, and
3.4.3 provide opportunities for Inuit trainees to participate in internship programs within the Gallery.[99]

We cannot understand the positioning of Inuit art – and, I would argue, other Indigenous arts within the National Gallery – without understanding these behind-the-scenes and extra-curatorial decisions. Curatorial desires to improve a discriminatory system could not, on an individual level, result in a shift of this magnitude: the acquisition of what remains the largest collection of Indigenous art within the gallery was in no small part due to plans emanating from those higher up in the federal government, interested collectors, and equally interested lobbying by the CEAC. Moreover, the nation's largest collector of Inuit art was an arm of the federal government, and as such DIAND was able to negotiate an ongoing space in which Inuit art would be displayed, as well as make the gallery commit to continue using that same amount and prominence of real estate, seemingly in perpetuity. In other words, this gift came with a significant obligation that has had ongoing repercussions. Regardless of the fact that there have been differing opinions about the appropriateness of a separate space for Inuit art, the gallery essentially committed to leaving the Inuit collection in place.

These forces (significant lobbying on the part of the CEAC, governmental input from both DIAND and the National Museums Corporation, architectural restrictions in space in the new building as well as

the special needs of the prints, and especially the final agreement with DIAND) combined to situate Inuit art and culture differently than that of other Indigenous peoples in the narrative of the National Gallery. When the new building opened in 1988, two small rooms were allocated to Inuit art.[100] As Jean Blodgett has pointed out, at many galleries, Inuit art was (and is) shown in gallery spaces that are separate both from other Indigenous art forms and from Euro-Canadian arts.[101] While the space allotted to Inuit art amounted to significantly more representation than the gallery had allocated previously, concerns arose immediately about how small the space was and how it isolated Inuit culture from Canadian art, contemporary art, and other Indigenous arts. The explanation for the separate space given to Inuit art was that "the decision to develop an Inuit collection and display it on a permanent basis came after the building plans were well underway, making the present location the only one available."[102] While this may partially explain the move, and while the collection of prints requires special lighting considerations, it was not a neutral decision. While on the one hand it might seem appropriate to recognize Inuit culture as distinct from Canadian culture by giving it a separate space, doing so paradoxically allowed the settler narrative to be told uninterrupted in the NGC's Canadian galleries. Additionally, it removed all Inuit production from the Contemporary galleries, allowing for the continuation of paradigms that implied a temporal distance between contemporary Inuit art and other forms of contemporary production. Despite these problematic consequences, since 1985 and especially since the opening of the new building in 1988, Inuit art at the NGC continues to be a uniquely marked and distinctive category, a curatorial position restricted by the terms of the 1989 DIAND acquisition.

Whether one sees the separate sphere for Inuit art as positive or negative, or perhaps both, the exhibition history provides a useful counterpoint to that of other Indigenous identities as well as to the largely unmarked category of female artist. Since 1988, the gallery has had regular, rotating exhibitions of Inuit art continuously on display.[103] The shows were typically, but not always, curated from the collection and they often showcased recent acquisitions, such as the 1993 exhibition *Building the Collection: The Department of Indian Affairs and Northern Development Gift to the National Gallery of Canada* and *New Voices from the New North* in 2013/14. It is

important to note, however, that beginning as early as 1990, the Inuit galleries held significant solo shows by artists including Pudlo Pudlat, Jessie Oonark, Luke Anguhadluq, Pitseolak Ashoona, and Karoo Ashevak, among others. Many of the exhibitions had catalogues. They often travelled, most frequently to the WAG or the AGO, with occasional international venues. The 1993 Oonark show stands out, given my interests, as I believe it was the first solo show of an Indigenous woman at the NGC. The exhibition record at the NGC, particularly prior to the 2003 opening of *Art of this Land*, makes clear what is also obvious: that despite whatever problems it creates, having a marked space and a dedicated curator leads to more exhibitions, more research, and greater visibility.

Nevertheless, it is important to note the limitations inherent in this paradigm. Some critics have seen the majority of these exhibitions as reliant on colonial-settler ideologies and practices, and the exhibitions have been critiqued for how little they typically deviate from Western modernist aesthetic concerns. The Pudlat exhibition was the first solo show of an Inuit artist at the NGC, but, as Shannon Bagg has argued, despite efforts at cultural sensitivity, in the end the "artist's cultural experience is subordinate to, or in service of the art historian's analysis."[104] If, on the one hand, the practice of maintaining separate spheres helps in resisting the assimilation of Inuit peoples into the dominant story of Canadian history, ensuring their status as distinct nations, then on the other hand, it can also marginalize Inuit art into a subordinate, minor position, entirely framed by Western narratives. As with artists designated female, artists designated Inuit have expressed concern with the limits of the category and the marginalization it implies. This sentiment, which parallels in some ways that of Rachel Whiteread at the opening of this book, was expressed by artist Michael Massie at a conference in 2000: "I don't make Inuit art, I make art, plain and simple ... I myself I don't want to be just shown as an Inuit artist in Inuit galleries. You know I am just an artist. I'm Canadian. I'm a Labradorian. I want to be shown as an artist, not just [as an] Inuit artist ... I wasn't intending to make traditional Inuit art, I was intending to make art. I just happen to be part Inuit."[105] In addition to creating a potential marginalization, the small space at the NGC also seemed to position Inuit art outside of the chronology so often emphasized in the NGC's Canadian galleries and European galleries, as well as outside the global paradigms of

contemporary art. This positioning of some peoples as existing outside of contemporary time has long been recognized as a central technique of Western colonialism.[106]

We might understand the separate Inuit galleries at the NGC as producing what Irit Rogoff has called "compensatory visibility." She describes the trend in the 1990s and 2000s of celebratory exhibitions of the formerly excluded as a kind of xenophilia, which results in exhibitions of the "other" that "address neither the sources of the initial exclusion nor their traumatic effects but attempt to redress the balance through strategies of compensatory visibility."[107] That is to say, without addressing the effects of colonialism, the federal government through its arm's length cultural institution, the NGC, has used its promotion of Inuit culture as a kind of screen for its role in the drastic changes it wrought upon that culture. In many ways, Inuit art seemed to fit more easily into the values the gallery has traditionally embraced than some other practices: materially, Inuit prints and sculpture fit Euro-Canadian material preferences, and thematically, Inuit art often celebrates the land, which has been so central to the NGC's definition of Canadian culture. While clearly, compensatory visibility is limited in its capacity to shift the paradigm that governs museum practices, it may nevertheless have some strategic value. Is it better for marginalized artists to be exhibited, even problematically exhibited, than not to be? While the factors at play for female artists are different than those of artists categorized as Indigenous, is there anything to be learned from the comparison?

With the benefit of hindsight, we might reconsider how change happened at the NGC. Factors that aligned to allow for change certainly included external lobbying on the part of minoritized groups; curatorial recognition of both artistic quality and the racism inherent in older paradigms; and increased theoretical sophistication in museum studies. It must also be admitted that business-as-usual was a significant factor. That is to say, financial incentive in terms of donations worked hand in glove with governmental pressures to promote certain ideologies of nationhood, which led to the acquisitions of both the Birks silver and the Inuit collections, all before the much-lauded Beam acquisition. An examination of DIAND and the CEAC, as well as the Birks controversy, make clear that Indigenous art was, to some extent, pushed into the National Gallery from above.[108] It is also clear that within the gallery there was support from certain sectors for certain kinds of Indigenous cultural production that fit curatorial definitions

of "artistic merit" and fine art, but this did not involve a broader conception that included what might be classified as decorative arts or craft, such as are seen in the silver collection. The hiring of an established Inuit art expert to report on whether the NGC should collect Indigenous art also suggests a certain degree of internal support. Nevertheless, it is important to recognize that neither the lobbying nor the good intentions of the curators would have been likely to lead to such significant amount of space for Inuit or any other Indigenous art.

Fast on the heels of the Inuit acquisition came action with regard to other Indigenous arts. Lobbying for non-Inuit Indigenous arts was taken up by other actors – although not by any with such deep pockets as the Inuit Art Section of DIAND.[109] Lobby groups such as the Professional Native Indian Artists Inc. (PNIAI), active in Winnipeg in the 1970s, and the Society of Canadian Artists of Native Ancestry (SCANA, formed in 1983) were also actively lobbying for the inclusion of Indigenous artists.[110] As we shall see, this art would take a different path than that of the separate sphere allotted to Inuit art.

The Beam acquisition in 1986 signalled an immensely important shift, as the gallery's first intentional purchase of Indigenous work. However, it should not be seen in isolation. The positioning of the Beam acquisition as instigating the most important paradigm shift allows for the continuation of a narrative that focuses on the positive agency of contemporary curators at the NGC. This narrative emphasizes the progressive practices of curators, who undoubtedly deserve praise, as they must have lobbied hard internally to help the changes come to fruition. However, it also obscures the ongoing role of the government and its branches in promoting a particular ideology of nationhood, newly reconfigured to include Indigenous arts, as well as the role that significant donations can play in shifting the terms of inclusion.

By the early 1990s, several major temporary exhibitions of contemporary Indigenous work signalled important changes in institutional practice: *Cross-Cultural Views* in 1986, *Strengthening the Spirit* in 1991, and the much-studied *Land, Spirit, Power* in 1992 were each significant. These need to be understood within the changing context of the wider political and museum world. After the failed 1987 Meech Lake Accord, the important controversies around the 1988 exhibition *The Spirit Sings*, and the 1990 Oka Crisis, many in non-Indigenous society had become aware of the rights of Indigenous peoples. In

the wake of *The Spirit Sings*, the Canada Council commissioned Indigenous curator Lee-Ann Martin to examine Indigenous representation in Canadian museums. Her report, "The Politics of Inclusion and Exclusion: Contemporary Native Art and Public Art Museums in Canada" was released in 1991. The following year the Task Force on Museums and First Peoples, jointly created by the Assembly of First Nations and the Canadian Museums Association, published "Turning the Page: Forging New Partnerships between Museums and First Peoples."[111] Despite the centrality of the question "It's Indian art, where do you put it?" (to use the title of a 1985 Canadian Museums Association panel and subsequent article by Ruth Phillips), substantial changes on the ground were slow in coming.

In the decade after *Land, Spirit, Power*, there were no large surveys of Indigenous art and only one group show included even a single Indigenous artist (outside the Inuit galleries) until the opening of *Art of this Land* in 2003.[112] The gallery did, however, continue to acquire works by contemporary Indigenous artists and to exhibit them in the contemporary galleries. From 1995 through 2000 it regularly devoted one room in the permanent contemporary galleries to Indigenous artists.[113] So Indigenous art was being exhibited more frequently, but in particular ways. The NGC situates its contemporary galleries within a post-national global discourse, although it has also framed subthemes within this area at various times. The gallery's dedication of one of its rooms to non-Inuit contemporary Indigenous artists situates this group in the international avant-garde, but also situates them slightly apart, underlining the conception that they are working from a unique cultural background. This is a different strategy than that seen in *Land, Spirit, Power*, or in the gallery's Inuit section. While the Inuit galleries emphasize ties to traditional Inuit culture, the contemporary galleries minimize cultural considerations, and assert a greater tie to the global art world. Of course, depending on the artist and the artwork, either paradigm could seem more appropriate; however the NGC's strategy for exhibitions was not specific to the artist or the work but depended instead on the overarching categorization. Nevertheless, the position taken for non-Inuit Indigenous art at the NGC in the 1990s avoided appropriating Indigenous arts into a narrative of "Canadianness" (in that the gallery was not collecting historical Indigenous art, and the Canadian galleries ended in the 1970s). Within Indigenous communities, there have been a diversity of opinions expressed on the issue of separate or autonomous spaces;

some have compared the separation to the reservation system and others have seen it as the only way to get adequate representation. This space-within-a-space suggests that the NGC was to some extent mainstreaming Indigenous art in the contemporary galleries. However positive this might seem, the fact that almost no Indigenous art was exhibited in any groups shows after 1992 must temper our response to this solution.

Art by women, art by Inuit artists, art by non-Inuit Indigenous artists – all have taken distinct paths into the exhibition history of the NGC. While Inuit art has been marked and separated, and has had both a dedicated space and a curator, non-Inuit, contemporary Indigenous art has been treated in a very different way. Positioned as distinct, yet part of global contemporary practice, Indigenous art has been both more and less visible – more visible in that anyone going through the contemporary galleries would encounter it, whereas the Inuit rooms are off the beaten path; and less visible in that a much greater diversity of practices, a greater geographic range, and more varied histories have been shoehorned into a single space. In contrast to art marked as Inuit or Indigenous, art by female artists – whether they identify as Inuit or Indigenous, or not – has been marked as such far less often. With the exception of three exhibitions, art by women has not been promoted in a marked way; when gender has been a marked category, female artists have objected to it and have generally preferred to have a non-marked identity. In terms of exhibition history, however, for Indigenous and female artists, the promise of the first celebrated exhibitions has not been fulfilled.

SOLO SHOWS 2000 TO 2009: TOWARD INTERSECTIONALITY

In the decade from 2000 to 2009, as discussed in brief above, the National Gallery had fifty-one solo shows of living artists. Forty-one were male artists – over 80 per cent, and statistically considered a highly significant deviation from equity.[114] The ten shows by female artists were by Vikky Alexander (2000); Esther Warkov (2000); Lynne Cohen, Gathie Falk, Kenojuak Ashevak, Betty Goodwin, and Janet Cardiff (all in 2002, a banner year); Tacita Dean (2004); Janet Cardiff again (2006), and Daphne Odjig (2009).[115] The list of names and exhibitions makes clear some of the limitations of statistical analyses. If you looked at a five-year span, for example from 2000 to 2004,

the numbers would be quite high; if you looked from 2005 to 2008, however, they would be dismal. More significantly, the shows are not all equivalent in terms of resources, exposure, or level of commitment from the NGC. As discussed above, we might quibble with which shows should be included and which excluded, but I do not think it is possible to make the data suggest that female artists were well represented during this period.

Delving more deeply into the exhibition history, data reveals that several of the shows were relatively minor: Alexander and Warkov had single work exhibitions, involving significantly less real estate, exposure, and commitment on the part of the gallery. Others are more difficult to assess. For example, Cardiff's *Forty-Part Motet* won the NGC's Millennium Prize in 2001, leading to the purchase of the work, which amounts to significant support. Exhibited in the Rideau Chapel in 2002 and again in 2006, the work has proven extremely popular with audiences in Ottawa and internationally.[116] Cardiff's *The Paradise Institute*, made with her partner George Bures Miller, was also shown in 2002 but is not counted, because we chose not to include artist collaborations in our study. How does one compare this level of support with, for example, a retrospective like that of Falk's or Odjig's work? It cannot be done using the data I have collected. Nevertheless, my data does allow for other insights.

Half of these exhibitions classified in our study as major shows. Cohen's 2002 exhibition was a retrospective, with an exhibition catalogue, that travelled to two Canadian locations and one European gallery. The gallery had been supporting her work since making purchases in 1976, three years after she moved to Ottawa, and in 2016 it owned 154 of her works.[117] The Falk exhibition was also a major retrospective. Curated by Diana Nemiroff and Bruce Grenville of the VAG, the show travelled to six Canadian venues. Although Falk was the first woman from Vancouver to be exhibited at the NGC in many years, she is similar in profile to the other female artists in that she is also regarded as a very senior artist, and has had a long relationship with the gallery. Goodwin, by then a very senior Montreal artist, represented by the Toronto commercial gallery Sable-Castelli, might also be considered long overdue for an NGC exhibition. She had already had a major retrospective at the AGO in 1998, curated by Jessica Bradley, who had moved from the NGC to the AGO. Her NGC show, curated by Rosemarie Tovell, exhibited nearly 100 prints from

1969 to 1994. With an exhibition catalogue, the show marked a significant acquisition of her works in 1998/99.[118]

The 2009 Odjig retrospective was also a major show, comparable in many ways to those of Cohen, Falk, and Goodwin. It is also useful, however, to compare it to Ashevak's and Marion Tuu'luq's exhibitions. The Odjig exhibition was curated by independent curator Bonnie Devine but produced by the NGC and the Art Gallery of Sudbury. The exhibition travelled to the Kamloops Art Gallery and internationally to the Institute of American Indian Arts Museum in Santa Fe. It had a significant catalogue, the first from the NGC to be produced in an Indigenous language. In contrast, Ashevak's 2002 exhibition largely flew under the radar, however noteworthy it may have been: it was the first solo show of a living Indigenous female artist at the NGC. Marie Routledge, then curator of Inuit art, selected twenty-five prints from the collection to show in the Inuit art galleries. This space had already been used to exhibit several solo shows of female Inuit artists: there were posthumous exhibitions of Jessie Oonark's work in 1993 and Pitseolak Ashoona's work in 1996. Marion Tuu'luq died mere weeks before the opening of her exhibition later in 2002 (excluding her from our statistical count). Curated by Marie Routledge and Marie Bouchard of Winnipeg, the Tuu'luq exhibition was significant, with a large catalogue, and after showing at the NGC, it toured to the WAG, the AGO, and the Macdonald Stewart Art Centre. It had significant real estate, taking up five contemporary galleries; that is to say, it was not confined to the Inuit spaces.[119] Promotions and records of Ashevak's milestone exhibition did not reflect its significance: the gallery website does not note its status as the first Indigenous solo show of a living female artist, and there was no catalogue to celebrate the fact. Ashevak's and Tuu'luq's exhibitions were marked in terms that we have come to see as typical of the NGC: gender goes unmarked, while ethnicity, particularly Indigenous identity, is often highly marked. In Ashevak's case, her Inuit identity was both highly visible and paradoxically difficult to see, in that while her work was clearly marked as Inuit, it was exhibited separately from other forms of contemporary practice. In contrast, Tuu'luq's show, curated after the gallery created a curator of Indigenous art position, was highly visible. Can we conclude anything about the curatorial position and the Inuit galleries from this? Without the institutional support of the larger museum apparatus – the catalogue, the press releases, the online presence, the

potential for touring – the impact of an exhibition is short-lived, whether it be in the Inuit art section or the contemporary section.

What criteria for inclusion can we draw from this? We might first notice that the list of solo female shows from 2000 to 2009 is almost completely Canadian – nine of the ten shows – and that the one international female artist was exhibited only through an installation drawn from the permanent collection. By comparison, the solo shows of living male artists include a mix of Canadian and international artists – with 34 per cent of the male shows going to international artists (twenty-seven Canadian and fourteen international men) (see figure 2.5).

The resources required to bring in an international show are significant, and the NGC seemingly has not seen fit to lavish those on a non-Canadian female artist. More importantly, as figure 2.6 shows, the exhibitions are overwhelmingly white.

This chart also indicates the intersectionality of race and gender in the National Gallery solo shows. Of the ten shows by female artists, only two are by artists of colour: Inuit artist Kenojuak Ashevak, and Daphne Odjig, a First Nations artist of Odawa-Potawatomi-English heritage. No black, Asian, or other racialized contemporary female artists had solo exhibitions in the period. Although the forty-one male solo shows demonstrate greater diversity, because of the larger sample size the percentage of artists of colour is about the same, at just under 25 per cent. Of the forty-one male shows by male artists, four artists are Indigenous, three are black (though Stan Douglas had two shows, so is counted twice), and two are Asian/South Asian. The small number of shows given to female artists, then, particularly disadvantages female artists of colour, while representation of artists of colour of either gender remains quite poor.

The regional representation of the female artists is also interesting to consider. Of the nine Canadian female artists, none are from Toronto or the Atlantic provinces, two are from Vancouver, two are from Montreal, one is from Ottawa, and one is from Winnipeg. The number of female artists from Vancouver is interesting for several reasons. As will be discussed in chapter 3, the representation of female artists at the VAG is quite poor, so the exhibitions at the NGC are, perhaps, some recompense.

One of the starkest markers of gender difference is the age of the artists. Falk, Goodwin, and Ashevak were all well into their seventies at the time of their exhibitions; Odjig was ninety; and Tuu'luq, though

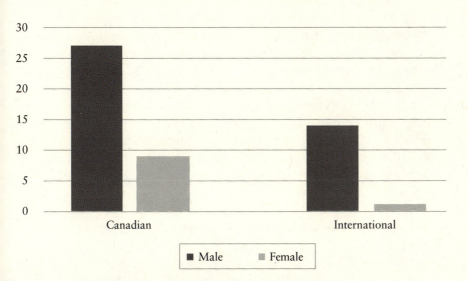

2.5 Canadian versus international solo shows and artists' gender at the NGC, 2000–09. The gallery devotes an even higher percentage of its international shows to male artists than with its Canadian shows.

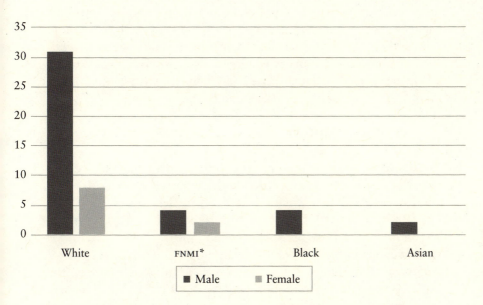

2.6 Gender and ethnicity in contemporary solo shows at NGC, 2000–09. Female artists are poorly represented, as are artists of colour, an issue that is compounded if they are both.

* First Nations, Métis, and Inuit.

not included in my count, was ninety-two. Cohen was a mature artist
at fifty-eight, while Cardiff and Alexander were comparatively young
in their forties. Using the exhibitions listed on the NGC website, fully
half these artists were born in the 1920s or earlier. Their ages stand
in sharp contrast with those of the male artists. The median birth year
for men was 1947 versus almost a decade older for women (with a
median birth year of 1939). The youngest male artist was born in
1970; the youngest female artist in 1959. Much greater seniority is
required for female artists than male, and although the numbers are
small they suggest that even greater seniority is required for Indigenous
women than white women.

This examination of gender in solo exhibitions reveals some import-
ant occlusions. Despite what we may want to believe, representation
in solo shows is not improving. In fact, it got worse in the period
2000 to 2009. Time alone will not solve this inequity. More interest-
ing to me, however, is how the discourses around difference, inclusion,
and representation relate to these changes. The initial inclusion of
women in the public site of the NGC as major players happened
concomitantly with social protest movements in the wider public
sphere. As the women's movement's protests around gender equity
died down, so too did the representation of female artists. Personnel
changes undoubtedly played a role, too, and likely shifting curatorial
roles and the general upheaval of the National Gallery in these years.
Yet given how the category of gender became increasingly unmarked,
I wanted to directly compare categories of diversity to explore whether
marked or unmarked categories fared better.

MAKING INDIGENEITY VISIBLE: 2000 TO 2016

In the early 2000s the NGC made significant structural changes in
both its historical and contemporary departments. It hired Mohawk
curator Greg Hill as assistant curator of modern art in 2000. Hill
went on to work with Denise Leclerc, curator of modern Canadian
art, on *Art of this Land,* which opened in June of 2003.[120] *Art of this
Land* was a transformative re-installation of the gallery's permanent
installation of historical Canadian art, in galleries renamed the
Galleries of Canadian and Aboriginal Art.[121] While we might debate
the installation's inevitable compromises and omissions, this inclusion
of First Nations, Métis, and Inuit art within the historical Canadian

galleries was truly a paradigm shift and an important step towards rectifying historical wrongs. However, as has been well established elsewhere, the fact that the NGC did not – and does not – collect historical art of Indigenous peoples has lead to myriad complications around loan agreements and the availability of objects. Regardless of its limitations, the exhibition fundamentally changed the story the National Gallery tells of "Canadian" art and the art of this land (the title pointing to the difference between these two categories). It was a valiant attempt to find a balance between telling a story that resists integration but without over-emphasizing separation; between show-ing the independent and the connected development of Western and non-Western traditions – sometimes interacting with and influencing each other, but maintaining separate identities: what Gerald McMaster has called "our (inter) related history" using the two-row wampum analogy.[122] Given this immense change to the historical galleries, I wondered if the data would show any concomitant shifts in the rep-resentation of contemporary Indigenous and Inuit artists at the National Gallery.

Since 2003, in the aftermath of *Art of this Land*, a series of struc-tural changes at the NGC have affected the positioning of Indigenous art in the gallery. The hiring of a permanent Indigenous curator was an important step towards improving the relations between the gal-lery and Indigenous peoples. In 2002, Hill shifted from assistant curator of modern art to assistant curator of contemporary art; how-ever, until 2007, his position was not specifically focused on Indigenous art. Nevertheless, his expertise and interest in the area were well established. He expressed his intent to discontinue the practice of separating Indigenous art into a specific room in the contemporary galleries, meaning that contemporary Indigenous non-Inuit art would effectively be less marked and more mainstreamed.[123] Concomitantly, there was a new emphasis on major blockbuster Indigenous shows, undoubtedly facilitated by Hill's new position in 2007. He was appointed curator and department head of Indigenous art, a position that was renamed the Audain curator of Indigenous art later that same year in a show of support by then-board chair and major col-lector of Indigenous art, Michael Audain. The restructuring has had several important effects: most obviously, it positions a specific curator to focus on the area, which facilitates both acquisition proposals and exhibition proposals; it transcends the often artificial divide between

modern and contemporary art; and it brings the Inuit collection into alignment with other nations. Since 2003, Hill has made a concerted effort to dedicate major solo shows to contemporary Indigenous artists, in accordance with SCANA's longstanding requests.

Considering the NGC's history of solo exhibitions of Indigenous artists, it is clear that administrative and personnel decisions can have a substantial effect (see table 2.1). Considering the shows as a group allows us to trace some of these changes. First, the pattern since 1988 of roughly one or two Inuit shows per year in the dedicated Inuit galleries has continued, although changeover has slowed somewhat. However, a new emphasis on major solo Indigenous shows has been extremely successful. There have been six major solo exhibitions in Hill's ten-year stewardship. Although the gallery had exhibited solo shows of Inuit artists (the first was Pudlo Pudlat in 1990), these were not on the same scale as the shows recently curated by Hill, which typically had significant real estate, travelled to other venues, and had the full scholarly apparatus of significant, illustrated catalogues. SCANA had been lobbying for such attention since its inception. This points to another shift in the discourse of curatorial studies. Theoretical positionings in the 1980s and 1990s might have focused on whether art galleries and museums were using an appropriate Indigenous lens with which to represent the art and might have critiqued the solo show as the archetypal Western paradigm, asserting the individual over a larger group. However, these concerns seem to have given way to the idea that it is worse *not* to have a major solo show, despite their roots in the canonization of the white male genius. The argument, also used to excuse a lack of solo shows by female artists ("feminists don't want this kind of show"), no longer seems to be an issue. This may be in part because the solo show is only one strategy among several that the new department has been pursuing.

In addition to the major solo exhibitions, the gallery also had six major group shows in the decade since Hill was repositioned as curator of Indigenous art. From 2008, group shows beginning with *In the Shadow of the Midnight Sun: Sámi and Inuit Art 2000–2005*, which included artists from Canada, Norway, Sweden, and Finland, consistently highlighted international Indigenous art. While previous shows had occasionally made gestures towards international Indigenous art through including a single artist, this show marked the beginning of a more consistent assertion of a supranational Indigenous art. From the outset, the issue of the relation between First Nations and the

Table 2.1
Exhibitions of Indigenous art at the NGC, 2006–16, from the creation of a dedicated Indigenous curatorial position.

Year	Solo/group	Artist or title	Location	Details
2006	Solo	Norval Morrisseau	Special exhibition galleries	Catalogue. Travels.
2007	Solo	Robert Davidson	Special exhibition galleries	Organized by MoA – UBC; circulated by NGC. Catalogue.
2008	Group	High-definition Inuit Storytelling	Inuit galleries	Inuit video pieces by woman's collective. Inuit galleries.
2008	Group	In the Shadow of the Midnight Sun: Sámi and Inuit Art 2000–2005	Inuit galleries	Inuit from Canada and Sami Indigenous peoples from Norway Sweden and Finland; organized by AG Hamilton.
2009	Solo	Daphne Odjig	Special exhibition galleries	Co-organized with AG Sudbury. Travels. Trilingual catalogue.
2009	Group	Uturautiit: Cape Dorset Celebrates 50 Years of Printmaking	Prints, drawings, photo galleries	Prints from Cape Dorset. Catalogue.
2010	Solo	Carl Beam	Permanent collections galleries	Travelling. Catalogue.
2011	Group	Don't Stop Me Now	Contemporary galleries	Indigenous artists from Canada (incl Inuit), the United States and New Zealand; from permanent collection.
2013	Group	New Voices from the New North	Inuit galleries	85 works from the permanent collection spanning a century
2013	Group	Sakahàn: International Indigenous Art	Special exhibition galleries and prints, drawings, photographs and external partners	Recent Indigenous art by over 80 artists from 16 countries. Catalogue.
2014	Solo	Charles Edenshaw	Inuit galleries	Organized by VAG
2016	Solo	Alex Janvier	Special exhibition galleries	Catalogue. Travels.

Canadian nation-state has been challenging for the Euro-Canadian paradigms so entrenched in the N G C and its mandate. In the historic installation *Art of this Land*, the title and exhibition didactic texts make clear that Indigenous arts are not quite contiguous with the "Canadian" nation, and that the peoples included in *Art of this Land* represent a broader scope in both time and space than the nation-state. Absorbing Indigenous traditions into the Canadian nation-state is clearly problematic, as it replicates and extends colonial relations; yet not including Indigenous art within the Canadian narrative is also problematic, as it maintains a separation and may have the effect of ghettoizing. Consequently, as was the case with *Land, Spirit, Power*, the contemporary group exhibitions have refused a Canadian national narrative by including Indigenous artists from outside the geopolitical realm of Canada. The geographic range has become increasingly broad; this was most notable in the group show *Sakahàn*, but in fact has been true of every non-Inuit group show since Hill became the curator, and of some of the Inuit shows, too.

With all the solo Indigenous shows, however, the artists have all been born within the geopolitical borders of Canada. There is evidently still some tension here, but I think it is important that, whatever the tensions and compromises, the exhibitions happen.

Despite the significant allocation of resources to a new curatorial area, the N G C has not yet begun to collect historical art by Indigenous peoples, which would seem to be the only way to begin to balance the collection. As an example of the necessity of collecting historical works: since the pieces in *Art of this Land* are on loan, the number of works has steadily diminished since 2003, because loans expire, and works are not always replaced. Consequently, because all the historical Indigenous art is on loan, the so-called permanent installation in the Canadian galleries is not all that permanent.

The evidence gleaned from the solo and dedicated group exhibitions is overwhelming: having a dedicated curator of Indigenous art has significantly improved the representation of Indigenous peoples at the N G C. The return of the biennial in 2010 also seemed an interesting way to trace the longer-term effects of this curatorial position. While the position has demonstrably increased the representation of Indigenous artists in solo and group shows, I wondered if it would lead to a similar increase of Indigenous artists in major, collective group shows that were not specifically marked as Indigenous.

BIENNIALS: THE BOUGHT, THE BOYS,
THE BLINDNESS?

Despite the promise of the 1989 biennial, the NGC would not hold another until 2010. Despite their intermittent nature, the biennials remain one of the clearest markers of inclusion.[124] In 2010, 2012, and 2014, the NGC's biennials claimed to track contemporary art in Canada, but because the show is selected from the gallery's acquisitions, it is a restricted list. That is to say, biennials combine fundamentally different kinds of shows (biennials and recent acquisitions) under one banner. Reid Shier and others have noted some of the inherent problems with the merged aims, or as Shier calls it, the "shotgun marriage of parallel responsibilities."[125] Among the inherent problems is how certain kinds of art are unlikely to be considered: for example, performance art is not generally acquired, but is surely a significant contemporary art form. Consequently, the NGC biennials skew in certain directions. Despite the many critiques of these shows, few have lamented that if acquisitions continue to be skewed away from diversity, so too will the biennial. Whatever their limitations in terms of the conventional definition of a biennial, the NGC dual-purpose shows function as a convenient snapshot of what "art of this land" the gallery is supporting, if not necessarily of Canadian contemporary art. The newfound direction of the NGC's biennial pivoted when the gallery decided not to hold a biennial in 2016, citing Canada's sesquicentennial exhibitions. In 2017, the newly named Canadian Biennial included, for the first time, international works.

2010: It Is What It ... Wait ... Just What Is It?

I wanted to explore intersectionality in subsequent biennial exhibitions, since the 1989 biennial exhibited more female than male artists and yet was very far from representative with respect to Indigeneity. In 2010, the exhibition *It Is What It Is: Recent Acquisitions of New Canadian Art* was billed by the gallery as "a show that highlights recent acquisitions from the most significant public collection of contemporary Canadian art in the world." It was curated by Josée Drouin-Brisebois, Andrea Kunard, and Greg Hill. Of the fifty-seven artists represented in the 2010 biennial, thirty-eight (67 per cent) were men and nineteen (33 per cent) women (see figure 2.7).[126] This is

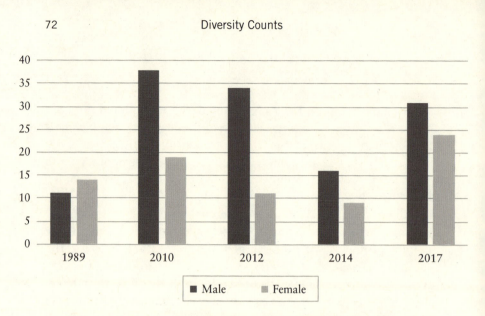

2.7 Artists' gender in NGC biennials. Changes in the biennials indicate that gender equity declined significantly after the 1989 exhibition but improved in the 2017 iteration.

substantially better than the gallery's record on gender equity in the previous decade, although still far from equitable. Even worse, when Joyce Zemans calculated the number of works per artists, she found that there were fewer works per female artist.[127] In terms of Indigenous representation, eight of the artists (14 per cent) shown in *It Is What It Is* were Indigenous (see figure 2.8). Of these, six were women. This is a significant number, although it points indirectly to how few non-Indigenous women were shown: if we look at non-Indigenous artists, the percentage of women drops from 33 to 25 per cent. Although we cannot ascribe the inclusion of specific artists to specific curators (i.e., I do not think we can assume that only Hill curated all the Indigenous artists, and that Kunard and Drouin-Brisebois independently selected all the non-Indigenous artists), the differences between the artists raises interesting questions about how a curator's gender relates to the artists they select. These numbers suggest, again, that simply having female curators will not, as is often assumed, solve the problems around representation; it is a mistaken panacea.

It is curious that with the NGC's first biennial in twenty years, the lamentable representation of female artists – much worse than with the 1989 show – did not cause a flicker of complaint, much less a national protest. Given how much worse the gender representation

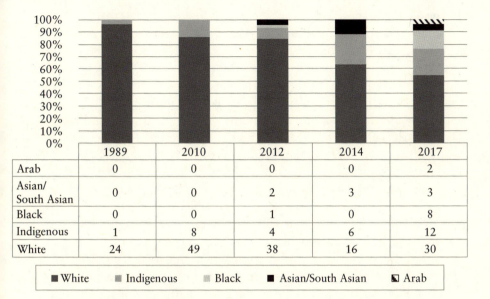

	1989	2010	2012	2014	2017
Arab	0	0	0	0	2
Asian/ South Asian	0	0	2	3	3
Black	0	0	1	0	8
Indigenous	1	8	4	6	12
White	24	49	38	16	30

■ White ■ Indigenous ■ Black ■ Asian/South Asian ◩ Arab

2.8 Ethnicity at NGC biennials. Representation of artists of colour improved markedly in the 2017 Biennial.

was, we might have expected some public discussion of the issue. However, this issue was not raised. Nor, for the most part, was the lack of representation of artists of colour. Once again, when the issue of whether the gallery was representing contemporary Canadian art adequately was mooted, it was only with respect to regional diversity. Several papers in New Brunswick reported that no artists from that province were included, and a controversy ensued. Carmen Gibbs, the director of the Association acadienne des artists professionel.le.s du Nouveau-Brunswick, criticized the exhibition for not living up to its promise: "It's an exhibition that is supposed to be a mirror of what is done in Canada, so we're a little outraged that some of our great artists are not there. I find it completely unacceptable that they have not done a rigorous job to discover our artists," she said.[128]

Consistent with his reputation, the National Gallery's director, Marc Mayer, did not try to soften the blow: although he did not use the word "quality," he made it perfectly clear that for the gallery it came down to artistic quality: "We have a duty to look everywhere in Canada for works that are extraordinary in a national and even international context since we have an international mandate. And so far, we have found very little in New Brunswick and we are sorry,"

he said. He specified that curators are looking first for originality, innovative practices, things they have never seen before, and truly unique careers, saying: "We are also looking for relevance, that is to say works that speak to us today ... I met really great people, friendly, great talent, but unfortunately, it is not by sentimentality that we organize our collection. We try to be as scientific as possible."[129]

The idea that assessing contemporary art might be a scientific process seems mistaken, but is particularly rich given the NGC's resistance to actual numbers. Paul Gessell reported that only one artist from the entire Atlantic region was included, and he lamented the paucity of purchases from the region. He cited Drouin-Brisebois as noting that there were few dealers in the region, which meant she had fewer invitations to visit.[130] This seemingly insignificant excuse points to the little-studied influence of commercial dealers on our public galleries, a subject that is outside the scope of this book. And given the dearth of commercial dealers across the country, this explanation is hardly reassuring to those of us outside the country's major centres.

Although regional representation continued to be a regional concern, national reviews of the 2010 biennial typically did not address other areas of a lack of diversity, whether gender, ethnic, or regional. In a review in *Canadian Art*, Bryne McLaughlin performed the kind of rhetorical flourish that attempts to minimize dissent:

> While disputes are bound to arise over which artists have
> or have not been included, on the whole the exhibition offers
> a clear and impressive picture of the wide-ranging trajectory
> of contemporary Canadian art. It's also firm proof that NGC
> curators Josée Drouin-Brisebois, Andrea Kunard and Greg Hill
> are doing their due diligence in tracking and lobbying for the
> acquisition of works from some of the most exciting artistic
> practices across the country.[131]

So, his review implies, if you disagree with his assessment (in one of those pesky disputes that are bound to arise), you are ignoring the curators' clear and impressive due diligence with regard to the most exciting practices across the country. McLaughlin manages to make differing opinions sound not only wrong but also petty.

While gender apparently did not warrant his consideration, McLaughlin did discuss how Indigenous identity relates to the exhibition, but primarily in the context of questions raised in a talk by

Mohawk curator Ryan Rice, in the symposium "Conversations About Contemporary Canadian Art," which the gallery held in conjunction with the exhibition. Shier revised his talk at the symposium for publication in *Canadian Art*, and likewise avoided the issue of gender. He focused on the paradoxes of a "recent collection" survey and a biennial, particularly on how combining the two slants the biennial away from certain media (a kind of diversity). Neither Rice nor Shier seemed to notice that the exhibition was incredibly male centred, and they only took note of ethnicity insofar as it was raised by (racialized) others.

The timing of this blindness is particularly interesting. The exhibition opened on 5 November 2010, shortly after the biggest controversy around representation at the National Gallery since the 1990s. In February and March 2010, gallery director Marc Mayer had come under serious scrutiny and criticism because of comments he made in a CBC story called "Diaspora Art," which aired on the news show the *National*, on 2 February 2010. The interviewer questioned the gallery's lack of "ethnic minorities" and "outsider art" (seemingly conflating the two at points, which raises other issues). In his defensive response, Mayer repeatedly emphasized excellence as the only standard:

> MAYER: Our real mandate is excellence. We do think about diversity however. Uh, but ... uh ...
> INTERVIEWER: [*interrupts*] You just don't put it in the gallery?
> MAYER: No, we're only interested in excellence, so we put what we find in the Canadian art scene that is excellent and we're blind to colour or ethnic background. Or even whether you were born in Canada. We don't care ... We're looking for excellent art. We don't care who makes it ... We're only interested in excellence, so we put what we find in the Canadian art scene that is excellent and we're blind to colour or ethnic background.[132]

Mayer's comments drew condemnation from a significant proportion of the art world. The ensuing controversy around his statement was a rare example of vocal public criticism from the arts community. Spearheaded by curators Emily Falvey and Milena Placentile, an open letter was sent to Mayer and the NGC board of trustees, and circulated online. It gained more than 500 signatures (including my own).[133] The kernel of their argument was that Mayer's faith in excellence and in

the institution's ability to be "colour blind" relied on a long-discredited belief in objectivity. The letter situated their criticism in the context of the gallery's seemingly recently improved relations with Indigenous artists. They argued that Mayer's stated faith in excellence "begs the question: Whose excellence? This is what women and ethnic minorities have been asking for centuries." They rightly point out that feminist and postcolonial studies have shown such objectivity to be not only impossible but a pernicious lie. As they wrote, "we know 'excellence' when we see it, and today we prefer to call it hegemony."

This was a revealing moment in the shifting discourse around representation, and an important cleavage point. The controversy and Mayer's response to it were reported in the *Ottawa Citizen*, with Mayer trying to reframe his comments by shifting from the criterion of excellence to argue that the gallery did have a diverse collection: "Every significant artist who was not born in Canada or whose parents were not born in Canada is pretty much already in the collection of the National Gallery and, if they're not, it's because we couldn't get our hands on the right one yet or we're looking for it ... We're not a racist institution and diversity is Job 2 after making sure we have the right amount of money to do what we have to do."[134] The odd elision of diversity as being about where one was born, or where one's parents were born, as if there had not been people of colour in Canada for generations, went unremarked.

In a few short days, Mayer went from proclaiming that the NGC's only criterion as a colour-blind institution was excellence to claiming that diversity was a top curatorial concern. While Gessell's report in the *Citizen* provided good coverage of the protest, the paper responded with a dismissive editorial the next day. The editorial, titled "Maltreating Mayer," began with: "Silly debates about the intersection of art and identity politics seem so 1990s."[135] I don't think there is a specific term for this kind of logical fallacy – that is, for not engaging with the substance of an argument and trying to dismiss it by calling it outdated – yet it is utterly illogical. The editorial went on to claim, "The National Gallery, and indeed most Canadian cultural institutions, bend over backwards to showcase the country's diversity, and Mayer has never suggested that the gallery do otherwise." Mayer himself continued to defend the gallery's record through equally offensive means, making spurious remarks about the signatories, such as: "It does sometimes get scary what some artists and artists' representatives will stoop to to try to get into the collection ... It's young

artists. Artists who've been out of school maybe a month."[136] Both claims are demonstrably untrue, but if the gallery repeats such trumpery often enough, perhaps it will be believed.

Given these three factors – the pointed public critique, Mayer's claim that diversity comes second after a balanced budget, and the claim from the *Citizen* that Canadian cultural institutions bend over backwards to showcase diversity – one might have expected a diversity of representation in, for example, the National Gallery's next biennial. Given this heated context, it may seem particularly surprising that the fall biennial later that year had such poor representation. One might protest that the selections would all have been made long before the controversy arose. Yet, is that really an excuse or does it merely prove the point? What is more surprising to me, however, is that even after that letter with hundreds of signatories, those who responded to the biennial did not think it worth mentioning that only 33 per cent of the artists were women, only 14 per cent were Indigenous, and none were black, Asian, or Arab (see figure 2.8). Perhaps the next biennial would better reflect the diversity so touted by the editors of the *Citizen*.

2012: Builders

The 2010 biennial was jointly curated by Drouin-Brisebois, Kunard, and Hill; however, for the 2012 exhibition Jonathan Shaughnessy was given top bill, with contributions by Ann Thomas, Christine Lalonde, Kunard, and Heather Anderson. While the 2010 show had a deliberately loose curatorial theme, Shaughnessy's exhibit, *Builders: Canadian Biennial 2012*, was framed more explicitly around a narrow curatorial concept: that artists are builders of things, but that they might also build a community. The term "builder," it was much asserted, was borrowed from the world of hockey, although it seems an overly narrow reading of the term. That the title would also flatter a significant donor (dare I say, playmaker), Michael Audain, whose fortune was made in housing development, was not noted. The exhibition featured the work of forty-five artists from the gallery's recent contemporary Canadian collection. The press releases and other information put out by the gallery stressed the exhibition's diversity: "Curators working with the art of today are tasked with discovering, following, understanding and processing a varied range of production. This diversity is reflected in *Builders: Canadian Biennial 2012*."[137]

Diversity of materials is a valid concern for biennials, but it is not the only kind of diversity that needs to be addressed. Would the show also have greater diversity in other areas?

As Joyce Zemans has shown, the exhibition included works by thirty-four male artists (just over 75 per cent) and only eleven female artists (less than 25 per cent),[138] which is considered a very statistically significant deviation from expected equity (see figure 2.7). Looking at ethnicity, the show included two Indigenous men, two Indigenous women, one black man, and two Asian men, and the rest were unmarked. The percentage of artists of colour actually decreased from the already homogenous 2010 show (see figure 2.8). The "boyennial" atmosphere was reinforced by Shaughnessy's repeated references to the "builders" concept coming from the Hockey Hall of Fame. The structure of his introductory essay was broken into subheadings that allegorized the exhibition as a hockey game (Pre-Game Show, Puck Drop, and Post-Game Analysis).[139] Given that hockey is notably less diverse than many other sports, it seems a strange analogy to use if you want to highlight diversity as "job 2."[140] The opening paragraphs of Shaughnessy's essay state how curators need to understand a diverse range of production that likewise enlarges the range of human experience to reveal "underappreciated creators and personalities who have been toiling away teaching and building the community."[141] The inclusion of Leslie Reid was often cited in reviews in this regard.[142] The last time this Ottawa artist's work had been exhibited at the National Gallery was in the 1975 exhibition *Some Canadian Women Artists*, even though she was championed as an important builder of the Ottawa art scene. The difference between the rhetoric around the show and the actual numbers reveals the gap between what the gallery sees as appropriate, or even wants to accomplish, and what it is actually doing. While Shaughnessy's 2012 show gave some long overdue exposure to significant female builders, the larger issues around diversity and equity remained unaddressed – indeed, obscured by the promise of the text. In an exhibition allegedly devoted to underappreciated artists, the pre-eminence of Michael Snow, Edward Burtynsky, and Evan Penny might take one by surprise.

2014: Shine a Light

The subsequent biennial, *Shine a Light: Canadian Biennial 2014*, showed a marked improvement in terms of gender diversity. With

sixteen male and nine female artists, it had the highest percentage of women since 1989 (see figure 2.7). While this number is still far from equitable, it is not a statistically significant deviation – meaning with only twenty-five artists, this percentage could happen randomly (given the history of the NGC, I do not think it is random, but statistics cannot make that determination). *Shine a Light* also showed a marked improvement in Indigenous representation (with six of twenty-five artists, or 24 per cent). Three Asian men were included in the exhibition. There were still, however, no black artists represented and no women of colour who were not Indigenous (see figure 2.8). Nevertheless, this was a significant improvement and needs to be applauded. It is important to note that instead of a single directing curator, there was a curatorial team of five, which correlates with having greater diversity. However, as Emily Falvey noted in a generally positive review that praised the exhibition's diversity, the biennial was strangely situated that year, and "As a final indignity, it isn't even the main attraction at NGC, instead playing second fiddle to director Marc Mayer's Jack Bush exhibition."[143]

2017: The Canadian Biennial in Two Parts

The 2017 biennial took a notable turn by including international art for the first time. It was also the first time that the biennial had what was variously described as a satellite location or a companion exhibit, with the "larger component of the exhibition at the National Gallery of Canada in Ottawa" and a separately titled exhibit, *Turbulent Landings*, at the Art Gallery of Alberta (AGA) in Edmonton. The exhibition was notably much more diverse and equitable than previous iterations. In total, there were thirty-one male and twenty-four female artists, which is a marked improvement from previous years and not a statistically significant difference from equity (see figure 2.7). More impressive, however, is the significant increase in terms of artists of colour (see figure 2.8). Of fifty-five artists, twenty-five were artists of colour. Of these, the largest group was Indigenous artists, with eight male and four female artists. The show included eight black artists, which is a laudable increase. Curiously, however, seven of these were international artists, and only one was Canadian, Stan Douglas. This made me look more closely at the way the artists were distributed, which revealed what the otherwise inclusive catalogue from the NGC did not highlight: there were five artists who were only shown at the

AGA; all five were artists of colour, four of them black international artists, and one a Canadian of Indian descent. Indeed, if we consider *Turbulent Landings* separately, it included twelve artists, only two of whom were white.[144] Promotional materials from that exhibition highlight outreach activities that attracted a significantly more diverse audience than is typical of NGC events (see figure 2.9) Even if we excluded the Edmonton component, however, the 2017 biennial represented a much more diverse and inclusive group of artists.

The Sobey Art Award at the NGC

In 2015, the NGC undertook the administration of the Sobey Art Award, a major annual prize for Canadian artists under forty. Given the biennial, the Sobey and the Governor General's Awards in Visual and Media Arts exhibitions that the gallery now holds, the available floor space seems increasingly competitive, although all three of these are contemporary. In any case, the addition of the Sobey exhibition in the fall lineup serves as an interesting counterpoint to much of the biennial criticism: it has specific regional representation, both in the artists and the judges, which addresses the most vocal complaint raised about representation in this country. Artists, audiences, and jurors seem to accept regions as natural and unproblematic: the West Coast and the Yukon, the Prairies and the North, Ontario, Quebec, and the Atlantic. I have not heard anyone say, "I don't want to be a Prairie artist – I'm just an artist, period." Nor has anyone thought to criticize the rather arbitrary construction of the areas. It is curious that it is completely acceptable to categorize artists by region, but the idea of noting any other category raises such hackles. Increasingly, however, the structure seems to be beneficial in terms of diversity. According to the gallery, on the long list in 2016, "Indigenous artists from several different regions make up nearly a quarter of the list, and women artists slightly outnumber men."[145] Nevertheless, a non-Indigenous man won the prize. In 2017, the short list did not include any white men; the only man was Raymond Boisjoly, of Haida and Quebecois descent. Two of the four women shortlisted were white, one was of Indian descent, and the winner, Ursula Johnson, is from the Mi'kmaq Eskasoni First Nation. The short list for 2018 includes three women and two men, three Indigenous artists, and one black artist. A quick review of the winners since the award's inception in 2002 reveals that however diverse the nominations have been, the

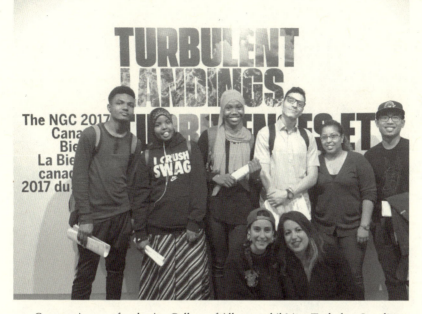

2.9 Community tour for the Art Gallery of Alberta exhibition *Turbulent Landings*, 2017, with members of Newcomers are Lit and the Canadian Council for Refugees Youth Network. Photo courtesy of the Art Gallery of Alberta. Newcomers Are Lit is a youth-led initiative focused on promoting empowerment through the arts for migrant and refugee youth. The 2017 Biennial was the first to include significant representation of artists of colour; shown in two parts, the component at the AGA included a majority of artists of colour and included outreach activities to under-served communities.

winners are in line with the NGC's poor history of diversity: ten men and four women have been awarded the prize, and once again there has been a stronger representation of female than male Indigenous artists, with only one of the ten men being Indigenous, yet three of the four female winners being Indigenous (see figure 2.10).[146] No artists of other ethnicities have been awarded the prize. Of course, it is an honour just to be nominated, as they say.

THE VENICE BIENNALE: A NATIONAL GALLERY TRADITION?

The other biennial that was re-associated with the NGC in these same years was the Canadian pavilion of the Venice Biennale. From the

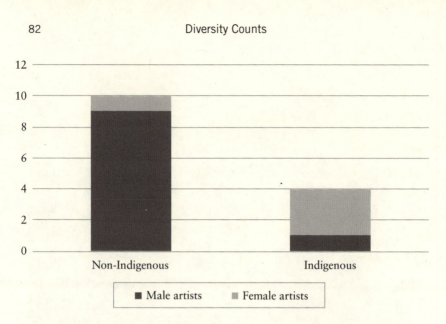

2.10. Gender and Indigeneity, Sobey Art Award winners, 2002–17

outset of Canada's participation in 1952, through to the 1986 exhib-
ition, the NGC ran this prestigious, career-making event. For the 1988
exhibition, the process shifted to a less centralized model, with the
Canada Council for the Arts creating a peer-review panel that adjudi-
cated proposals from curators. While more open, this process was
problematic in terms of funding (a problem that remains unresolved
to this day). With rising costs and fewer galleries willing to take on the
project, the NGC announced its intent to take over the process again
in 2010.[147] There were concerns about this centralization, no doubt
fuelled by Mayer's blunt assessment of the system: "It was broken. It's
been broken for 25 years. So we have the intention of taking over."[148]
Murray Whyte, reporting for the *Toronto Star*, covered some of the
controversy. Given the financial crisis (created by the elimination of
the Department of Foreign Affairs funding program ProMart), smaller
galleries would now find it very difficult to raise the necessary funds
for an exhibition of that scale. While it was widely agreed that the
funding changes made it impossible to continue the Canada Council,
peer-review model, the art world was more concerned about what it
would mean for the Canadian pavilion. Despite assurances that there
would be wide representation, Mayer made his intentions clear to
Whyte: "We're hoping to be in charge permanently, but we're in charge
for this one ... It's a huge responsibility, Venice. We're a unique

institution in that we really do service and observe a whole country and its culture, we really are in the best position to be responsible for Venice in the long term." For the 2011 exhibition, the NGC took the reins, but Mayer assured people that he was "open to the possibility of guest curators working within the gallery structure."[149]

So, what happened in that 2011 show? Drouin-Brisebois curated the exhibition of Vancouver artist Steven Shearer. Review titles such as "Head Bangers at the Biennale," "Boy Trouble," and "Dude Culture Near the Doge's Palace" sum up the responses to the work of this artist who was so interested in male youth culture.[150] It would be unfair, however, to draw any conclusions from one exhibition, however masculinist the show appeared. Indeed, by some estimations, an exhibition that critically interrogates masculinity is a feminist triumph. It is, however, a challenge for me to see this show that way.

True to his word, Mayer formed a selection committee with external curators for the 2013 exhibition: their selection of Shary Boyle seemed to right the balance. However, curators such as Barbara Fischer voiced ongoing concerns about the ability of any single gallery to be representative. As Fischer said, "The idea of having other institutions involved is unique to Canada ... It shows that nothing but diversity can represent Canada."[151] Although there was a selection committee, Drouin-Brisebois was again the curator. In 2015, the selection committee (comprised of different members) included Marie Fraser (from UQAM), who would be named curator of the show, and the committee selected the artist collective BGL. Similarly, for the 2017 selection, Kitty Scott (from the AGO) was on the committee and was named as curator for the Geoffrey Farmer exhibition.

So, what do the numbers tell us? Has the NGC process provided significantly different results than that of the Canada Council? From 1988 to 2009, the Canada Council-guided process led to four exhibitions by female artists and nine by male artists (30 per cent female artists), and two by Indigenous artists and eleven by non-Indigenous artists (15 per cent Indigenous). Since 2011, under NGC direction, the artists have been Shearer, Boyle, BGL (comprised of three men), and Farmer – statistically, this represents a small drop in the percentage of female artists and a larger drop in the percentage of Indigenous artists. The numbers are so small and it is not enough data from which to draw significant conclusions; it hints, however, that Fischer's commentary is correct: less centralized representation leads to greater diversity. Nevertheless, recent donations by the Sobey and Koerner

families suggest that, for the foreseeable future, the Venice selection committee will remain in the hands of the NGC.

As exhibitions that purport to tell us about trends in contemporary Canadian art, these biennials continue to represent a shockingly inequitable slice of the Canadian art world. Although there continues to be protest over a lack of regional diversity, protests around other kinds of diversity have been minimal. While there is some reason to be optimistic about greater diversity in the Sobey awards, how this will relate to the larger NGC practices remains an open question.

Like the biennials, other recent group shows are also variable with respect to diversity. What is consistent, however, is that female artists typically make up less than 30 per cent of group shows. For example, in group shows of contemporary art from 2012 to 2013, in five shows, we counted 143 artists, of which only 38 were women: that is 26 per cent.

TO MAKE KNOWN THROUGHOUT CANADA

The NGC's various outreach programs are an essential part of its mandate, which includes furthering the knowledge of art throughout Canada.[152] Given that most Canadians do not travel to the gallery's Ottawa location, we wondered if the story the gallery told across the nation might be more diverse. Since Mayer's appointment, the NGC has pursued several new outreach partnerships. These seemed promising, since various curators at the gallery told me that one of the contributing factors to the lack of diversity is a structural problem of simply not having enough space to include as many shows as they would like. While this alone does not excuse the gallery's problematic record, it does suggest that curators who are pitching shows to a committee are feeling pressure to make proposals that are more likely to get selected by the committee. In terms of organization, there is little space for temporary exhibitions, and getting an exhibition proposal approved is a competitive process. One curator who worked at the gallery in the early 2000s explained how hard it was to get shows approved or work purchased, which would lead curators to take fewer risks:

> The director was known to have a bias against woman artists generally – although he would probably never say that publicly. There's a couple of women he supported. Conceptual woman artists? He would just laugh if you brought it forward to buy.

So why would you humiliate yourself and that artist in this process? This was another curator's activity, where the artist was well known, doing quite well in her career – the director had okayed it and then at the last minute he said no, he didn't think it was interesting. Why are you going to humiliate yourself and the artist in the process?[153]

I wondered if the touring exhibition program might be a way of working slightly outside the tight confines of the very top-down management model.

In 2010, the NGC launched a venture with the AGA. The success of this venture spawned further partnerships: with the Museum of Contemporary Canadian Art (MOCCA) in Toronto later that year, and in 2013 with the WAG. According to the 2010–11 annual report, "the NGC@MOCCA will see the two institutions jointly plan and stage exhibitions, allowing citizens in one of the country's most vibrant cultural centres access to notable works from the Gallery's collection of contemporary Canadian art."[154] These new partnerships raised interesting possibilities.

The majority of the NGC@AGA shows have been historical, perhaps in reaction to the contemporary turn the Ottawa space has taken under Mayer's leadership, as well as the needs of the Alberta space. The fact that material production by women and people of colour has historically been excluded from the category of "art," and that art by women and people of colour has historically been so under-valued, makes things complicated when staging a historical exhibit that includes works by women and all artists of colour.[155] Using this as an excuse for a lack of diversity, however, only perpetuates those earlier paradigms, as it does nothing to redress the larger issues around how categories of exclusion have functioned to define the majority of work by women and people of colour as being outside of the category of art. It means seeing the art museum's role as that of accepting the status quo, rather than something more progressive. In any case, the solo exhibitions in this AGA collaboration have been devoted to Goya, Escher, Piranesi, Lawren Harris, Bourgeois, and Chagall. That is, five male artists and one woman, no Indigenous artists or artists who are not of European heritage, and all but one non-Canadian. My hope that this collaboration might be more diverse was not met – although admittedly, the historical nature of the exhibits does complicate the count.

The majority of the group shows in the collaboration have also been historical, but one has been contemporary, and it is notable: *Misled by Nature: Contemporary Art and the Baroque* (2012–13), which was curated by Catherine Crowston (executive director/chief curator, AGA), Josée Drouin-Brisebois (curator of contemporary art, NGC), and Jonathan Shaughnessy (associate curator of contemporary art, NGC). It looks at contemporary artists informed by Baroque art in either form or content.[156] In terms of diversity, this show suggests that certain caveats need to be taken into account in any interpretation of the National Gallery. All of these collaborations suggest how seriously the NGC takes its mandate to make art known across the land: they are willing to explore new ways of functioning to make their collections more accessible. They also highlight how little space for temporary exhibitions is available within the National Gallery itself. *Misled by Nature*, a collaboration between the AGA and the NGC, did not get exhibited in Ottawa, despite the high quality of the works, the interesting thesis, and the serious funds devoted to a gorgeous catalogue. Moreover, while most of the works were drawn from the NGC's collection, Tricia Middleton's piece was commissioned for the exhibition, which is indicative of a deep engagement with the artist. Despite this support, the NGC still does not own any works by Middleton. In terms of the gender breakdown, the exhibition had four female artists and two male artists. Only two of the artists were Canadian. All four international artists were artist of colour, a preponderance that recurs in the later AGA/NGC collaboration *Turbulent Landings*, discussed above. One cannot help but wonder if, freed from the constraints of the NGC exhibition selection system, these curators would be producing very different kinds of exhibitions. Conversely, one cannot help but wonder why a show of this calibre was not shown in the nation's capital.

The collaboration with MOCCA, however, tells a different story. In the first three years of the partnership (November 2010 through 2013), NGC@MOCCA mounted seven solo shows, only one by a woman and none by any artists of marked ethnicity.[157] Moreover, that lone woman was Louise Bourgeois, who is the only deceased artist in this list (all the male artists were living at the time of the opening). She also was the only female artist in the AGA collaboration. While Bourgeois is surely deserving of a solo show at MOCCA or the NGC, this is revealing of how high the bar is for female artists. She is also, of course, historical rather than contemporary. The sample size

here is small; consequently, in the section on MOCCA in chapter 4, I look at the group shows in the NGC@MOCCA collaboration, which do not prove to be much better.

The NGC@WAG collaboration is similarly lacking in diversity. Exhibitions of Janet Cardiff, Keith Haring, Christian Marclay, and Don McCullin in 2013, followed by Lynne Cohen, Brian Jungen, and Ragnar Kjartansson in 2014, and Ron Mueck in 2015 produces a total of six men and two women, and only one Indigenous artist. Interestingly, as a list of artists in Anne Whitelaw's recent analysis of the NGC's loan program reveals, the 1925 NGC loan to the Moose Jaw Public Library Gallery included a higher percentage of works by female artists, at more than 27 per cent (although no artists of colour were included).[158] What does it mean that the National Gallery's extension program has a worse gender equity record in 2012 than it did in 1925?

CONCLUSIONS

This project reveals several important things about the strategies of inclusion and exclusion at the NGC. At this most important site for telling a national story, and perhaps also for resisting a national story, but certainly for making visible the art of this land, can be found some consistent patterns of exclusion. Despite decades of activism, and centuries of art production by non-male, non-white artists, the NGC still largely exhibits white male artists. How does it continue to exclude others? The data suggests that the answer depends on the type of "other." Gender has almost always been a nearly invisible category: it is generally only marked by our language, and, with a few exceptions, it has not been something that the NGC seems to consider with regard to the artists it exhibits. In contrast, the NGC has emphasized the category of Indigenous arts. Initially, this was done to exclude them from collection. Later, Inuit art was separated and given its own space, and resources were allocated, but it is clear that those resources were linked to governmental agencies rather than to a drastic change in policy. Subsequently, the NGC has devoted resources to rectifying the historic wrong of Indigenous exclusion, and has devoted personnel to this area, leading to a laudable increase in inclusion and diversity. These numbers establish beyond a reasonable doubt that the National Gallery's exhibition record in contemporary art is far from equitable in terms of gender;

and that while it has made great strides increasing the representation of Indigenous artists, other racialized groups have not been accorded similar consideration.

Can we draw any conclusions about strategies that can be used to increase the representation of female artists? Whether we believe that female artists should be marked as a unique category or that we have moved beyond this and should not register gender, the data shows clearly that female artists certainly have not achieved equitable representation at the NGC. Indeed, in most counts of any category at the NGC, female artists rarely surpassed a third of the artists shown, despite having represented a majority of the artists in Canada since at least the 1980s. Using the criteria of equitable representations, the strategy of refusing a marked category has not served female artists well.

In contrast, the strategy of adopting a more evidently marked identity, as seen with the allocation of resources to Indigenous arts, has led to some gains, but continues to remain problematic in a variety of ways.

I do not want to end with "we're damned if we do and damned if we don't" – what I think these findings show is that we need to adopt multiple, flexible strategies, to embrace both the mainstreaming and the marking of categories. But most of all, I think we need to know what we are exhibiting: we need to count. Because the numbers show that the categories are still marked, that female artists are being treated differently, that while some progress has been made around Indigenous artists, almost none has been made with respect to many other racialized groups and artists of colour. The radical promise of the feminist movement and of "Art of This Land" continues to make inroads at the National Gallery, which at the time of writing has just reconfigured its galleries. I await with anticipation the new Canadian and Indigenous galleries and their promise of more substantive progress.

3

Let's Hear It for the Boys! Vancouver and Diversity

"Well, you know, those boys…"
"It would be different if the boys weren't making such great work."
"It's all about the boys here."

The boys, the boys, the boys. In my visits to Vancouver, I heard repeatedly about "the boys." The success of the so-called Vancouver school and the concomitant rise of Vancouver as a significant international art centre should be considered one of the most significant decentrings in Canadian art in recent years. It shifted Canada's traditional centres and peripheries, and broadened definitions of what mattered in Canadian art in more than just geographic terms. From an outsider's perspective, Vancouver can seem a little obsessed with its own image; spun more positively, it has a "strong history of introspection and critical assessment."[1] It has devoted exhibitions to its own history, hosted symposia and published multiple essay collections, all of which have contributed to the success of its art scene. If we compare this to Toronto, for example, the extent of Vancouver's galleries in identifying and promoting the city's strengths (or creating its own buzz) becomes clear. Yet despite the significant and well-deserved success of "the boys," as people persist in calling them, this legacy must also be part of the larger puzzle of the city's overall lack of gender equity.

As with the rest of this study, we collected information on solo exhibitions of artists living at the time of the opening of their exhibition. The gender of the artists was determined by references about them in institutional materials like press releases or other readily available

material. Exhibitions by collectives were not included. To be included, institutions had to have at least five years of available data, and at least five solo shows between January 2000 and December 2010. In Vancouver, we looked at the artist-run centres Artspeak, the Helen Pitt Gallery (Pitt), the Or Gallery, and the Western Front; the galleries affiliated with the University of British Columbia: the Morris and Helen Belkin Art Gallery (Belkin), the Museum of Anthropology (MoA), and the Satellite Gallery (which was jointly run by the Charles H. Scott Gallery, at the Emily Carr University of Art and Design); and the public galleries Centre A (the Vancouver International Centre for Contemporary Asian Art), the Contemporary Art Gallery (CAG), Presentation House Gallery, and the Vancouver Art Gallery (VAG). Of these galleries, only Centre A has an explicit focus based on a specific ethnicity.

In total, of the 447 solo exhibitions in the city of Vancouver that were included in the study, 258 were by artists identified as male and 189 by artists identified as female (see figure 3.1). This is considered a very statistically significant difference from equal gender representation.[2] It is also a larger level of gender inequity than any other major city in our study, except for Toronto. (For a more detailed discussion of ways of considering equity, including why we used 50 per cent as our marker, see chapter 1.)

If we look more closely at individual institutions and their patterns, the data indicates that equity in one sphere of representation does not necessarily mean equity in other areas. So, if we consider the intersectionality of gender and ethnicity, for example, it becomes clear that institutions that are relatively equitable with respect to gender are often far less diverse when it comes to ethnicity, and vice versa, and some fare poorly in all categories of diversity.

SOME SMALLER GALLERIES

The Belkin, part of the University of British Columbia, has been an important part of Vancouver's contemporary art scene and played an important role in the rise of the Vancouver school. Despite its importance, my analysis must be somewhat circumspect because it has relatively few shows per year and had only twenty-two solo shows throughout the eleven-year span we covered. The Belkin has a ratio of fifteen to seven for solo shows by male to female artists. This may seem like a high preference for art produced by men, but statistically it does not count as a significant difference (see figure 3.1).[3] Some

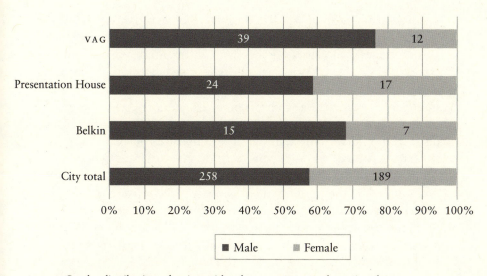

3.1 Gender distribution of artists with solo contemporary shows in select Vancouver galleries

interesting things happen, once again, around gender and nationality: if we consider nationality, male artists are almost equally divided between being Canadian and being international (eight versus seven). But with the female artists, of the seven exhibited, only two were international. I hesitate to draw hard conclusions from such a small sample size, but the Belkin has been more likely to spend its resources on male than female international artists. Although the data does not point to a cause, it is important to note that this is a trend happening across the country.

As discussed in greater detail in chapter 2, ethnicity is a much more difficult and less precise category to assess. The theoretical complexity that plagues gender analysis, by which any study can be seen as reinforcing categories that are restrictive and reductive, is even more complicated with respect to ethnicity. Yet, as with gender, to not examine it at all potentially allows for continued inequity to remain unrecognized. The majority of the artists in the larger data set did not have a marked ethnicity, and in no cases, at the Belkin or any other gallery, did we find a white Canadian artist whose identity was marked as such.[4] It seems that in the museum world, until very recently, the category "white" remains unmarked as the norm. However, where it was feasible, for some institutions, including the Belkin, we have

assessed ethnicity and cultural heritage. The census uses the term "ethnic origin," defined as "the ethnic or cultural group(s) to which an individual's ancestors belonged." It differentiates this from the category of "visible minority," which "refers to whether or not a person, under criteria established by the Employment Equity Act, is non-Caucasian in race or non-white in colour. Under the Act, an Aboriginal person is not considered to be a visible minority."[5] The 2006 census data, from mid-way through our study, indicates that 2 per cent of the city of Vancouver and 5 per cent of the province identified as Aboriginal; 42 per cent of the city of Vancouver identified as a visible minority, while the province as a whole was less diverse, with only 18 per cent self-identifying as a visible minority (see figure 3.2).[6]

Of the twenty-two living artists with solo shows at the Belkin, seventeen were unmarked or presumed white; Rebecca Belmore is Indigenous; two artists are black: Stan Douglas and Glenn Ligon; and two are Asian or Arab: Atsuko Tanaka and Jamelie Hassan (see figure 3.2). To test if something is statistically significant, you need to have an expected norm to which to compare your results. For gender, the 50 per cent benchmark, while not perfect, is relatively uncomplicated. With ethnicity, the benchmark is more debatable. One option is to look at the population of Vancouver – as one of the most diverse cities in Canada, it provides a possible model. Using this model, the Belkin's exhibition record of one Indigenous artist out of twenty-two aligns numerically with the provincial population. To some, this could be considered adequate, but for me it seems to underrepresent the importance of First Nations art and culture in British Columbia. Nevertheless, making the percentage explicit raises an important question: How do we assess what a fair representation of First Nations peoples would look like? One suggestion has been to estimate what their population would have been had Euro-Canadian settlers not attempted to erase their culture. I do not have the skills for that estimate, but it makes the point that proportion of the general population is not always an ideal marker.

If we consider visible minority status, the four artists of visible minority out of twenty-two in the Belkin's solo shows (18 per cent) roughly align with provincial numbers, but in this case are far below the population of the city. Chinese-Canadian artists seem particularly underrepresented (none of twenty-two), given that Chinese-Canadians make up the biggest group of self-identified visible minority artists. Given that the VAG has branded itself as a "Pacific Rim gallery" and

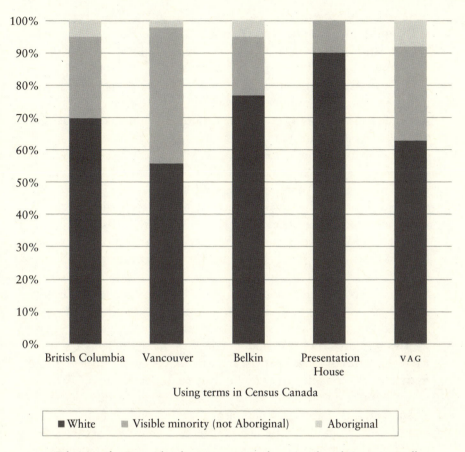

Using terms in Census Canada

■ White ■ Visible minority (not Aboriginal) ▨ Aboriginal

3.2 Ethnicity of artists with solo contemporary shows in selected Vancouver galleries and in population

that Centre A is dedicated to contemporary Asian art, it seems like the Belkin has not made the Asian population of the city central to its programming.

Presentation House Gallery, which focuses on photography, has a significantly whiter profile than the Belkin. Of the thirty-nine artists we considered, thirty-five were unmarked or white (whereas provincial representation would result in twenty-seven white), four were marked in some way as visible minorities (whereas ten would be more proportional to the overall population), and none were First Nations (see figure 3.2). Compared to the provincial makeup, this is a significant statistical difference.[7] Yet with respect to gender, with twenty-four

male artists and seventeen female artists, it is not considered statistic-
ally significant from the expected norm of gender parity (see figure
3.1). In short, Presentation House is more equitable on gender than
the Belkin but it is worse on ethnic parity.

Getting reliable data on the gender of the curator was surprisingly
difficult at most institutions. Unless there is a catalogue or guest cur-
ators, most institutions do not list the curator's name, and consequently
the curation of most institutions' exhibitions are presented as anonym-
ous. Presentation House, however, normally indicates the curator, so
with this gallery we were able to quantify how the gender of the curator
related to the gender of the artists they selected. Much of the literature
has assumed that when there is more equity in the higher levels of
administration, there will be greater equity among the artists exhibited.
This assumption relies on the belief that female curators are more
likely to show greater numbers of female artists than are male curators.
My data is not complete enough overall to analyze this, but the num-
bers from this institution and some others suggest that this persistent
supposition is often wrong. At Presentation House Gallery, our data
included thirty-eight solo exhibitions curated by single curators. Of
the twenty-one shows curated by male curators, more female artists
were shown than men; of the seventeen shows curated by women,
fourteen went to male artists and only three to female artists (which
is statistically significant). Based on this data, and others we will
examine in this chapter, it seems clear that the gender of the curator
is not necessarily a significant factor. Indeed, the numbers here suggest
that a female curator may be less likely to curate female artists; how-
ever, the variability on this issue is quite high, which suggests that
other factors, such as the individual curator and institutional politics,
may be more significant than gender. Less quantifiable factors like a
curator's sense of security in their position and their personal politics
and convictions would also presumably be highly relevant here. While
I do not think this is enough information from which to draw signifi-
cant conclusions, it is enough to make me doubt the commonly
accepted trope that increasing the percentage of female curators will
necessarily increase the representation of female artists.

THE VANCOUVER ART GALLERY

The VAG remains a conundrum to me. In many respects, it deserves
kudos for its strong female leadership, its commitment to First Nations

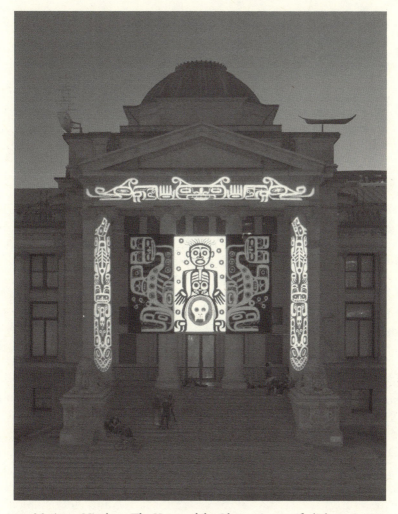

3.3 Marianne Nicolson, *The House of the Ghosts*, site-specific light projection with banner on the exterior of the VAG, 4 October 2008 to 11 January 2009. Photo by Trevor Mills, Vancouver Art Gallery.

and Asian art, and its 2008 milestone exhibition *Wack! Art and the Feminist Revolution,* which must be taken as evidence of a strong commitment not only to works of art by women, but also to challenging, feminist art. Despite these significant accomplishments, it remains one of the worst galleries in the country in terms of gender equity of solo exhibitions of living artists. Of fifty-one solo contemporary exhibitions, fewer than 24 per cent went to female artists.

Under the directorship of Kathleen Bartels since March 2001, the VAG has undergone significant growth, after weathering controversy immediately preceding Bartels's hire. In 2016, its website claimed, "since she joined the Gallery in 2001, the institutional endowment has increased from $200,000 to more than $10 million and membership has grown from 5,000 to a high of 50,000 Gallery members. The Gallery's permanent art collection has recently passed the 10,000 mark, representing approximately 4,000 acquisitions under Bartels's leadership."[8] Hired from the Museum of Contemporary Art in Los Angeles, her experience suggested the gallery would undergo a shift in focus that would be welcomed by many Vancouver artists. She started amid a fraught moment among VAG interest groups and had much work to do to repair relations between the gallery and local artists, collectors, and its own board of trustees. In 2000, Bartels's predecessor, then-director Alf Bogusky resigned, and while the official reason was health concern, there was much speculation that it was because he had declined an exhibition of photographs by Bryan Adams that the board had supported as a fundraiser. The trustees named one of the board members, Joe McHugh, interim director and there were protests about various aspects of the events.[9]

Bartels began by working to repair relations between the gallery and artists associated with the Vancouver school.[10] Reports suggest she started by contacting local heavyweights Ken Lum and Roy Arden. Lum described Bartels as having "a very clear mandate: to record, theorize and commission contemporary art in Vancouver and BC."[11] Despite this, the numbers suggest she was equally interested in the international scene. As Bartels argued, the local and the international are inter-twined: "Unfortunately, the Gallery never lived up to the expectations and success of the artists that lived and worked here," she says. "And so I needed to mend those relationships. I felt then and feel now that we need to be just as ambitious as the artists that are here – showing internationally, collaborating internationally, working with international artists."[12] When we look at the exhibitions from 2000 through 2010 at the VAG, the two opposing components – the Vancouver scene and the international stage – are very clear. The VAG had fifty-one solo contemporary exhibitions from 2000 to 2010. Of these, thirty-one – about 60 per cent – were Canadian and a relatively high proportion – about 40 per cent – were international artists. If we examine the ethnicity of these fifty-one artists, 63 per cent are unmarked/white, and 37 per cent were people of colour (see

figure 3.2). Of the marked artists, there were four Indigenous, two black, and thirteen Asian artists. Overall in terms of artists of colour, this is considered a very statistically significant deviation, and whiter than the city, although it is not statistically different from provincial values.[13] Despite being lower than what would be expected given the makeup of the population of Vancouver, it is much better than many other venues in terms of ethnic diversity, particularly with respect to artists of Asian descent. While Bartels has initiated significant partnerships with artists of the Vancouver school, she has also made significant outreach to other groups.

It is also a strong record with respect to representations of First Nations art (see figure 3.2). Numerically the solo shows of Indigenous artists are higher than the percentage of Indigenous peoples in the BC population, although that may not be the best measure or means of redressing a less representative history. Brian Jungen and Rebecca Belmore each had major solo shows with catalogues, and Jungen's show travelled within Canada and internationally. As part of the exhibition series *Next: A Series of Artist Projects from the Pacific Rim*, Dzawada'enuxw artist Marianne Nicolson's light projection *The House of the Ghosts* (see figure 3.3) transformed the exterior of the VAG. Nicholson's reconfiguration of the gallery, itself a former courthouse, as a traditional Kwakwaka'wakw ceremonial house was suggestive of the attempted eradication of Indigenous peoples in which Canada's legal system and art institutions played roles. Yet the vibrancy of the project simultaneously attested to the resilience of Indigenous peoples and the power of art to overcome complex histories. There were also group exhibitions, such as *Raven Travelling: Two Centuries of Haida Art*, which brought to light more than 250 little-known works and had a major, scholarly catalogue. More recently the important exhibition *Beat Nation: Art, Hip Hop and Aboriginal Culture* outlined a new way of understanding the links between traditional and contemporary Indigenous production. The VAG began to collect contemporary First Nations art in the 1980s, and First Nations artists are also regularly included in group shows that focus on the region, such as the 2009 exhibitions *Visions of British Columbia: A Landscape Manual* and *How Soon Is Now*, or earlier shows such as *This Place: Works from the Collection* (2002). If we compare the VAG's representation of Indigenous peoples with that of other local galleries, it fares rather well. Presentation House had thirty-nine solo shows, and none by Indigenous artists, so comparatively the VAG's record is strong.

However, compared to the National Gallery, which had almost
12 per cent of their solo shows by Indigenous artists in the same
period, the VAG, at just under 8 per cent, is less equitable with respect
to exhibiting the art of Indigenous peoples.

Since Bartels's arrival, the VAG has been branding itself as a "Pacific
Rim" gallery. Initially, the shift deliberately refocused the gallery
towards the international scene: The 2000 and 2001 reports open by
proclaiming that "The Vancouver Art Gallery is the largest art gallery
in western Canada."[14] Yet by 2003, this rather bland paragraph
situating the gallery within the Canadian context was replaced by a
tagline that frames the VAG as "an edgy, international forum."[15] In
2003, *Home and Away: Crossing Cultures on the Pacific Rim*, curated
by Bruce Grenville, brought together six artists – four women, two
men, with all but Jin-me Yoon being international. The geographic
construct of the Pacific Rim might seem a legitimate, fact-based geo-
graphic nomenclature, but like all such terms, it establishes a political,
social, financial, and ideological approach. It tells of the gallery's
desire to reorient itself away from the rest of Canada and towards
the global art world, particularly that of Asia and America; not coinci-
dentally, these are also key markets in provincial trade relations.[16] In
the first years after Bartels's arrival, this often included the West Coast
of the United States, for example in the touring exhibition *Baja to
Vancouver: The West Coast and Contemporary Art*. More recently,
the gallery has often narrowed the focus to concentrate more explicitly
on the Asian elements of this group identity, most evident in the cre-
ation in 2014 of the Institute of Asian Art.[17] This, also not coincident-
ally, mobilizes the diasporic communities that represent the greater
part of the Vancouver population, and their wealth.[18] Consequently,
the thirteen artists with solo shows who were identified as having an
Asian ethnicity often fit within this reorientation. Additionally,
Vancouver and the VAG were the only Canadian city and gallery at
the ninth Shanghai Biennale, where Jungen was showcased in 2012.

The first significant shift to promote the gallery's Pacific Rim identity
was the development of *Next: A Series of Artist Projects from the
Pacific Rim*. Announced shortly after the arrival of Bartels, *Next* was
described as a "new initiative to exhibit emerging artists from the
Pacific Rim … [that] will be a forum to present work by up-and-
coming artists not yet seen in Vancouver"[19] and that "seeks to engage
the diverse practices of Pacific Rim artists."[20] The first artist shown
in the series was the Korean-born, Los Angeles-based artist Won Ju

Lim, evidently selected by Bartels. The "diversity" described in the project referred to a diversity of practices; within the limits of installation work, there were significant material differences. However, there was less diversity around gender or ethnicity than one might expect. From its inception in 2002 through 2013, *Next* featured sixteen artists: four of Asian ethnicity, two Canadian Indigenous, ten white, and one Mexican. Of these, only four were women and, of these women, two were part of the only group show in the series. That works out to 25 per cent female and 62.5 per cent white, which is surprising given the geographic constraints of the series. In some ways, this series seems characteristic of the institution: compared to other institutions, the VAG does a better job of representing First Nations and Asian artists than of representing female artists. However, it is still overwhelmingly white and male.

Returning to the VAG's solo shows from 2000 to 2010, we can note some interesting things in addition to overall poor representation of female artists. If we look at only the Canadian artists, we see some interesting trends. Of the thirty-one Canadian artists, only six are women (Rebecca Belmore, Janet Cardiff, Dana Claxton, Gathie Falk, Liz Magor, and Marianne Nicolson), which is about 19 per cent, even lower than the percentage of female artists in all solo contemporary shows at the gallery (see figure 3.4). These artists had strong ties to the West Coast: five of six lived in BC, and even the artist least associated with the West Coast (Cardiff) lived there part-time. The regional issue might seem an aside but it points both to the gallery's orientation away from the rest of Canada towards the Pacific Rim, as well as to the crucial issue of funding: region is one of the only diversity categories that many funding bodies take into account.

Of these six female Canadian artists with solo shows at the VAG, three are First Nations: Claxton, Belmore, and Nicolson. This strong representation of female First Nations artists might seem to contradict the truism that women of colour are disenfranchised in multiple ways. Yet I would suggest that the debate needs to be more nuanced, since if we look at the numbers in the city, First Nations women are proportionally not well represented overall, nor are other women of colour well represented at the VAG. While the VAG as an institution deserves to be commended for its support of art by Indigenous peoples associated with British Columbia, we can also see the role that individuals play. Long-time board of trustee member Michael Audain has widely supported contemporary West Coast First Nations

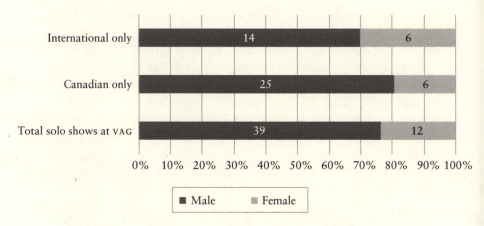

3.4 Gender and nationality in solo contemporary shows at the VAG, 2002–10. The VAG is somewhat unusual in that a higher percentage of its international solo shows than its Canadian solo shows are by female artists. Both categories still consist of significantly more male than female artists.

art, and has works by both Nicolson and Claxton in his collection, and Belmore was selected as the first Audain Professorship in Contemporary Art Practice of the Pacific Northwest at the University of Victoria.[21] While I would not want to imply that the VAG's support of First Nations women was attributable solely to this member, such support from board members can be a factor. Nevertheless, looking more broadly than just at the VAG, the city's galleries indicate that, overall, the intersectionality of race and gender contributes to greater inequities.

If we do the reverse and look only at the international shows – fourteen men, six women – the VAG displays a slightly higher commitment to international women artists compared to its commitment to domestic female artists. This is an interesting reversal of that of most other galleries, like the NGC, the AGO, and the MOCCA, which tend to show fewer female international artists than female Canadian artists.

I have focused on solo shows as a category of analysis partly as a way to reduce the amount of data to be analyzed, but the solo exhibition also remains, by most standards, the most significant marker of an artist's success. Yet it has frequently been suggested to me that because female and feminist artists are often critical of established paradigms and hierarchies, they are less likely to seek solo shows.

Consequently, the reasoning goes, it is worth looking at the numbers of female artists in group shows as well because this information may change our understanding of what is happening. From the outset, I was skeptical of the stereotyping embedded in such assumptions, but it seemed worth investigating.

I was pleasantly surprised when we assessed group shows of contemporary art from 2002 to 2010 at the VAG.[22] In the VAG's group shows of contemporary art, the percentage of artists gendered female was much higher than with the solo shows; about 45 per cent of artists in the contemporary art group shows were women. Even if we consider historical group shows, which usually have low percentages of female artists, the VAG's fabulous Emily Carr collection and their commitment to exhibiting her work translate to quite high numbers: 37 per cent, in this category. It seems, at first glance, that in group shows, women are shown much more frequently, albeit still far less than men. Moreover, the VAG surely deserves kudos as the only Canadian venue for the 2008 exhibition *Wack! Art and the Feminist Revolution*. It was a milestone that indicated a strong commitment not only to works of art by women, but to feminist art. Yet this single exhibition displayed works by 120 female artists (and no men). So, in many ways this show is an outlier, a point so distant from the others that it skews the data set. Statisticians regularly remove outliers from their data sets; if we remove *Wack!* from consideration, the percentage of women in contemporary art group shows drops down to only 13 per cent, which is even less than that of solo contemporary shows. These numbers suggest that the exhibition of a blockbuster contemporary feminist show is not much of a predictor when it comes to the inclusion of female artists in other group shows.

One of the interesting things the counts have shown me is that the percentage of female artist varies considerably from year to year. When I first considered annual variation, I speculated that *Wack!* (2008) might have a suppressing effect on the years bracketing it. But as I looked more closely at the data, it became apparent that the percentage of female artists is quite random (see figure 3.6). To me, this randomness seems consistent with a policy or a practice that purports not to "see" gender, a practice that believes gender is not a category that merits consideration or special interest.

Another oft-repeated explanation for gender imbalance has been that it occurs because galleries rely so much on donations, which they cannot control. Of course, they do have some control over what they

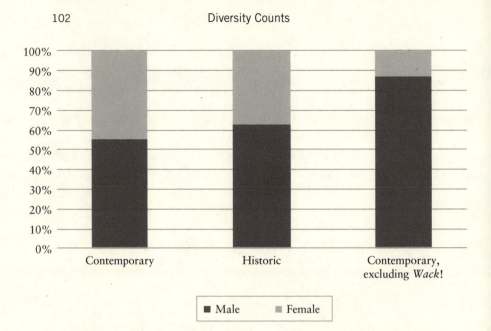

3.5 Gender of artists in group shows at the VAG, 2002–10. Both largely historical and largely contemporary group shows at the VAG appear to be more gender equitable than solo shows; however, if you remove the massive group show *Wack!*, which had 120 female artists and no male artists from the count, their contemporary group exhibitions have an even lower percentage of female artists.

accept, what they court, and what they buy in relation to donations, but there is some truth to the statement. Yet it is less true of solo contemporary shows, since, as has been outlined earlier, they are not generally curated from the collection. It may, however, explain some of the disparity we see in the group shows, which are more likely to be drawn from the collection.

Yet, if the overwhelming number of donations is of art by men, do institutions make up for this in some way in their acquisitions? Should they? Do they recognize and compensate for the bias of their collectors by skewing their purchases in other directions? Because gallery acquisitions are often quite extensive, I randomly selected three years to analyze: 2006, 2007, and 2008. In total, in the three years, the VAG acquired 437 works by single, identified artists. Of the gallery purchases, 30 per cent were works by female artists (eighteen of sixty, which is statistically significant). Of the donations, only 18 per cent were work by female artists. Thus, the gallery purchases

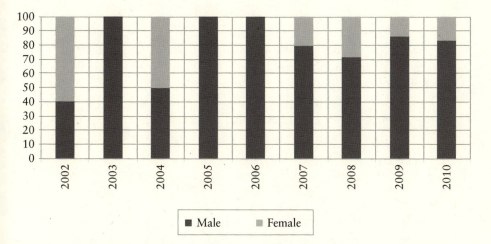

3.6 Gender balance of VAG solo exhibitions by year, 2002–10

over the three years scored much better than the donations, however, they certainly did not counterbalance the donations, since they were still far below equitable.

One of the things I have found interesting about doing this project is that no matter what numbers I consider, people suggest that other data might disprove the theory that there is a gender equity problem. Anecdotally, the same does not seem to be true of inequities around ethnicity, which is more demonstrably – and readily accepted as – an area in which improvement is needed in the Canadian art scene. When I first counted solo shows, the suggestion many gave me was that I should look at group shows. When I looked at group shows, people suggested that I should look at the amount of space given to each artist in the show or that I should look at acquisitions. I do not have the capacity to examine the amount of space, and perhaps people are correct that the ratio of space per artist is the key to disproving the conception of gender inequity. Perhaps if I did this research, it would become clear that although female artists consisted of only 13 per cent of the artists represented, this 13 per cent received a disproportionate amount of space that made up for their low number. Perhaps. Although it must be said that no show in my memory at any gallery rebalanced things in this way. However, some people's desire to rebalance the data by finding other information that might discredit the idea of inequity is remarkably persistent.

In sum, the VAG does comparatively well in terms of its representation of artists of colour, and much less well in terms of its record on gender equity. It has a demonstrably poor record on gender equity – among the worst in the country – in contemporary solo shows, and even in group shows, if you take the outlier, *Wack!*, out of the count. On the positive side, it has had significantly more exhibitions of Asian artists and artists of colour generally than other comparable galleries. With 62 per cent of its solo shows going to white artists, its level of diversity is still markedly better than the AGO, the NGC, or the MMFA.

THE MUSEUM OF ANTHROPOLOGY

Contemporary art is not the MoA's specialty, and it is the only institution included in the study that bills itself as an anthropology museum. Consequently, it may be unfair to make a direct comparison between it and other institutions. Nevertheless, I thought it was an important institution to consider, and not only because it exhibits contemporary art. While arguably all institutions function at the intersection of local and world culture, the MoA is one of the few to do so explicitly. Additionally, as a public museum that bills itself as a "teaching museum," it has been at the forefront of much of the work museums have done around settler–Indigenous reconciliation that has been so important. For example, in 1997 the MoA developed protocols setting out shared authority with the Musqueam First Nation, on whose unceded land the museum is situated, and it had long been noted for its close working relationship with the Nation.[23] Consequently, I was interested to see how this institution's embrace of sophisticated theoretical models and practices around diversity and cultural identity stood up in terms of statistics on gender, ethnicity, and nationality. From 2000 to 2010, it had nineteen solo shows of contemporary art. Only one was by a female artist. This show consisted of a single piece by Jamelie Hassan. Although it is listed on the MoA's site as a show by an individual artist, it was installed in conjunction with her 2010 exhibition *At the Far Edge of Words* at the Belkin; that is to say, it was part of a larger exhibition organized by another institution. Indeed, I am not sure this work should be included here at all, in which case there would be no female artists shown at the MoA in this period. Regardless, whether we count it as eighteen men and one woman, or eighteen and zero, the MoA's record is unbelievably far from equity.

When I first realized how much this data deviated from the norm, I started to hypothesize reasons for this deviation. My initial thought was that it might be due to a Western material preference masking a gender bias; that is, I guessed that predominantly Western curators preferred large-format sculpture, traditionally done by men in West Coast culture, to the art forms traditionally done by women, such as basket weaving. If there were an institution that you would expect to be sophisticated enough to overcome such biases, the MoA – widely respected as a leader in improving relations between institutions and constituents – would be it. Yet the evidence suggests that this is not the explanation. It turns out the MoA did have a solo basket weaving exhibition in the decade we are discussing, but it went to William White, a male artist widely praised for his gender-transgressive use of materials. The MoA has also devoted significant resources and attention to a group show that celebrated many female basket-weavers: *Continuing Traditions: Coast Salish Basketry.* While this was a substantial exhibition looking at the evolution of an art form typically practiced by female artists, it was a group show, without the "star" quality afforded to the male artist.

Some other interesting patterns emerge if we look at ethnicity and gender at the MoA. From 2011 to 2013, the MoA had four more solo contemporary shows, and three of these were by women. This leaves the total still highly skewed in favour of male artists, although it might seem to be a deliberate attempt to rectify a poor record. This brings up an even more interesting point with respect to First Nations women. The four women with solo shows from 2000 to 2013 were Jamelie Hassan, of Palestinian descent; Gwyn Hanssen Pigott, an Australian of British descent; Ishiuchi Miyako, Japanese; and annie ross, who self-describes as a "Daughter of a strong traditional Maya mother and auntie and WWII veteran father (Sydney Mines, NS)."[24] None of the women exhibited at the MoA have been from the territories of the First Nations associated with British Columbia – cultural groups to which the museum claims a special affiliation. In contrast, if we look at the male artists who had solo shows, West Coast Indigenous artists make up the clear majority: thirteen of the eighteen men are identified as First Nations artists and ten of these are from the West Coast. It is an interesting reversal of the situation for female artists at the VAG, where having a local connection seems to be a clear advantage.

Yet in my conversation with the MoA's curator of contemporary visual arts and the Pacific Northwest, Karen Duffek, it was clear that, as with the majority of curators with whom I have spoken, she thinks gender equity is important. Moreover, she was surprised by how inequitable the institution had been in the category of solo shows, and hoped they made up for it in other ways. Indeed, it was clear that Duffek has done a lot to promote female artists. She cited the major collections of weavers as projects that have highlighted the work of traditional West Coast women's Indigenous arts. Yet, like many others with whom I spoke, she was unaware of the inequity, because the institution does not quantify exhibitions in this way. Not counting – not knowing what your numbers are – allows curators to believe they are fulfilling a mandate for equity that they support; however, in actual metrics, they may be falling far short.

CONCLUSIONS AND THE REST OF VANCOUVER

Overall, Vancouver and the surrounding area was more inequitable than other urban centres, no doubt due in part to the numbers at the VAG, the MoA, and the Belkin satellite gallery. Even the artist-run centres (ARCS) in Vancouver stood out for being less favourable towards female artists than other ARCS. The Western Front had the lowest percentage of female artists of all the ARCS we covered, at 38 per cent. Centre A had almost equal male/female representation, disproving any suggestion that the issue was partly due to lower percentages of female artists in Asian culture (something that was hypothesized by one curator). The overriding explanation for Vancouver's gender inequity is "the boys." Virtually every curator or museum professional I spoke to mentioned the all-pervasive importance of "the boys." Jeff Wall, Ian Wallace, Ken Lum, Roy Arden, Rodney Graham, and Stan Douglas were cited repeatedly. There are, of course, significant, internationally recognized women in the scene: Liz Magor, Vikky Alexander, Judy Radul, and Jin-me Yoon were also noted. But there is not the same kind of cohesion among their work, and somehow most of them remain apart from the Vancouver school. The fact remains that even when looking internationally, the representation of women at the VAG is low. While the pre-eminence of male stars on the Vancouver scene may account for some of this, it does not fully explain the lack of equity.

The influence of the Vancouver school similarly fails to explain the MoA's numbers.

Several people I spoke to said the city was noticeably more welcoming to male artists, with a stronger mentoring culture for them. This is almost impossible to quantify, although its importance may be immense. One means of doing so would be to look at the shows co-curated by Kathleen Bartels and Jeff Wall. To date, they have co-curated four major exhibitions, all by international artists, and all male: Anthony Hernandez (2009), Kerry James Marshall (2010), Patrick Faigenbaum (2013), and Martin Honert (2013). I'm not sure if we can help where our own interests lie, but does an institution not have a responsibility to balance out those personal interests? One of the younger curators at a smaller Vancouver institution responded to my questions about whether their institution cared about diversity and gender, and if they collected data on it, saying:

Not formally. Informally absolutely. We talk about it all the time … When we're building a program … we want it to be diverse too and attract many different audiences … We feel the need to definitely try to explore different voices. But at the same time we've noticed and we have caught ourselves sometimes falling into maybe not a gender inequality but more a racial inequality like very European centric and North-American centric. New York, LA, England. It's very, very, well represented. So those are the ways we have to challenge ourselves more I think than gender.

She went on to explain how often she personally worked with female artists (something that was substantiated by her record) and concluded, "I'm not really sure that gender is a pressing issue to me."

And yet, if the community's awards are an indication of the will of the arts community itself, we have reason to be optimistic. While the gender of those who have received the Audain Prize for Lifetime Achievement in the Visual Arts more or less mirrors the distribution seen in the major galleries, the VIVA Awards are far more gender equitable. The VIVAs, established by Jack Shadbolt and Doris Shadbolt, have been awarded annually since 1988 to "mid-career artists, chosen for outstanding achievement and commitment by an independent jury."[25] As of 2017, the Jack and Doris Shadbolt Foundation has awarded more than half their awards to female artists

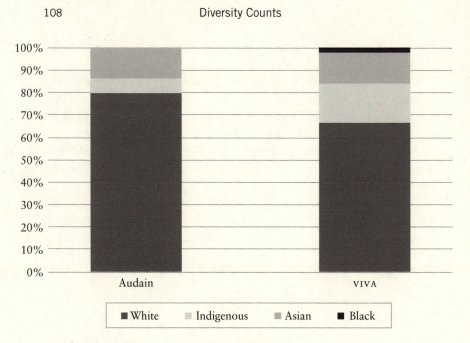

3.7 Vancouver arts awards and artists' ethnicity

(54.9 per cent): a percentage approaching that of the artist popula-
tion. Moreover, 18 per cent of their awards have been to Indigenous
artists, and 14 per cent to Asian artists (see figure 3.7). While overall
the record of Vancouver institutions has not been very progressive
with respect to gender or cultural identity, the VIVA Awards indicate
the strength of the Vancouver scene; it is this strength in diversity that
the galleries must champion.

4

Toronto the Not-So-Good

Diffuse, fluid, robust, transgressive, multifaceted: the strengths of the Toronto art scene make it difficult to get a handle on it. Too diverse to gel like the Vancouver school, too experimental and nonconformist to be contained in official galleries, it is a sprawling, inchoate ecosystem. This would seem to fit with the city that has been declared the most diverse in the world, where more than 50 per cent of its population identifies as a visible minority.[1] Perhaps every city's art network is unknowable, but this seems especially true of Toronto. It is bigger, and has more commercial galleries, auction houses, and capital to support art than other Canadian locales. But perhaps this sense also arises from the failure of the city's established galleries to successfully narrate Toronto's art history. Despite some strong recent attempts, the city's art history remains to be written.[2]

Toronto's lively art scene and diversity of exhibiting venues allowed us to collect statistical data on twelve local galleries. As with the other chapters in this book, I included institutions with more than five years of available online data and more than ten solo shows from 2000 to 2010: Art Metropole, A Space Gallery, Gallery TPW, Mercer Union, the Art Gallery of York University, the Blackwood Gallery at University of Toronto Mississauga, the Doris McCarthy Gallery at University of Toronto Scarborough, the Ryerson Art Gallery, the University of Toronto Art Centre (UTAC), the Art Gallery of Ontario (AGO), the Museum of Contemporary Canadian Art (MOCCA), and the Power Plant Contemporary Art Gallery.[3] In the first instance, I considered the gender of artists who had solo shows. As with the other chapters, I used this information as a jumping off point to consider some institutions in more detail, looking particularly at the intersection of gender

and ethnicity, but also to consider other issues, such as the relation between institutional type and their representations. Unlike the majority of other centres I looked at, Toronto had enough examples in every type of institution (ARCs, university galleries, and public galleries) to facilitate comparison by type.

As a broad survey of the Toronto scene, the overall numbers suggest that Toronto's art galleries are neither diverse nor gender equitable. Of the 474 exhibitions included in our sample, 275 went to artists identified as male, 199 to artists identified as female, and none to artists of any other gender identity. This is considered an extremely statistically significant deviation from expected equity.[4]

Breaking down the numbers by category (see figure 4.1) revealed some consistencies with the national data. Toronto ARCs were statistically gender equitable (ninety-one solo shows of women, ninety-eight of men), which is common across the country.[5] The university-affiliated galleries were also statistically gender equitable, although just barely so, with fifty female to sixty-eight male solo shows in the data set.[6] Even without significant statistical ability, it can be reasoned that if nine of the galleries are relatively equitable, the three remaining must be what are skewing the total, and these are discussed in greater depth, particularly with respect to ethnicity, in the remainder of the chapter.

The university galleries in Toronto also underlined some national trends. Overall, the 118 shows included in the data set are relatively gender balanced (or statistically not significantly inequitable). The data on what was then called the Ryerson Art Gallery is the most atypical, since it has undergone notable changes since 2010, includes a significant amount of student art, and is the only gallery that showed more female than male artists in the period. In fact, if Ryerson is not included (due to its significant student artist population), the numbers for the Toronto university galleries shift strikingly to favour male artists. When we look at the institutions individually, however, only UTAC is statistically significant in its deviation from equity, which is revealing. A number of factors differentiate it from the other university-affiliated institutions, and these correlate with factors in other institutions that are likewise less equitable. A leading factor is that it has a permanent collection, which correlates with worse gender equity. This closely aligns with but is not identical to another factor: having a greater variety of exhibition types – for example, more historical shows. If a gallery only shows contemporary artists, it is more obvious

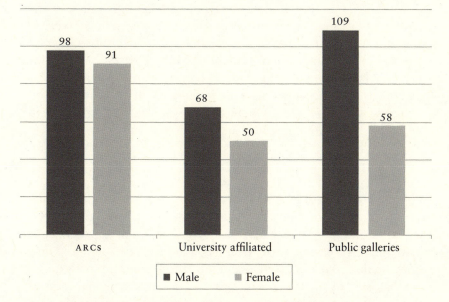

4.1 Artists' gender in solo contemporary shows in Toronto galleries, 2000–10, by institutional type. ARCS are the most gender equitable, followed by university galleries. Public galleries are the least gender equitable.

and more visible when it is significantly inequitable; however, since most people accept that there were fewer important female artists in historical times (though this is debatable), if a gallery has more historical shows this makes it less obvious if there is a preponderance of male shows, even in the contemporary shows. Similarly, UTAC has a larger number of group shows, which means that the contemporary shows are further apart, and curated with a variety of other competing themes in mind. Nevertheless, given that the University of Toronto has multiple programs related to museum studies, it seems especially important that it function in ways that represent the diversity of the city's population.

TORONTO'S PUBLIC GALLERIES

While UTAC was an exception in the university gallery category, which was otherwise gender equitable, and the ARCS in Toronto are all gender equitable, the AGO, MOCCA, and the Power Plant were decidedly not. These three galleries had very different profiles in the decade

from 2000 to 2010, but some similar problems constrained them. Both the AGO and the Power Plant suffered from frequent staff changes and high turnover; MOCCA had the opposite problem, since it effectively functioned as a one-man curatorial show, for better or for worse. Whatever other challenges each faced, they had quite similar and problematic records on gender and ethnic diversity. From 2000 to 2010, the AGO, MOCCA, and the Power Plant collectively held 167 solo contemporary shows, only 58 by women.[7]

THE AGO

For most of the decade that was my focus, the AGO was undergoing a major renovation and expansion. Under Matthew Teitelbaum's direction, and spurred by major donor Ken Thomson, the AGO began planning in earnest in 2002. Construction began in 2005. The new Frank Gehry expansion opened in late 2008, complete with major overhauls of all permanent collections. Thus, in the middle years of the study, the AGO was under construction and working out of a much-reduced position. Nevertheless, the transformation allows for some interesting comparisons.[8]

From 2000 to 2010, the AGO had sixty-four exhibitions of solo shows of artists who were living at the time of the opening of their exhibition. Of these, twenty-one were by artists identified as female and forty-three by artists identified as male, and none were identified as any other gender (see figure 4.2) Statistically, this is very different from equity.[9] Yet if we compare the AGO to similar institutions, with large historical and permanent collections and roughly the same number of solo shows – such as the NGC and the VAG – it does slightly better in terms of gender equity, and by percentages it looks a lot better.

In terms of racialized identities, however, the opposite is true. Using the same comparators, at the NGC, solo shows were roughly 25 per cent artists of colour, with a roughly equal split between male and female artists. At the AGO, the proportion is a lot lower, with only 15 per cent of the solo shows going to artists of colour (see figure 4.2). Unusually, however, at the AGO, more of the artists of colour are women than men: seven of the twenty-one women but only three of the forty-three men are artists of colour. That is to say, the absolute number of female artists of colour is larger than male artists of colour. In terms of ratios, it is a lot larger: it is more than

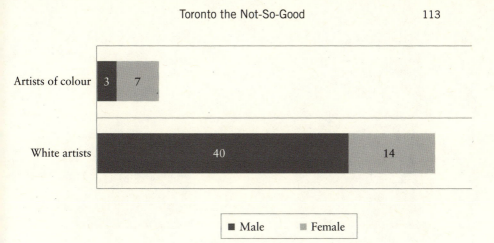

4.2 Gender and racialized identities of artists in solo contemporary shows at the AGO, 2000–10. Atypically, the AGO's solo exhibitions included a higher number of female than male artists of colour. Nevertheless, it has very poor equity in terms of both gender and race.

four times the ratio of men of colour to white men at the AGO. It is a surprisingly high number compared to other institutions, which typically show lower percentages of women of colour than men of colour, although the VAG similarly showed more female than male Indigenous artists. Why institutions might be more likely to select a higher percentage of women of colour than white women is an intriguing question; in other fields, the opposite is generally true: women of colour are typically underrepresented by a higher ratio than both white women and men of colour.

In contrast, if we look at international versus Canadian artists, the AGO is more consistent with patterns seen at other institutions: five of the twenty-one women were international artists whereas eighteen of the forty-three men were international. That is, the percentage of artists who were international was roughly twice as high for male artists than for female artists (see figure 4.3). This suggests that when institutions go to the expense and trouble of bringing in foreign artists, they are more likely to bet on a male artist than a female artist.

One of the interesting things about the AGO is how differently issues of representation play out in different galleries, permanent installations, and curatorial areas. If we look at the historical Canadian collection, the Thomson collection, and the contemporary shows, the

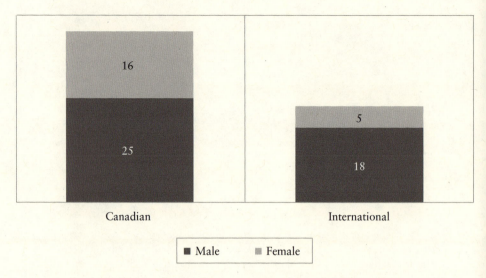

Canadian　　　　　　　　　　International

◼ Male　　　◼ Female

4.3 Gender and nationality in solo contemporary shows at the AGO, 2000–10

picture of gender and diversity awareness across the institution is quite different.

Meeting Ground, an important reinstallation of the McLaughlin Gallery in 2003, intimated powerful things for the upcoming renovation and reinstallation of the rest of the AGO. Contemporaneous with the NGC's *Art of this Land*, it promised a more radical reconsideration of the histories of this land. As curator Richard William Hill described in his analysis of the AGO's process, "*Meeting Ground* directly challenged the traditional categorical distinction between Aboriginal and European Canadian art, bringing art objects from diverse cultural backgrounds into conversation within a group of carefully chosen themes."[10] Hill makes clear how pressing the weight of institutional history was for him and the curatorial team, and his essay reveals both how much support and how much resistance there could be to institutional change. As with the NGC, the absences in the collection were a significant factor, and the team had to be very creative to work around the legacies of institutional racism and resulting lack of depth in the Indigenous collection. "An early suggestion was to simply introduce a few Aboriginal objects into the existing gallery. We rejected this option almost immediately,"[11] Hill recalls. Simply adding objects would allow the story to continue to be told from a Western perspective, so he proposed a more radical rehang in which "the gallery space

itself would become symbolically bracketed within an Aboriginal worldview." The installation upended the legacy of collections and power, overturning some of the most sacred principles of nineteenth century settler art: that this land was terra nullius.[12] As Hill concludes, "European-Canadian works of art enter this space as newcomers, arriving into a world that is not an empty wilderness but a space that was already culturally mapped and conceptualized by Aboriginal inhabitants."[13] Unfortunately, this transformative installation was short lived. A financial issue caused the AGO to close the Canadian galleries later that same year. The building project began as the gallery grappled with how to deal with "the largest gift ever made to a Canadian cultural institution," as Ken Thomson's donation is often called. This donation transformed much of the AGO, and came with many strings attached. With all these other changes, the radical promise of *Meeting Ground* was cut short.

When the renovated building opened in 2008, the Canadian and European galleries had been reinstalled in new and interesting ways, although to my eye they decidedly did not represent as much of a paradigm shift as *Meeting Ground*. Throughout the galleries, the rigid separation of categories characteristic of much of museum practice continued to be refuted; the European galleries included Canadian and First Nations work; the historical rooms were animated by contemporary pieces (although the reverse has not been true on any of my visits); and didactics suggested themes for viewers to engage with. While Hill had rejected a primarily additive approach in *Meeting Ground*, it seemed as if that was often the approach taken with both Indigenous arts and art made by women in the reinstallation. However, the addition of a few contemporary Canadian works in the still primarily chronological survey of European historical works does not seem to fundamentally unseat the traditional narrative – although the addition of Indigenous works to the Canadian galleries in conjunction with other changes proves more thought provoking.[14]

The reinstallation of the Canadian collection brought more substantial change. It engaged with diversity in ways that challenged older museum paradigms, not least by bringing new and much deserved attention to the arts of Indigenous peoples. The didactics, under the umbrella themes of "Memory," "Myth," and "Power," resonated through successive galleries. Each room included Indigenous and settler arts, which sometimes functioned in juxtaposition and sometimes in parallel. These productive associations facilitated a new

understanding of the relations between peoples – the similarities and
the differences in practices and circumstances. The thematic framing,
while not as transformative to the Euro-Canadian settler point of
view as was *Meeting Ground*, was heightened by the comparison
between cultures; the way that power works in your own culture, in
the past and the present, can go unrecognized if it is internalized, but
juxtaposing it with a different system can illuminate it.[15] As Ruth
Phillips concluded, "such an approach does important cultural work
in early twenty-first-century Canada, and it is categorically opposed
to the teleological and progressivist narratives that have perpetuated
the modernist, nationalist, and primitivist distancing of Indigenous
peoples. Yet it too silences other important ways of understanding.
It suppresses any sense of the historical meanings or development of
artistic expression over time in either Euro-Canadian or Indigenous
tradition."[16] The viewer, she continues, is also given less access into
other historical or cultural worlds than with other installation modes.
For me, one of the strengths of the AGO is its juxtaposition of differ-
ent modes of display, which encourages reflection about the benefits
and limits of each. One cannot pass from the historical Canadian
sections into the Thomson collection without an awareness of how
much the display affects the way the art resonates with viewers.

Nevertheless, in most of the institution, questions of gender and
identity feel quite separate. For example, gender is raised most
obviously in the Georgia Ridley Salon (room 234), which showcases
works from Confederation through the First World War. In 2013, the
installation drew attention to the relation between gender and power.
However, it is one of the rooms that feels the least affected by
Indigenous arts, despite a subsequent addition of a contemporary
cartoon series on Louis Riel by the contemporary white cartoonist
Chester Brown. The room's didactics focus on "Art and Power," and
the panels do more than just add women to the standard art history:
they describe a history of the minimization of women's contributions
to art in Canada. The didactics explain:

> Although women artists were active exhibitors and their work
> was appreciated by the public, few were considered professional
> artists or elected as full arts organizations members. As a result,
> their work rarely entered public or private collections. This gal-
> lery pays tribute to more than a dozen Canadian women artists
> by prominently featuring their work on the longest continuous

wall on your left. In our reimagining of a Salon exhibition from the early 1900s, the majority of paintings have been made by women artists.[17]

When I first considered this room, I was struck by how feminist it seemed, particularly in comparison to an institution like the National Gallery, where I do not recall any assessments of the historical exclusion of female artists. I was impressed that the room's wall text named the ongoing erasure of women's participation by museums as part of the structural problem, and thus implicating the AGO itself. However, when compared to how successful the inclusion of Indigenous art has been at unsettling the traditional museum categories, the overtures to gender issues seem to fall short. For example, the inclusion of Kent Monkman's *The Academy* in gallery 238 explicitly critiques the art history that occluded and participated in the oppression of Indigenous peoples.[18] It uproots the very terms of settler art history by illuminating the conventions of traditional nineteenth century academic painting – the very painting found elsewhere in the room. One cannot look at Monkman's academy and see the AGO's Paul Peel paintings as completely separate from Indigenous history. Such a transformative intervention in any gallery is rare, and it is undoubtedly unfair to suggest that this artistic and museological tour de force should be the bar by which other revisions are measured. Nevertheless, I think it is fair to say that it is unparalleled by a similar feminist intervention in the historical collections. In the Georgia Ridley Salon, the text makes the argument, and works are not labelled, meaning viewers have to actively seek out information on the artists' gender. Barring this time-consuming map reading, viewers are given little to help them assess whether the inclusion of works by female artists fundamentally changes the artistic field. Indeed, it could be argued that since the work by women artists in that salon is work that fits the model of the day, it only serves to reinforce the terms of exclusion. Where the Monkman illuminates the terms of artistic training from which First Nations artists were excluded, the way the Ridley Salon is presented implies that when (white) women artists wanted to participate, they were able to. That is to say, while the text makes a feminist argument, the artworks do not. If a similar strategy as that of the Monkman were used within other spheres, would it be similarly transformative? Could a Suzy Lake work from the series *Beauty at a Proper Distance* allow for the same kind of experience, so that her critique of contemporary

gendered beauty standards would also illuminate the gendered standards of representation of the past, in a way that collapsed some of the distance between then and now? Or more subversively, would the inclusion of both settler beadwork and Indigenous beadwork in the same room deconstruct the art/craft hierarchy that is otherwise left uncontested? I am suggesting that working across gender and ethnicity categories – working intersectionally – could lead to a more fundamental deconstruction of the gendered and racialized hierarchies that currently structure arts and cultures.

When I was conducting my analysis in the summer of 2013, the Georgia Ridley Salon held seventy-nine works. Twenty-two were by female artists, which amounts to 28 per cent. This low number, it should be recalled, is almost the same as that of the AGO's contemporary solo shows. The inclusion of these artists, and more significantly the text that points to it, raised real issues for visitors to take with them into other rooms. As the viewer moved into the twentieth century rooms, for example, they might be encouraged to consider why similar efforts were not being made today. When they got to the Thomson collection, they might have had even more questions.

It is clear that the AGO is working towards the inclusion of more female artists in the historical Canadian sections. Online, the AGO notes on its Canadian page that, "over the past decade, improving the AGO's holdings of work by women artists has been a priority."[19] This statement raises awareness of the issue, instead of trying to minimize it. Some of this success must be attributable to the presence of one of the only curators I met who sees her job as that of consistently advocating for greater recognition of female artists: Georgiana Uhlyarik. In a generous interview, she stated that one of her priorities was the inclusion of at least one work of art by a female artist in every gallery of the Canadian collection. It is a different approach than the one advocated by Hill in *Meeting Ground*, but perhaps one that, while less radical, has proven to be more sustainable. As she explained, it was the contribution she was able to make in her (then) position as an associate curator. In both acquisitions and exhibitions, she said, "there's such a complete imbalance, it seems like I wouldn't be adding anything if [I weren't focusing on the imbalance] … In terms of what I actively pursue, what I generate, what I initiate, it's almost exclusively women." The difference between the AGO and the NGC in terms of foregrounding feminist thought seems markedly clear in the treatment of historical Canadian female artists. Although Uhlyarik's position is

not specified in the way that Hill's is at the NGC, she seems to have
made it function in an similar way: a curator with an interest and
expertise in an area that is then supported in ways that unnamed
categories, like gender or indigeneity, are not.

Such progress seems to halt completely when it comes to the
Thomson collection. Tagged as "the largest gift ever made to a
Canadian cultural institution," the Thomson collection raises fascinat-
ing and difficult questions about the power of major donors to shape
a viewer's experience and the direction of an institution. At more than
2,000 works, the collection fundamentally altered the direction of
the AGO. A major permanent installation of model ships, for example,
takes the AGO in an uncommon direction for an art institution. It
also belies any argument that any underrepresentation in the gallery
of the cultural production of certain groups is due to a distinction
between art and craft. So, while "crafts" by women – both settler and
Indigenous – continue not to be collected, a huge space in the gallery
is given over to the model ships, which had not previously been con-
sidered art. Nevertheless, the Thomson collection was an integral part
of AGO overhaul, and was installed in 2008.[20]

In the initial hang, works were installed by Thomson's own team,
according to his vision, which is a significant amount of donor control.
Minimalist, with no labels on entire sections and few visible didactics
of any kind, the hang harkens back to earlier museum installations
organized by connoisseurs rather than exhibits with more engaged
didactics found elsewhere in the museum. Construing this as a posi-
tive development, Teitelbaum has suggested that the demands of the
Thomson collection allowed the team to imagine the rest of the insti-
tution in a different way.[21] The stark difference in installation does,
I think, encourage visitors to reflect on modes of presentation and
how they shape our engagement with the works. There are more than
700 works in the "Canadian Paintings and First Nations Objects"
part of the Thomson collection, and one employee stated that only
four are by women – well, technically by one woman: Emily Carr.[22]
The Thomson collection dedicates an entire gallery to work by William
Kurelek, a fine artist to be sure, but one would not merit this kind of
special consideration at the AGO were it not for the Thomson dona-
tions. How an institution balances the generosity of this kind of gift
with the control its benefactor exercises is a serious question with no
easy answers. Thomson's interests sway the emphasis of gallery's col-
lection in ways that would require radical reconsiderations of the

remainder of the collection to rebalance, in addition to a fundamentally different acquisition policy.

One of the issues that arises while looking at these institutions is how structure influences what is shown. The AGO has undergone a series of restructurings, all of which move the decision-making ability from curators to other positions. Regardless, however, the importance of attracting audiences and "gate" (or attendance numbers) came up repeatedly. More than other Canadian institutions, under Teitelbaum's leadership the AGO has sought to engage new audiences, and this has gone hand in glove with greater authority being granted to the education department and programming.[23] Interpretive planners Jennifer Wild Czajkowski and Shiralee Hudson Hill have written with an insider's view about the redrafting of institutional values that happened at the gallery in the early 2000s:

> The key value that emerged: "the visitor experience is paramount." The articulation and focus on this value launched a complete rethinking of how this institution would plan and install its new galleries. A multidisciplinary team (including interpretive planners and educators) was charged with developing institutional criteria for visitor experiences in exhibitions ... the team developed six guiding principles for AGO programming: diversity, relevance, responsiveness, creativity, transparency, and forum ... In order for the AGO to be successful in the future, its programming must reflect diverse art, audiences, and experiences; be relevant and responsive to our communities; inspire individual creativity; contribute to institutional transparency; and provide a forum for active dialogue about art, ideas, and related issues.[24]

The effects of this redrafting may be most visible in the AGO's leadership team, which for several years did not include a chief curator, a position that was left unfilled for more than two years after Stephanie Smith's departure in 2016.

While Czajkowski and Hill describe the strategic plan as essentially positive, the various employees and former employees of the AGO with whom I spoke mentioned the limitations of this focus on attendance numbers in a variety of ways. Some criticized certain activities as not fostering meaningful engagement with the art. First Thursdays, a monthly party with live music, dancing, food, and drinks, and art events spread throughout the gallery, targets people in their twenties

and thirties. It continues to be very successful in terms of numbers, and is often sold out – though whether a party scene leads to greater engagement with the art remains to be seen. However, it is the activities that more directly affect curatorial autonomy that seem to sting the most. As one former employee put it: "this was my perception of it, that there was a determined anti-intellectualism, so the issues that are being raised in scholarship are not of importance. Only issues that are raised by educators are important." Sometimes curators stated directly how disempowered they felt, but at other times, and more often, they approached the subject indirectly, in terms of strategy, such as: "How that should be moved forward was felt to be in two ways: either get a powerful collector to back your idea, or have something that appeals to the board of education." I heard repeatedly from those associated with the AGO how important attendance numbers for a show were, and how that skewed what curators felt they could accomplish. As one former employee saw it, compared to acquisitions:

on the exhibition side, it was harder to push because of the perceived gate-value of an exhibition. So, if it was playing just to a feminist agenda, whether overt or covert, maybe an artist who was quite minor, it just wasn't worth the finances. So you either would have to have a sponsor who was really on board with you or [it would not happen] ... Inevitably the conversation will be "who cares about this show" and unless it fits well within school curriculum [the show would not be supported] ... because another way to push it is school curriculum.[25]

On rare occasions, this challenge of balancing the popular and the scholarly makes its way into the public eye. The 2012/13 exhibition *Frida and Diego: Passion, Politics, and Painting*, however, might be seen as a notable misstep in the name of popular appeal: staff patrolled the streets handing out plastic "unibrows" that garnered 50 per cent off admission, and the gallery provided photo booths to encourage patrons to take a self-portrait with the unibrow, allegedly à la Frida Kahlo.[26] When the stunt raised some real eyebrows, the gallery's first response was to say that it was meant as a joke, a strategy I expect all feminists are familiar with. Much of the criticism rightly centred around gendered issues of beauty standards, such as Sarah Mortimer's letter to the *Huffington Post* in which she wrote, "I hate to be a killjoy here, AGO, but since when did celebrating an artist who challenged

our ideas of feminine beauty by refusing to change the way she looked involve breaking her down through the implicit public ridicule of her appearance?"[27] Less attention was paid to the racializing that went along with the stunt, which seems a particularly problematic aspect to me. In terms of how the event highlights the problems of valuing attendance numbers over more thoughtful, nuanced access, the AGO response was illuminating. The AGO stressed the importance of getting people through the door, even at the cost of a potentially offensive gambit, so that once inside they could have more meaningful experiences. In the words of the director of marketing, "The three-day promotion was just that – an entry point – and the real opportunity to share a deeper understanding of the content exists once visitors are through our doors."[28] Research on stereotypes, however, suggests that once invoked, they are difficult to negate. An exhibition that might have been lauded as a feminist milestone engaged racist stereotypes by depicting "racialized women as hairy and masculine," in paradigms commonly invoked in colonial discourses.[29] To be sure, such problematic constructs were avoided inside the exhibition and in the catalogue; however, the marketing of this exhibition points to the disconnect that can happen between the scholarly and the popular.

Matthew Teitelbaum, who was director and CEO from 1998 until 2015, and chief curator before that, is proud of his elevation of education and programming. It was a signal piece of his leadership, which overall was remarkably successful for the institution. It has activated the space in diverse ways and has been effective at bringing new audiences into the gallery. In conversation, he was more frank than most other directors I interviewed about the problems around representing diversity in an art gallery, while strongly rejecting the idea that the lack of diversity related in any way to quality. He saw the role of the commercial gallery system, which replicates the larger structural inequalities found in society, as a significant contributor to the problem. From his perspective, the exhibitions are part of an ecology and all the pieces have to move in relation to each other. He lamented, for example, the dearth of female collectors (and, implicitly, of feminist collectors, an elision that I always find troubling) in Canada:

> I would say that one of the broad challenges that we've had is
> that if you take Ydessa [Hendeles] out of it, we've had no great
> women collectors. If you think of the United States and think of
> Aggie Gund, she's had a huge impact in changing behaviour and

ways of thinking because she pushed certain things and she asked very straightforward questions. And we've had no equivalent. Ydessa has taken a very interesting and very powerful position ... If you look at her collection, it's really got a point of view. It engages the work of women artists in a very deep way – Cindy Sherman, Barbara Kruger and so on. But in the Canadian area it's Liz Magor and that's it. I'm not being critical of Ydessa, because Ydessa sees it through the lens simply of art whereas Aggie Gund saw it very much through the lens of an activist position.

That's what I mean when I say that it's all sort of connected. If you're looking at exhibition programs you've got to say: where are the pressure points from dealers on institutions? If they're getting pressure from their collectors in certain directions, then their pressure point on the institutions is going to follow those pressure points that the collectors are putting on them. It's not simply a matter of institutions saying, "it shall be so." You've got to move a number of markers up at the same time. There have been a number of great women dealers in Canada, though.[30]

While we might want to float the hopeful idea that male collectors might also advance a feminist cause, Teitelbaum's point remains: that commercial galleries and major collectors favour male artists and that the relation between the commercial galleries, the collectors, and the institutions is an ecosystem. Teitelbaum spoke highly and enthusiastically of "smART women," a fundraising initiative of the AGO formed in February 2007.[31] This group of "more than 20 accomplished women – primarily leaders in the arts and business world" supports the AGO's arts education programs. Although it is comprised of women, it does not exclusively support feminist causes.

Since Teitelbaum's departure in 2015, there have been a number of significant changes at the AGO, and some noteworthy staff changes. At the top, Teitelbaum was succeeded as director in 2016 by Stephan Jost, who came from the Honolulu Museum of Art. His commitment to diversity representation was brought into question with the unexpected departure of Andrew Hunter, the Fredrik S. Eaton curator of Canadian art, in the fall of 2017. Hunter had been a surprising hire in 2013. He was seen by Murray Whyte and others as the incarnation of Teitelbaum's new vision for a revitalized, more progressive institution that would better attend to the city's history and diversity.[32] For *The Idea of North: The Paintings of Lawren Harris*, a

collaboration with comedian and collector Steve Martin, Hunter turned what might have been a very predictable show for a Canadian audience into something that broadened audiences and refuted myths. His approach for Martin's exhibition – designed to introduce Los Angelenos to Harris's northern landscape painting – was essentially to bookend Harris's "idea of north" with its unspoken other: the city, linking the two. At the outset, Harris's urban images of the poor, diverse Toronto district known as the Ward revealed a messier world, replete with human endeavour. On the other end was a series of contemporary artists working in styles and media that challenged the insular Toronto establishment of which Harris was a part, including work by Nina Bunjevac (a female Serbian-Canadian cartoonist), Jennifer Baichwal and Nick de Pencier (a Canadian documentary film male-female duo best known for their work on Edward Burtynsky, *Manufactured Landscapes*), Tin Can Forest (an animation studio comprised of the white Canadian male-female duo Pat Shewchuk and Marek Colek), and Anique Jordan (an African-Caribbean woman from Toronto).[33] In terms of media, histories, and identities, this latter section particularly challenged the kinds of presentation that the AGO has traditionally foregrounded in relation to the Group of Seven. If this exhibit shook up the establishment, it was Hunter's plans for Canada's sesquicentennial that really rocked the boat. *Every. Now. Then: Reframing Nationhood* was widely lauded as a critical success and a brave and necessary response to the Canada 150 celebrations. This critical success made Hunter's decision to quit during the run of the show a surprise. More surprising was his letter-cum-article in the *Toronto Star*, "Why I Quit the Art Gallery of Ontario," which laid out his concerns with the direction of the institution, and which is worth quoting at length. Hunter explained of the exhibition and its relation to his departure:

It was our critical response to Canada 150, designed to be a catalyst for significant change within an institution that remains (like so many others in this country) burdened by, and seemingly committed to, a deeply problematic and divisive history defined by exclusion and erasure ... My choice rests in a disappointment: not in what we achieved, but the fragility of its ability to persist. As I leave, I worry about an institution wavering in its commitment to make space for new voices – voices traditionally excluded from senior roles at public cultural institutions in Canada ...

I have always been concerned about the role art museums play
in the wider world, about how truly engaged they are with the
critical issues of our times ... The contemporary museum ...
was born out of the private collections of wealthy Europeans
who had built their fortunes on the extraction of resources,
and people, from the most vulnerable nations in the world.

Out of this dubious practice evolved public educational institu-
tions, or so they self-described. Really, they were outward dis-
plays of power that reinforced class division and validated the
corporate and colonial systems that had made their founders
rich. From wealth came power and then cultural dominance:
museums set social rules, coercing the broader public toward
shared values they deemed to be "acceptable."

Despite everything, for most institutions, that's the model that
remains: "value" is decided by the very few and then presented to
the many. When I look at the AGO and so many of its peers, I see
an institution guided not by public participation, but by the gen-
eric, elite consensus that rules the global art market, which sees
product over public good.

I see institutions that look for leadership and to fill critical
content roles outside of this community and country (a remark-
able community, by the way, of cultural professionals with diverse
and distinct voices that has been deeply invested here for decades).
At the AGO, the curatorial department is becoming dominated
(at various levels) by individuals from, or primarily trained in,
the United States. It has become abundantly clear to me that it is
highly unlikely that the currently vacant position of chief curator
– a critical role, from which many content decisions flow – will
be filled by a Canadian.

I see too many who lack true knowledge of this place ...

The current program of reinstalling the permanent collections
of European and Modern art, called *Look: Forward*, lays bare
this disconnect: it lacks any deep engagement with Canada,
Canadian art or the diversity of this community ...

The star system of the contemporary "art world" and the hier-
archical corporate model create divisive, competitive, unhealthy
environments for work. For Indigenous peoples, people of colour
and many youth, these institutions remain unwelcoming spaces
of trauma – spaces where their marginalization remains at the
core of the institutions' mission.

... Engaging with diversity has to mean more than just expanding an audience for an established model, to be more than some insidious missionary program of converting more to have faith in these institutions, and drawing communities into a program of their own marginalization and erasure.

These debates were front and centre when I was a student in the 1980s. The key critical texts of that time continue to be primary references, three decades on, confirming that little has changed.[34]

Of course, since the hiring of Hunter, the leadership had changed at the AGO: Teitelbaum had left to take the helm at the Museum of Fine Arts in Boston in the summer of 2015 and was replaced in 2016 by Stephan Jost. The same day as Hunter's explosive letter appeared, the AGO announced a revised department structure – a newly parallel Department of Canadian and Indigenous Art – and claimed a "a strengthened commitment to Indigenous art, including First Nations, Inuit and Métis."[35] Moreover, it announced that Georgiana Uhlyarik, formerly the associate curator of Canadian art, had been promoted to Fredrik S. Eaton curator of Canadian art, and that she would "oversee" the newly formed department. At the same time, it announced that Wanda Nanibush, formerly the assistant curator of Canadian and Indigenous art, had been promoted to the newly created position of curator of Indigenous art "in recognition of her outstanding contributions to the AGO's exhibition program since her hire in 2016, including *Toronto: Tributes + Tributaries, 1971–1989* and *Rita Letendre: Fire & Light*. Nanibush will lead the AGO's strategic direction as a leading presenter of Indigenous art." Whatever one might feel about hasty searches conducted without openly advertising, it seems clear that the hires were meant to defuse Hunter's arguments. In an interview shortly after his departure, Hunter said "that while inclusivity was a frequent topic of conversation with his colleagues, those discussions did not always make it to the decision-makers. And even when change was implemented, he said he was often frustrated by how hard it was to sustain."[36] In the intervening months, announcements about the rehang of the permanent collection and future Indigenous exhibitions suggested that his provocation may have worked. Although this rehung collection will open too late for analysis here, reports suggest the new Canadian and Indigenous galleries, which opened in summer 2018, will include substantially

more Indigenous art, and will be hung thematically. Recent events suggest that the AGO's commitment to female and racialized artists has been reinvigorated.

THE MUSEUM OF CONTEMPORARY CANADIAN ART

MOCCA was formed in 1999, out of the demise of the former Art Gallery of North York (AGNY), which had also been a recent entry on the scene. The AGNY was situated within North York's Ford Centre for the Performing Arts, and partially funded through it. But with the bankruptcy of Garth Drabinsky's company Livent, which had contracted with North York to run the Centre, the Ford Centre was thrown into disarray, with the city scrambling to cover its basic costs. Not surprisingly, the AGNY fell victim to resultant fiscal cuts in 1999. The amalgamation of North York into the "megacity" of Toronto brought the centre under the purview of the City of Toronto, and MOCCA was born of the chaos. Then-curator and director Glen Cumming assessed the collection, which focused on Canadian art since 1985, at $1.3 million.[37] In the transition period, in 2000, David Liss became the artistic director and curator, with the plan to create a contemporary art museum in Canada's largest city.[38] Liss was responsible for a rebranding of the new institution, which became the Museum of Contemporary Canadian Art, and which opened in a new building on Queen Street West in 2005. Its mandate (as of 2014) was "to exhibit, research, collect, and promote innovative art by Canadian and international artists whose works engage and address challenging issues and themes relevant to our times. MOCCA is committed to providing a forum for emerging artists that show particular promise and to established artists whose works are considered to be ground-breaking or influential."[39] Despite the term "museum" in the title, and the inclusion of the term "collect" in the mandate, the collection was generally not part of its programming. The focus was on contemporary art in the broadest sense of the term, including arts as diverse as tattooing and graffiti. It became a vibrant part of the Queen West scene. However, their ten-year lease expired in 2015, at which point the gallery announced ambitious plans. Rebranded once again as the Museum of Contemporary Art Toronto Canada (MOCA), it reopened late in 2018 in a much larger space.

Looking more closely at the decade covered in my initial study (2001 to 2010), the significance of Liss's achievement with MOCCA

needs to be recognized. He was the central driver behind the revital-
ization of a near-defunct institution and did much to invigorate the
Toronto scene. The gallery must also be lauded for its numerous
outreach activities, including Nuit Blanche, the Scotiabank CONTACT
Photography Festival, and NGC@MOCCA. Under Liss's leadership, it
has become a really active, dynamic space. As early as 2002, his
exhibitions seemed to attend to the nuances of Toronto art in ways
that the city's other institutions were not known for; in Carla Garnet's
review of a 2002 group show she noted that he "cleverly puts his
finger on the pulse of Toronto's new school of painting."[40] Even more
interestingly, in 2000 he was the only employee, and the institution
had a budget of only $63,000, plus his salary.[41] To have become, by
2010, a major player on the Toronto scene is a significant accomplish-
ment. Whereas the AGO or the Power Plant might suffer from layers
of bureaucracy, Liss has been sole director/curator, which the data
indicates brings with it its own consequences.

From 2001 to 2010, as listed on their website in July 2013, MOCCA
held twenty-six solo shows by male artists and ten by female artists,
which is considered a statistically significant difference from equitable
gender representation.[42] Both male and female shows skewed heavily
towards Canadian over international artists, as befitted the gallery's
mandate at the time, with only three solo shows by international
artists, two male and one female. Even worse was its representation
of artists of colour (see figure 4.4). Thirty of thirty-six exhibitions
were by white artists; only two were Indigenous (one man, Kent
Monkman, a First Nations artist of Cree and Irish ancestry, and one
woman, Winnipeg-based First Nations artist K. C. Adams); and only
one artist was black, the American Glenn Ligon (again). There were
two male Asian artists (Thai Apichatpong Weerasethakul and Taiwan-
born Canadian Ed Pien) and one female Asian artist (South Korean-
born Canadian Insoon Ha).

What does it mean that such an ambitious gallery can have such a
poor record on gender equity and ethnic diversity? Moreover, what
does it say that, to my knowledge, this has not been protested or
considered newsworthy? To me, it suggests that the numbers are invis-
ible to the public at large, and perhaps even to the institution itself.
Given its stated commitment to emerging artists and its place in
Toronto, a city in which 44 per cent of the population identified as a
visible minority in 2001, a percentage that increased to over 50 by
2016,[43] the programming seems to maintain an older, whiter version

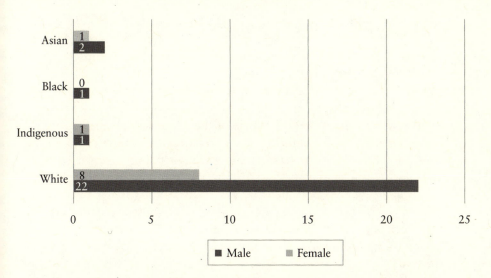

4.4 Gender and race of artists with solo contemporary shows at MOCCA, 2001–10

of the city. Liss was unavailable for comment, as were all the other people I contacted who worked or had worked at the institution.

While I have not tabulated MOCCA's group shows in this period, these also seem very male dominated. Curatorial interests must, of course, influence curating, and some of MOCCA's most talked about events draw from traditions that skew white and male. *Demons Stole My Soul: Rock 'n Roll Drums in Contemporary Art*; *Darkness Ascends*, which included a heavy metal component; and *Arena: Road Game*, which drew on Canadian interest in hockey, all seem to favour male artists and viewers.

MOCCA's partnership with the NGC is both an example of its ambition and indicative of its problems. Discussed in chapter 3 as an example of the NGC's outreach activities, the partnership is here considered as an example of a continued lack of diversity. It was initiated in 2010 as a mutually beneficial program that allowed the NGC to exhibit its collection more broadly. From 2010 through 2013, NGC@MOCCA (as the partnership is called) had six solo shows, of which only one was of a female artist. More than that, while the male artists were varied in terms of their international reputations, the lone female artist was Louise Bourgeois, an artist of considerably higher international profile than any of the others. All six were white. In addition, the Bourgeois show should technically be excluded from

my statistics, because she was no longer alive at the time of her exhibit, having died in 2010 at the age of ninety-eight. That is to say, if we consider solo shows of living artists, this collaboration consists of 100 per cent white men.

Given this poor diversity, I decided to check the numbers for group shows in this partnership from 2010 to 2013 in the hope that they might be somewhat better because of the larger sample size. There were fifty-four participants in the four group shows exhibited during this time: forty-two male artists and twelve female artists, which is extremely significant statistically.[44] The group shows were also over-whelmingly white and included only three Asian and three Indigenous artists (see figure 4.5). When our national art gallery collaborates with other galleries in this way, with results that are so far from representing our nation, it is damaging to the way our histories will be told.

Staff changes following the expansion announcements promised greater diversity, but subsequent changes suggest the gallery's old ways may continue apace. In October 2015, Chantal Pontbriand was announced as the new CEO who would oversee the institution's expansion into the new building. While the impetus for the move seems to have come from the expiring lease, the new space has more room for the permanent collection (as it existed from the AGNY days), new acquisitions, and a shift in focus from predominantly Canadian art to a more international scene.[45] This alone is a significant shift. Liss had long chafed under the Canadian mandate and has stated, "we will not be showing exclusively Canadian art here. That's a parochial view and it's not relevant in the twenty-first century to take a nationalistic approach."[46] The mandate of the new institution emphasizes "innovative art by Canadian and international artists whose works address challenging issues and themes relevant to our times."[47] But Pontbriand's interests also suggested that the institution's record on exhibiting artists of colour might shift significantly. Pontbriand has significant international experience, and had recently left her position at the Tate Modern to take up a position in Toronto as the artistic director and founding curator of the Canadian Community Arts Initiative project *Demo-Graphics 1*, an international art event planned for the Greater Toronto Area, billed as a diversity-based biennial.[48] Planned to open in 2017, the same original date as the new building, it was in-line with her vision for a new kind of institution on the Toronto scene. At the MOCA launch, Pontbriand reportedly

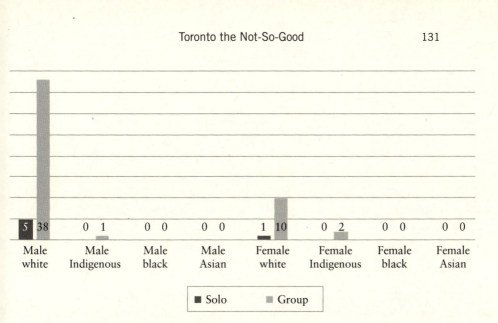

Male white: 5 | 38
Male Indigenous: 0 | 1
Male black: 0 | 0
Male Asian: 0 | 0
Female white: 1 | 10
Female Indigenous: 0 | 2
Female black: 0 | 0
Female Asian: 0 | 0

■ Solo ■ Group

4.5 Gender and race of artists in NGC@MOCCA collaboration, 2010–13

"spoke of a new museum model geared toward a globalized world, with Toronto, the most diverse city on the planet, at its core."[49] The rebranding was designed to facilitate a shift in approach:

> the new name reflecting a move away from the former MOCCA's purely Canadian content and agenda toward a global engagement … with an international agenda at the forefront. Its inaugural exhibition, curated by Pontbriand, says as much. Called *Odyssey 2040*, it's slated to open the museum with works and performances drawn from across the country and the world.[50]

Pontbriand described the slipping position of Canada's curators on the international scene and suggested that embracing Toronto's diversity was the means to put the city on the map:

> We need to make something acute, connective, researched, about a globalizing world, and how can Canada contribute to that in an original fashion. It can do so because of its unique demography. It's the only G8 country with 20% immigrant population. In the US, 12%. Germany, France, and the UK are all beneath 10%. That's why I think it's very powerful to analyze our unique demography – without ignoring our founding peoples in this

country – but by finding a new way of looking at our own past, and at our present, and at our future.[51]

Despite this promising beginning, Pontbriand's abrupt departure came less than a year after she was hired, and neither of these planned exhibitions came to be.[52] Given the institution's history and Pontbriand's record of interest in diversity, it is difficult to see how these visions could have melded. Terry Nicholson, a long-time cultural manager in Toronto, took over as interim director, which seemed fitting, since he had been part of the crisis management team in 2000.[53] In late fall of 2017, Heidi Reitmaier was hired as the new executive director and CEO; which direction she will take the institution remains to be seen.

THE POWER PLANT

If we compare MOCCA to the Power Plant, the differences are stark. The Power Plant has changed directors numerous times in the decade under consideration, and departing staff have expressed dissatisfaction with the board, reputed to be less interested in art than social functions. Whereas Liss has been running the show at MOCCA with seeming autonomy, Gregory Burke, director from 2005 to 2011, was widely reported to have left because of a poor fit with the Power Plant's board. For others, Harbourfront – the larger umbrella cultural organization under which the Power Plant resides – was the sticking point. Wayne Baerwaldt, the gallery's director from 2002 to 2005, described the situation between the gallery and Harbourfront as "always problematic. There was always ... some sort of expectation that you would always pay heed to the fact Power Plant was a department of Harbourfront."[54]

In 1987, the Power Plant emerged out of the Art Gallery at Harbourfront, which had been established a decade earlier. With a mandate to exhibit contemporary Canadian and international art, at its founding the gallery filled a gap in the Toronto scene. Yet, located off the beaten path in the Queens Quay development, known more for tourism than a deep connection with the city, the gallery has struggled with its relation to the city's artists. Since MOCCA's move from North York to Queen West, the two institutions have sometimes seemed to compete, and have struggled to find their differences.

But if we look at gender representation from 2000 to 2010, we might see some of the differences more clearly. The Power Plant had

forty solo shows of male artists and twenty-seven of female artists, or 40 per cent female artists; although this is still a record that could be improved, it is the only Toronto public gallery whose statistical deviation from equity was not significant.[55] Moreover, interesting things emerge when we look at the numbers more closely: the Power Plant brings in roughly equal numbers of Canadian and international female artists, but a greater percentage of international male than female artists, which is too often the case.

However, if we consider ethnicity from 2000 to 2010 (see figure 4.6), the Power Plant has an even poorer diversity record that than MOCCA. Of sixty-seven solo shows, only six were of artists of colour, which is less than 9 per cent. Given Toronto's diverse makeup, this is a truly problematic number. Moreover, if we look at black artists, there was only one: the American Glenn Ligon, who also happens to be the only black artist to have had a solo show at MOCCA in the period. Asian and South Asian artists are seriously underrepresented, with only four artists. The only Indigenous artist with a solo show at the Power Plant from 2000 to 2010 was Annie Pootoogook, an Inuk artist from Kinngait (Cape Dorset). While the gallery might be praised for its early support of the rising star (this was her first major solo exhibition), like the other institutions in the Greater Toronto Area, there was no acknowledgement that the gallery is on the traditional territory of the Haudenosaunee or that the city is home to many Indigenous peoples, or that the institution should be representing the population. It is also interesting that, as was the case with the NGC@MOCCA collaborations, the Indigenous representation was comprised entirely of Inuit art. Perhaps this reflects the history of settler aesthetic taste and art collecting, which valued Inuit art before arts from many other nations, or perhaps it relates to a preference for Indigenous content that is less overtly political. Moreover, given the significant Asian and South Asian populations in the city, this group is seriously underrepresented. The Power Plant's mandate states that it supports "a diverse group of living artists while engaging equally diverse audiences in their work"; we might question how these numbers relate to that mandate, as well as what "diverse" means in many institutional statements.[56]

While these three public institutions present a range of practices with respect to gender representation, they have similarly poor records around ethnicity. Indeed, when I began to compile the data around ethnicity, I was surprised by how relentlessly white the big Toronto

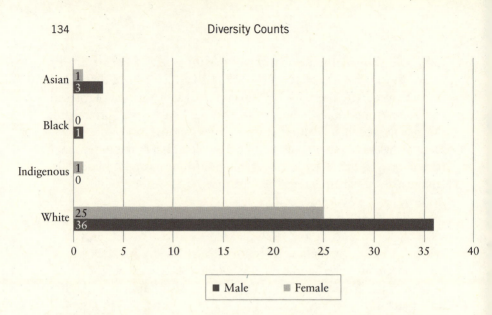

4.6 Gender and race of artists with solo contemporary shows at the Power Plant, 2000–10

galleries continue to be (inadvertently proving my point that when we do not know the numbers, our perceptions can end up being far from the mark). Very poor representation of artists of colour continues to be a pressing issue across the country, but given the diversity of Toronto, the numbers seem particularly egregious (see figure 4.7). As a point of contrast, at the VAG about 63 per cent of the artists with solo shows were white; at the Power Plant, that number rises to 87 per cent, while at MOCCA it was 82 per cent and the AGO was 83 per cent. In all of these, the actual numbers of exhibitions of artists of colour are so small that it would be unwise to draw strong conclusions about differences among these groups. However, the numbers do strongly demonstrate a bias in favour of white male artists. According to the 2006 census, taken in the middle of our study period, 47 per cent of the population of the Greater Toronto Area self-reports as a visible minority (using Statistics Canada's definition as non-white or non-Caucasian and non-Aboriginal).[57] The city that prides itself on being one of the most diverse in the world certainly does not appear that way when looking at its public galleries. Moreover, given our national investment in the idea (or ideal?) of multiculturalism as our guiding principle, and cultural pluralism as our strength, it is a hard truth to swallow that these numbers do not come close to meeting those ideals.

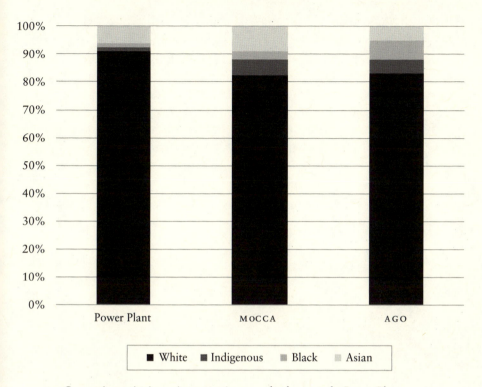

4.7 Comparing artists' race in contemporary solo shows at the Power Plant,
MOCCA, and AGO

CONCLUSIONS

In one sense, it is clear that the very large institutions that have mul-
tiple layers of oversight, such as the AGO and the NGC, have constructs
at various levels where diversity is likely to drop off. If curators are
themselves less interested in diversity, or conversely, if they believe
that the next level of approval is less interested in diversity, if they
pitch shows to those at the next level who are more interested in
popularity, gate-value, and audience numbers, it is clear how the
lessening of diversity can be compounded through a multilayered
process. One of the central themes that came out of the project was
how disempowered curators feel they are at large institutions. Many
curators gave a Gallic shrug, which I read as their being resigned to
the state of things, as if to say, "What can you do?" As one ex-curator
put it, any attempt to move an agenda, of whatever sort, is almost

impossible when gate-value is the primary factor, since the wider audiences being targeted with these shows tend to be normative. An examination of MOCCA reveals, however, that the single curator model can be equally fraught. A director-curator has far greater autonomy, and presumably does not have to justify the lack of diversity to anyone, save their board or their public. Given how little public outcry there has been about gender and diversity records, it seems that neither have called for much attention to be paid to these issues.

5

Hard Facts and Soft Power: Rhetoric, Reality, and Influence in Montreal

I'd hope I had been chosen for what I had between my two ears and not because of what I don't have between my two legs.[1]

Nathalie Bondil

Montreal has long been one of the most vibrant contemporary art centres in Canada. Its unique mix of francophone and anglophone culture, its inexpensive rents, and especially Quebec's validation of the importance of culture all make Montreal an extremely lively and attractive art centre for artists at all stages of their career. It has nearly twice as many artist-run centres as Toronto (despite its smaller population).[2] Most importantly, it has a remarkable number of contemporary art galleries – both private and commercial – that foster a strong art economy, including Parisian Laundry, Art Mûr, Joyce Yahouda Gallery, and Pierre-François Ouellette art contemporain, as well as the Darling Foundry and DHC/ART Foundation for Contemporary Art. With such an active art scene, it is perhaps not surprising that Montreal also seems to have an art community that is willing to protest and take an active, even interventionist, role.

The city's two largest public art institutions, the Montreal Museum of Fine Arts (MMFA) and the Musée d'art contemporain de Montréal (MACM) have very different histories and cultures. Digging into the statistical evidence reveals some commonalities, which, in turn, suggest that diversity and equity issues are conceptualized differently in Montreal than in other Canadian cities. In the case of the MACM, the numbers and frequent changes in leadership led me to consider

the effect that personnel changes both in the museum and on the board can have on programming diversity. Examining the solo exhibition record of the MMFA made me aware of the significant difference between its track record, its recent aspirational rhetoric around diversity, and how such lofty goals roll out in practice. Though they do so in very different ways, both cases reveal the power, often hidden, of the board or development offices in making curatorial choices.

MUSÉE D'ART CONTEMPORAIN DE MONTRÉAL

In its own words, the MACM "is Canada's largest and most important museum dedicated exclusively to contemporary art."[3] It is currently undergoing a significant renovation (also called a "transformation," like at the AGO) and plans to reopen in 2021. For the most part, this study has focused on institutions rather than individuals, recognizing how complex the distribution of power is in museums. The MACM has had significant leadership changes in the last fifteen years and the resultant changes in direction reveal the importance of the leadership, at the level of both the director and the board. Consequently, at this gallery, I decided to look more closely at how the institutional numbers shifted with successive directors, which proved to be significant. Unusually for Canada, the Montreal art community has been quite vocal about certain staffing decisions, which have correlated in interesting ways with diversity issues. Tracking the numbers in relation to changes in diversity under each director has left me with lingering concerns about how such community activism can be double-edged when mobilized in relation to progressive curating.

Founded by the province of Quebec in 1964, the MACM was the first museum of contemporary art in Canada. In 1984, it became a provincially owned corporation, and there was much uncertainty about what this would mean for the future of the institution. Rumours fuelled fears that the province intended to turn the MACM into an exhibiting institution and to disburse the collection to other museums in the province.[4] The integrity of the Borduas fonds, acquired in 1972, has been seen as integral to the institution's founding and significance.[5] The gallery's mandate is "to make known, promote and preserve contemporary Québec art and ensure a place for international contemporary art through acquisitions, exhibitions and other cultural activities."[6] The exact parsing of "contemporary Québec art" and how this relates to Borduas, the Automatistes, and the Plasticiens

would play out in interesting ways. Indeed, this dual mission remains a dilemma at the heart of the institution: its duty to the collection, which by definition is always in the process of becoming historical, and its role in supporting truly contemporary Quebec and international art.[7]

Central to the institution's shifts through these years was Marcel Brisebois. An ordained Catholic priest may have seemed a surprising choice for director of a contemporary art museum nearly forty years after the Quiet Revolution. Nevertheless, Brisebois had a long and successful run as the MACM's director from 1985 to 2004. He led the museum through major transformations that remain significant in its operations, including the drafting of its collection policy and its move to the new building that opened in the Place des Arts in 1992. Until the end of his career, he saw safeguarding the independence of the museum from provincial interference as a central concern.[8] Given the institution's next major acquisition, the Lavalin collection, it is understandable that Brisebois chafed at the power of the province.[9] The soft power of Montreal elites in these politicized decisions and consequently in the running of the museum is hinted at in the Lavalin acquisition but impossible to fully assess.

Behind both the appointment of Brisebois and the acquisition of the Lavalin collection was another significant figure on the Quebec cultural scene: Bernard Lamarre. Lamarre made his fortune as the head of the major engineering and construction firm Lavalin. Under his leadership, the company had grown into a diversified multinational and was the largest engineering firm in Canada by the 1980s. Since the 1970s, the firm had been building a significant collection of contemporary Quebec and Canadian art, particularly after Lamarre hired Leo Rosshandler, a painter and curator hired away from the MMFA, to curate the company's art collection.[10] As chair of the board of the MMFA and head of several of its expansion campaigns, Lamarre was already an influential player on the Montreal art scene. Convincing his friend and colleague on the MMFA board, Brisebois, to apply for the directorship of the MACM in 1985 would have strengthened his role in this already tight art scene.[11] When financial difficulties in the early 1990s led to Lavalin's merger with its competitor, SNC, the company was forced to sell off its extensive art collection. Given that the collection comprised approximately 1,300 works, fears that its sudden entrance into the market would be disastrous for the provincial art market set off a flurry of activity. Given his position at the MMFA,

Lamarre must have been constrained in how much he could act – or be seen to be acting – as an intervener in the collection's fate, which presumably made its acquisition by the MMFA a non-starter.[12] The government interceded and financed a loan so the MACM could purchase the entire collection.

From the outset, there were concerns about the collection's appropriateness for the MACM, given the number of historical works, its uneven quality, its primary instigation as a corporate rather than museum collection, and the difficulties around the sheer number of works, which would take an immense amount of resources to acquisition and care for.[13] Perhaps most significantly, paying back the $5.4 million loan had the museum working in arrears for years.[14] Prior to this massive acquisition, the MACM's collection had consisted of 65 per cent Quebec artists, and 84 per cent male artists, with a preponderance of pieces by the Automatistes and Plasticiens; these tendencies would only be exacerbated by the acquisition.[15] Given the centrality of the Automatistes and Plasticiens to any history of modern Quebec, it makes sense that they be well represented in an institution devoted to Quebec art; however, as years pass, those fonds are increasingly historical and increasingly far from contemporary. Accordingly, MACM's purpose is bifurcated – to tell a longer history of modern Quebec art and to devote itself to contemporary art.[16] By the beginning of this study, in 2000, the Lavalin collection had been integrated, but the museum was still suffering from a very small acquisitions budget and small space, and more changes were on the horizon.

Upon Brisebois's retirement at the end of 2004, it seemed inevitable that there would be fundamental shifts at the gallery. As John Bentley Mays observed,

> it will be no ordinary changing of the guard. Now 70, Brisebois will be the museum's last director to come of age with contemporary art itself in Quebec, during the critical, uncertain hours of the Quiet Revolution. His unnamed successor will be, as Brisebois is not, an ex-combatant in the vivid culture wars of the sixties and seventies of the last century. He or she will probably not be a Christian, and certainly not a man rooted in mid-century Catholic humanism.[17]

More pivotal than the generational change, arguably, is the fact that since Brisebois's nineteen-year run, directors of the MACM have had

an unusually short tenure. Marc Mayer took the position in 2004 but announced his departure for the NGC in 2008. Paulette Gagnon would similarly last four years, from 2009 to 2013, and John Zeppetelli has been in the position since 2013.[18] As the statistics show, directorial changes significantly affect programming.

MACM's Diversity Record, 2000–2017

Given the generational change predicted above, we might expect the record of the MACM on gender and diversity to have been the worst under Brisebois. However, that is far from the case. Our counts for the MACM from 2000 to 2017 tally 63 per cent of solo shows of living artists going to male artists. Because the sample size is quite large, with 138 exhibitions, the ratio of eighty-seven male artists to fifty-one female artists can be considered a statistically significant deviation from expected equity.[19] However, when we break the numbers down further by director, major differences between the directors become apparent. Figure 5.1 categorizes solo shows of living artists that opened under each director and excludes a small number of shows that opened during interim directors. Although the opening date is not a perfect way of attributing responsibility, as some exhibitions might have been planned under the previous director but not have opened until after their departure, it is at least consistent.[20] Despite its margin for error around start and end dates, the differences under specific directors is remarkable.

Under the direction of Brisebois, we might expect to find the lowest percentage of female artists, either because he was the earliest director or because of our own perceptions about his generation, however this is not the case. In the latter years of his term, from 2000 to 2004, more than 45 per cent of the MACM's solo shows went to female artists. Under Gagnon, who had been Brisebois's chief curator and became director from 2009 to 2013, the percentage edges up to above 48 per cent. What is truly startling, however, is the difference in the intervening years, between these two directors. Under Mayer's leadership from 2004 to 2008, the percentage of female artists plummeted to just over 20 per cent, less than half of Brisebois or Gagnon, despite the fact that Gagnon remained chief curator throughout and most of the other curators remained consistent. While Zeppetelli's record on gender is not as equitable as Gagnon's, it is much better than Mayer's. Indeed, Mayer's is the only record for which the difference from expected equity is statistically significant.

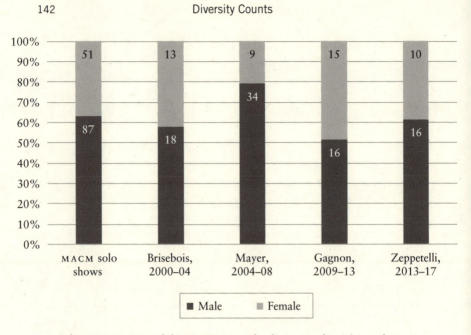

5.1 Solo contemporary exhibitions at MACM by director and artists' gender, 2000–17

Discovering these differences encouraged me to consider anew the controversy surrounding Gagnon's promotion to director and Mayer's move to the National Gallery. Gagnon had been chief curator since 1992. As early as 2003, Mays suggested that it was due to Gagnon's curatorial leadership that "the MACM has sharply intensified the exhibition of outstanding women artists from home and abroad."[21] Reportedly, she was rejected for the position of director in 2004, when Mayer was chosen to succeed Brisebois. The consensus around Mayer's hire was very positive. He was seen as a corrective to the sometimes overly insular focus on Quebec artists and as bringing a necessary international balance to the institution. The numbers bear out the assumption that he had increased international shows: the percentage of international artists rose from less than 30 per cent under Brisebois to more than 40 per cent under Mayer. He was applauded for bringing powerhouse international art stars to the city such as Thomas Hirschhorn, Anselm Kiefer, William Kentridge, and Fiona Tan. Paradoxically, given earlier and later complaints about the museum's insularity, the success of the first Québec Triennial seems to have been what most delighted the city's art scene. A *Globe and Mail* review of

the exhibition began, "Is Montreal the new Vancouver? I've heard the question floated the last few days following the opening of the Québec Triennial."[22] Reviews of the show typically interviewed or quoted Mayer and barely made mention of the curatorial team.[23] As one example, Isa Tousignant's review in *Canadian Art* is representative of the paradoxical way Mayer is credited with both internationalizing the institution while at the same time proving Quebec's vitality:

> the MACM has been accused of provincialism in the past. Not since the change of guard, mind you, when Marc Mayer took the helm in 2004. But in Marcel Brisebois's days an oft-recurring critique was that the museum's gaze was myopic and exclusive, promoting Quebec art to the detriment of international exposure. Since Mayer's arrival, the museum has expressed a concerted effort to internationalize its shows, and has brought in some of the biggest international names there are (albeit with a slight delay on "it factor," understandable given the MACM's humble Canadian budget). In contrast to this distant and recent history, this show is a delightful mix of the old and the new. It brings the institution's attention back home. After all, there is no shame in being from Quebec![24]

As chief curator, Gagnon got none of the credit in any of the reviews I read of the triennial. The immense popularity of this exhibition of emerging and established Quebec artists made the announcement of Mayer's departure late in 2008 all the more surprising.

The next summer, in June 2009, museum board chair Marc DeSerres announced that Gagnon had been hired to replace Mayer. A major controversy erupted.[25] As she had been such a fixture in the museum for almost two decades, Gagnon's promotion led some to worry that the worst of the institution, particularly its insularity and lack of influence on the international stage, would return. Within a month, a letter by Quebec art historian Laurier Lacroix and Anne-Marie Ninacs, former curator of contemporary art at the Musée national des beaux-arts du Québec – eventually signed by more than eighty members of the art community – was sent to DeSerres and copied to Christine St-Pierre, the minister of culture, communications, and the status of women. The letter purported to be about the hiring process rather than its outcome and avoided naming Gagnon. It repeatedly noted the need for major change. Throughout, however, it is perfectly

clear that the most significant impetus was the person hired. The letter
begins by claiming surprise at the announcement of the new director's
hire, explaining, "Our surprise came from the fact that a large part
of the cultural community was hoping at this time for a profound
change for the institution."[26] Fear that Gagnon was not capable of
instituting such change, that she would steer the MACM down the
same old path, is rife throughout the letter. The authors complained
that the selection committee had only been comprised of the board
members, had not availed itself of the considerable expertise in the
local arts community, and had chosen not to interview viable candi-
dates selected by the head hunters, eventually concluding that the
entire search was a sham. They go on to list what they saw as the
weaknesses of the current institution, including that the MACM

> is generally content to welcome values from the outside without
> taking a close look at them, ignores for no apparent reason the
> essential figures of its environment (artists, curators, researchers,
> designers, etc.), does not use not the exhibition as a mode of reflec-
> tion, most often favors artistic practices that pose no challenge to
> the rules of museology (to the detriment of a whole section of cur-
> rent practice), sees a reduction from year to year in its cycle of
> colloquiums and conferences, and only exceptionally circulates a
> living Quebec artist on the international scene where the Museum
> remains unknown, even invisible.[27]

None of these issues were raised publicly in the Mayer years, which
makes the claim that they were purely about the institution and not
the person somewhat suspect. As *Le Devoir* reported, much of the
discontent came from the fact that many of the signatories would
have preferred Louise Déry, director of the UQAM gallery, who was
rumoured to have been shortlisted. It was also rumoured that the
committee had been split, and Gagnon had been the compromise
candidate.[28] DeSerres wrote in defence of the selection and, more
surprisingly, so did Gagnon. Unsurprisingly, the replies did not satisfy
the complainants; claims and counterclaims of who had offered to
meet with whom did not lead to any satisfactory outcome. Eventually,
Lacroix and Ninacs organized a colloquium, "Le MACM en question,"
at which the Montreal community bemoaned the state of the institu-
tion; no museum employees attended.

Some of the concern around Gagnon's leadership was mitigated by the hiring of Marie Fraser as chief curator in December of 2009. It was hoped that Fraser, a professor of museum studies at UQAM, would bring a more rigorous scholarship; her deep connection to and interest in the Quebec scene suggested she would usher in more contemporary and edgy programming. More importantly, she had curated multiple European shows, which implied that she had the potential to increase the city's standing on the international stage. By 2011, Fraser had brought in her first international show, by Albanian artist Anri Sala, who would go on to represent France at the Venice Biennale in 2013. The show was a critical and popular success. In 2012, Gagnon's term was renewed for another three years, following the success reported in *Le Devoir* of "prizes at the recent Visual Arts Gala ... for the best public event for the Quebec Triennial, accepted by Marie Fraser and for the best exhibition in a museum for the retrospective devoted to Valérie Blass."[29] With ambitious exhibitions that winter of Blass, Wangechi Mutu, and Ghada Amer, each with a catalogue, it seemed Gagnon had proven the critics wrong and reset the institution.[30] Gagnon announced an ambitious expansion plan (costed at more than $80 million). Given these successes, the future looked promising.

Knowing how much more gender balanced exhibitions were under Gagnon's tenure as director, I was curious to see if she was equally progressive on other measures. Looking at artists of colour, some surprising things came to light. First, the MACM's record on ethnic diversity is shockingly bad. Of the 138 solo shows by living artists from 2000 through 2017, only one was by an Indigenous artist – Brian Jungen in 2006. The implications of this are jaw dropping: as of December 2017, the MACM has not had a solo show of an Indigenous artist in more than a decade. It also has not had a solo exhibition by a female Indigenous artist since the beginning of my count in 2000.[31] Since Jungen is of Dane-zaa and Swiss descent, and working with West Coast Indigenous traditions, it also means they have not had a solo show by any artists from the Indigenous nations of the land now known as Quebec.

In addition to the lack of Indigenous representation, the MACM also has a very poor exhibition record for other racialized artists. In this count of 138 exhibitions, the gallery has had six shows by artists of Latino heritage, four shows by artists of Asian and South Asian heritage, three black artists, three Arab, two Israeli, and one Indigenous

artist, as well as 120 white artists. In total, that amounts to 19 of 138 shows by artists of racialized identities. Given that 31.7 per cent of Montrealers identify as belonging to a visible minority and 3.5 per cent identify as Indigenous, the MACM's record of giving under 14 per cent of its solo shows to racialized artists is quite poor. It suggests a pattern of exclusion that strongly favours white artists.[32]

As with its record on gender, when we look at the galley's show openings by director, there are also notable differences. Of the four directors, Gagnon also has the best record on exhibitions of artists of colour, at just over 19 per cent of solo exhibitions. The four last years of Brisebois's leadership had the worst record in terms of exhibitions of racialized artists, at just over 3 per cent, while Mayer's record was close to Gagnon's at 18.6 per cent, and Zeppetelli's was slightly less at 15.3 per cent.

As figure 5.2 shows, when we break these numbers down further to consider the intersection of gender and race, even starker differences appear. Once again, Gagnon has the most progressive record, with almost 10 per cent of her solo shows going to women of colour. Zeppetelli is close at almost 8 per cent. Brisebois had only one solo show that went to a female artist of colour, which makes his record on diversity 3.2 per cent. Under Mayer's time as director, the MACM again had only one solo show by a female artist of colour, but the higher number of shows makes his record 2.3 per cent of shows going to female artists of colour.

It is tempting to interpret Gagnon's record on diversity and representation as confirming what several curators intimated off the record: that it would be bad for their careers to curate equitably. While these factors may have contributed indirectly to Gagnon's eventual ousting from the gallery, there were other factors. It seems her relationship with St-Pierre, the minister of culture, had not improved. Reportedly, the minister's only response to the expansion plans were the insulting instructions that Gagnon should "redo her homework."[33] Moreover, provincial cuts to funding and low gate revenues were substantial challenges facing the institution. Then, with the departure of board president DeSerres, who completed his second term in 2012, things shifted dramatically, and it would not be long before Gagnon was out.

Changes to the board of directors seem to have been particularly significant in this case. In 2004 to 2005, just as Mayer was taking over from Brisebois, the board of trustees was chaired by DeSerres,

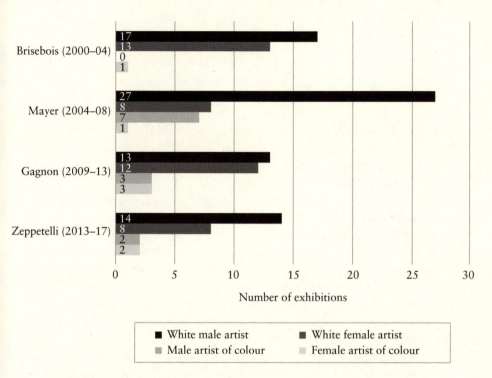

5.2 Solo contemporary exhibitions at MACM by director, artists' gender, and artists' identity, 2000–17

and was comprised of ten men and three women. Like most governing boards, MACM's is usually dominated by business and society people, overwhelmingly white, and wealthy. The *Westmount Independent* weekly neighbourhood newspaper popped up repeatedly in my searches on board members. The occasional artist, politician, or academic tends to round out the roster. Under the combined leadership of Mayer and DeSerres (covering the 2004–05 through 2008–09 annual reports), the women were outnumbered at least two to one on the board, and some years three to one. After Gagnon became director, the gender ratio shifted dramatically; in 2010 to 2011, the board consisted of eight men and seven women; two years later, women outnumbered men for the first time (twelve women and nine men).

While the number of women on the board continues to be relatively equitable, it is clear that the most recent change in board chair had a significant effect on staffing. Reportedly, the media savvy, even showy, Quebec nationalist Alexandre Taillefer was approached and

asked to become chair of the board by Minister St-Pierre, based on his success in saving the Opéra de Montréal from near-certain bank-ruptcy.[34] Taillefer is well known for his stint on Quebec's version of *Dragons' Den* and as an opinionated entrepreneur. Society pages of Montreal newspapers frequently mention his significant personal art collection, noting that it includes works by artists Pascal Grandmaison, Scott McFarland, and Marc Séguin (who now sits on the MACM board), among others.[35] Indicative of the changes to come were his reputation for making tough decisions and his self-description as a "pro-interventionist" board chair.[36] Articles announcing his appoint-ment often included his opinion that the plans for expansion were too expensive and should be scaled back considerably, undercutting Gagnon's proposal in a very public and undiplomatic manner. Few were surprised, then, when the museum announced the following spring that the "Board of Trustees of the Musée d'art contemporain de Montréal is embarking on a strategic repositioning process, to meet the expectations of the museum's various clienteles and to reflect the business model which is being revisited in keeping with the global cultural and competitive environment."[37] The announcement con-tinued that Gagnon would resign in several months time. Within days, rumours that chief curator Marie Fraser and director of communica-tions Danielle Legentil would also resign were confirmed, and reports attributed the resignations to friction with Taillefer.[38]

Taillefer was frequently interviewed, announcing that there would be further cuts to staffing and a much cheaper expansion plan. Taillefer also seems to have been behind the decision that the MACM would essentially shelve the Quebec Triennial and play a larger role in the Montreal Biennale, which would realign itself to include more Quebec artists. Given Gagnon's recent departure and the resignation shortly after the announcement of Nicole Gingras, curator of the biennale, it seems this realignment was cooked up by Taillefer and Cédric Bisson, board chair of the biennale.[39] At the time of writing, it appears that this merger was not successful, since the biennial has filed for bank-ruptcy and appears to be defunct.[40] Although the MACM is closed for long-term renovations, it has been suggested that perhaps a new triennial will rise from the construction dust.[41] That these redirections were shaped by the board chairs seems indisputable; however, Taillefer's ability to shrug off his role in the failure of these two important cultural events is startling. As Robert Everett-Green wrote in the *Globe and Mail*: "He blames the financial collapse on poor

controls by the team led by festival director Sylvie Fortin. The issue had come up during the first biennale, he says, but the director was left in place, because 'you think that if someone makes a mistake once, they won't do it again.' As for the creditors – most of them art-transport companies – he says simply: 'I think they'll eventually go bankrupt.' It's not quite the response you expect from a socially conscious entrepreneur."[42]

From all these machinations and personnel changes, several conclusions can be drawn. First is that Brisebois seems to have been prescient in 2003 when he suggested that the most important job of the director is to resist the interference of the government. As *Le Devoir* reported, the minister sought out Taillefer, whose reputation for slashing costs and being interventionist preceded him. Second, the numbers suggest that the public did not notice or care that under Mayer the museum became significantly less open to women and especially to women of colour. Nor did they applaud that under Gagnon the museum continued to have a strong balance between successful international shows and well-received Quebec shows. Indeed, I have a lingering doubt that her more progressive gender stance may have affected people's perceptions of the importance of the shows during her tenure. Perhaps the most significant issue for me is how little concern there is here (and elsewhere) about the lack of diversity in museums. As is so often the case, however, the artists lead the way. In a recent series of posters and projects, artist Florence Yee has raised questions about how few black, Indigenous and artists of colour are visible in Montreal. Her series *Finding Myself at the Museum* asks the question more broadly of how racialized artists fit in the history of "Canadian" or "Quebec" art. Her painting *From the Asian Art Collection at the MMFA* (see figure 5.3) raises issues about identity and representation that need to be asked of the MACM and the MMFA.

MONTREAL MUSEUM OF FINE ARTS

The growth of the MMFA in recent decades is astounding. By many counts it is the largest museum in Canada, with the most visitors, the most members, a significant collection of both historical and contemporary art, and an ambitious program of internationally touring exhibitions.[43] It is lauded for shows that are both popular and scholarly. In recent years it has partnered with major international museums to produce significant touring exhibitions that mark the MMFA as a

5.3 Florence Yee, *From the Asian Art Collection at the* MMFA, from the series *Finding Myself at the Museum*, 2018. Image courtesy of the artist.

player on the global stage.[44] Its long history as one of Canada's oldest arts institutions, its historical roots in Montreal's Anglo-Scottish community,[45] its more recent links to francophone elites, its successful leadership, and its position in a city that cares deeply about art make the MMFA a major force.

Museum Leadership and the Francophonie

For the majority of the time since 2000, the MMFA has been under the dynamic and effective leadership of Nathalie Bondil. Like her predecessor, Guy Cogeval, Bondil was born in France and trained at elite French institutions: the École du Louvre and the École nationale du Patrimoine de Paris. Before coming to Montreal, she was a curator at France's Musée national des Monuments Français, where Cogeval was director. Their effective working relationship continued after Cogeval was recruited to Montreal as director in 1998. Bondil came to the city the following year to take up the position of curator of European art (1800–1945); she was quickly promoted to chief curator

and later stepped in as acting director as necessary. She was appointed director upon Cogeval's departure in 2007 and retained her position as chief curator. [46] It was widely noted that she was the first female director of the MMFA.[47] She, like Cogeval before her, has leveraged her French connections to the museum's benefit. Major touring exhibitions such as *The Fashion World of Jean Paul Gaultier: From the Sidewalk to the Catwalk* have toured worldwide to immense popular success; co-productions under Bondil's supervision like *Focus: Perfection – Robert Mapplethorpe* engage more challenging material and deliberately, even vocally, "reinforce the values of tolerance and openness that [Bondil wants] ... the Museum to convey."[48] Moreover, three major expansions since 2011 – which have facilitated the reinstallation of the Quebec and Canadian collection, major growth in education, and most recently a Pavilion for Peace – signal unprecedented success.

Although it predates my consideration, the story of the MMFA's major expansion in the 1990s elucidates how shifting power dynamics work in Quebec. In the mid-1980s, board chair Bernard Lamarre set his sights on a major expansion. A trip on the Trans-Siberian Railroad with Pierre Elliott Trudeau, who had recently retired from his position as Prime Minister of Canada, Senator Leo Kolber and his wife Sandra, and Paul Desmarais Sr afforded him the opportunity to make an extended pitch. Desmarais was by then one of the wealthiest men in Quebec, head of a family regularly listed as one of the ten richest families in Canada. Lamarre's appeal reportedly hinged on francophone pride:

> Never in the history of the Montreal Museum of Fine Arts has a francophone made a substantial donation for the construction of a building or other major project. The newest addition, the one built by Fred Lebensold in the year of the Olympics, was paid for in large part by the Cummings family. And most of our collections were assembled by anglophones. You'll agree that it's time that a francophone had his name on an important construction. Just think, the Paul Desmarais Pavilion on Sherbrooke Street.[49]

Lamarre's nationalist pitch was successful. It would open in 1991 and be named the Pavilion Jean-Noël Desmarais, after Paul's father. The museum reports that surveys taken in the following years indicated that the building was attracting a younger, more French-speaking audience.[50]

The Hard Facts

Like most other institutions, contemporary art has recently begun to play a larger role in the MMFA's programming. Given the museum's significance, the fact that it has a dynamic and high profile female director, who has recently been proclaiming museums as special sites of inclusivity and interculturalism, I hoped that it would have a strong recent record on diversity. Looking at solo shows of artists alive on the date their show opened, using the annual reports for the twelve years from 2005–06 through 2016–17, I compiled statistics that are disturbing.

Out of thirty-six solo contemporary exhibitions, twenty-nine went to white or unracialized artists, and thirty-one to male artists. That is 81 per cent white and 86 per cent male (see figure 5.4). Just one of the thirty-six artists is Indigenous (Kent Monkman, 2009), one is black (American icon Kerry James Marshall, 2016), and one is of Asian heritage (Chih-Chien Wang, 2012). Two are Iranian (Shirin Neshat, 2014, and Aydin Matlabi, 2012), one Algerian (Adel Abdessemed, 2017), and one Latino (Iran do Espírito Santo, 2007). Moreover, of the racialized artists, only one is female, which is less than 3 per cent.

When we dig into the non-Canadian artists, there are several Americans and Europeans, and one South American artist, with the largest proportion of international artists from Iran, Morocco, and Algeria. Given that Montreal's racialized population accounts for roughly 34 per cent of the city's residents, representation of artists of colour is much lower than that of the population as a whole. We may see these low numbers as explained, if not mitigated, by the fact that "the proportion of visible ethnic minorities in the arts, particularly in the visual arts, is reportedly negligible, with visible minorities less likely to possess degrees in the arts and the gap particularly acute among younger members."[51]

If we look more closely at the five female artists who had solo shows in the time period being studied, the numbers are even more alarming. Australian artist Tracey Moffatt exhibited as part of *Le Mois de la Photo à Montréal*, which was guest curated by Martha Langford in the fall of 2005, the year before Bondil became acting director. Not until 2011 do we see another female solo show: Montrealer Dominique Blain's permanent installation *Mirabilia* opened as part of the Claire and Marc Bourgie Pavilion of Quebec and Canadian Art. Blain's

5.4 Gender and identity of artists with solo shows at the MMFA, 2005–17, using the annual reports from 2005–06 through 2016–17

installation is situated on the roof of the Erskine and American United Church and was commissioned as part of Quebec's so-called 1 per cent law, which requires new public buildings to put some budget towards the construction of public art; it is visible only from the upper floors of the pavilion; that is to say, while it is significant and is listed as an exhibition in the annual reports, it is a long-term installation of a single work rather than a solo exhibition with the attendant research, such as a catalogue, or the potential to tour. The next reported solo show by a female artist was in 2014 when, as part of the Montreal Biennale, the gallery showed *Illusions and Mirrors* by Iranian-born artist Shirin Neshat, who now lives and works in New York City. The next year, the Marion Wagschal exhibition paid tribute to a long-time Concordia painting professor; the show was produced in association with the Art Gallery of Nova Scotia (AGNS) and curated by AGNS's chief curator, Sarah Fillmore. As the *Globe and Mail* pointed out, in its AGNS iteration the exhibition included forty-three works, but the Montreal edition was significantly smaller, and included only thirty.[52] The following year another partnership led to the

exhibition of work by Montreal artist Julie Favreau. She was the fourth artist (and the first woman) shown from the gallery's partnership with the Darling Foundry. So, if the raw numbers of only five of thirty-six exhibitions by female artists was not bad enough, closer examination shows that, with the exception of Favreau, these exhibitions of female artists at the MMFA were either not quite a solo show in the case of one or guest curated in the others. It reveals a profound lack of support for female artists.

Issues of regionalism and linguistic identity also seem to play an important role. As Alice Ming Wai Jim has described, the relation between ethnicity, national identity, provincial identity, and linguistic identity in Montreal is complicated, and linguistic factors tend to be the most significant.[53] Of the twenty Canadian artists shown, almost all were from or were living in Quebec, most in Montreal. The three Canadian artists who were not associated with the province were Owen Kydd, born in Calgary, educated in Vancouver and LA, where he continues to work and make an international reputation; Kent Monkman, a Cree and Irish-descent artist from Manitoba; and sound artist John Oswald, from Toronto. Of the artists from Quebec, the vast majority (thirteen of seventeen) appear to be francophone, with only four seeming to not be native French speakers; three of these appear to have English as their mother tongue (18 per cent). Looking at the international artists, six of sixteen are French-speaking, and several others are from former French colonies. Unlike the MACM, the MMFA's mandate does not explicitly address the promotion of francophone artists, however it seems unsurprising given its cultural context that it does so.

An Inclusive and Humanist Museum?

These hard facts are incompatible with the lofty intentions Bondil has recently claimed for the museum. After this chapter had been written, in the spring of 2018, the museum announced another major project and significant reorientation that will affect issues of diversity and representation.[54] The Stéphan Crétier and Stéphany Maillery Wing for World Cultures and Togetherness is billed as a "new wing, which will encompass 15 galleries over 1,000 m2, [and] will present a rich selection of ancient to contemporary art, from here and abroad, to encourage knowledge and understanding of other cultures in a twenty-first century, where togetherness is a daily issue. The Museum

also wants to reinforce the transhistorical and intercultural discourse between different cultures of our past and the current day."[55]

Three major building projects since 2010 is a remarkable achievement for any director. These successes are particularly notable when provincial funding was declining and in comparison to MACM's difficulties in getting an expansion off the ground.[56] Each of these building projects facilitated changes that affect issues of diversity and representation and play into the vision of an inclusive space that has been articulated in Bondil's regular use of the term "humanist museum" since 2016. This final section considers recent changes at the MMFA that give strong evidence of a shift toward greater inclusivity and increased consideration of questions of cultural representation. Yet as positive as Bondil's intentions may be, their materialization has not been without missteps.

The opening of the Claire and Marc Bourgie Pavilion of Quebec and Canadian Art and the Bourgie concert hall in 2011, and the concomitant rehang of the Quebec and Canadian permanent collection, was the museum's first major expansion since the 1991 opening of the Pavilion Jean-Noël Desmarais.[57] It allowed for a significant overhaul of the installation of the permanent collection of Quebec and Canadian art, adding 20 per cent to the museum's exhibition space, with more than 2,000 square metres. The new installation significantly reoriented the permanent collection's narrative in two directions. First, it made Indigenous culture more prominent, most notably by the Inuit installation on the top floor, which in some ways reframed the Canadian installation as the art of settler culture. Second, it recentred the narrative with an emphasis on the significance and particular contributions of the city of Montreal. As Anne Whitelaw's analysis of the new pavilion notes, there has been a deliberate reorientation away from the Group of Seven narrative to a new emphasis on the Beaver Hall Group. However, the terms of inclusion are revealing: both the NGC and the AGO have reconfigured their collections and departments to give equal mention to "Canadian and Indigenous art," while the MMFA's collection and area titles – Quebec and Canadian – signifies different priorities. Indeed, the MMFA's collection is far stronger in pre-Columbian "art of the Americas" than in works from the areas now known as Quebec and Canada, and First Nations works remain a small part of the holdings. Regardless of departmental naming, the Bourgie pavilion significantly increased the presence of Indigenous art in the museum. Like with other major Canadian

institutions, Indigenous art was not a traditional collecting area for the MMFA; consequently, it made the decision to disrupt settler narratives in the historical galleries by including contemporary Indigenous art. The Founding Identities gallery, on "the dawn of Canadian art in New France" from the 1700s to the 1870s, opens with major works by contemporary Indigenous artists Nadia Myre and Kent Monkman as a means of unsettling colonialist narratives. The MMFA's collection of Indigenous art from Canada followed typical patterns of settler aesthetic taste: the earliest art to be appreciated was Northwest Coast art, followed by Inuit art.[58] That history of taste is underlined by the rest of the installations' emphasis on Montreal, since the Indigenous heritage of Montreal and surrounding regions is made invisible. In the end, however, and as Whitelaw points out, if the institution wants meaningful inclusion, it must begin collecting Indigenous art in depth.[59] As the museum website states: "Since it was founded in 1860, the Museum has built up an outstanding collection of Quebec and Canadian art comprising almost 3,000 works, including some 500 Inuit pieces and 180 Amerindian artifacts."[60] With this kind of disparity in the collection, equity in visibility in MMFA exhibitions remains elusive, as is also indicated by the record of solo shows, discussed earlier in this chapter.

Whitelaw's excellent analysis notes broader omissions in this rehang that seem related to the MMFA's ongoing systemic omission of non-male and non-white artists. She points out how male-centric the installation is, particularly in the gallery devoted to modernist art from the 1960s and 1970s: "Startling by their absence from this gallery are works by women artists such as Joyce Wieland (1930–1988), Betty Goodwin (1923–2008), and Françoise Sullivan (b. 1925) whose equally large-scaled paintings would have provided an important counterpoint to the canonical figures on display."[61] She goes on to note that "Artists of colour are represented to an even lesser degree."[62] Her conclusion is worth citing at length:

As the discussion of the representation of Indigenous artists, women artists, and artists of colour suggests, inclusion requires more than the addition of previously overlooked figures to an existing narrative of Canadian art history: it demands that we examine the foundations of that narrative and work to develop a new approach that can productively explore the wealth of objects of creative expression from across Canada's many

cultures. Indeed, it is imperative for museums as well as art historians to continue to reflect critically on the narratives that they construct.[63]

Fast on the heels of the opening of the Bourgie pavilion, in 2012 the Michel de la Chenelière International Atelier for Education and Art Therapy opened. It was billed as the largest art education facility in a museum in North America. In late 2017, the Michal and Renata Hornstein Pavilion for Peace (see figure 5.5) added a major collection of works by "old masters" and considerable exhibition space, which allowed for a planned rehang of the World Cultures collection that has been billed as "a large-scale project that celebrates diversity and fosters intercultural dialogue through art: the Stéphan Crétier and Stéphany Maillery Wing for World Cultures and Togetherness."[64] Both projects invoke similar language to emphasize what Bondil increasingly refers to as the museum's "humanist role" as a "socially engaged museum."

This new vision had been alluded to previously but was announced formally in 2016 and is detailed on their website. It explicitly states that the MMFA seeks to engage "immigrants, refugees, the underprivileged, the disabled, seniors and people at risk."[65] The reason for this vision, Bondil has said, is because "I am convinced that, in the twenty-first century, culture will be recognized as being as important for health as sport was in the twentieth century. I believe our innovative and multidisciplinary initiatives, supported by our numerous partnerships, anticipate humanity's future needs. I am certain that culture, in which museums play a vital role, has an overarching mission to respond to broad social issues – academic success, inclusion, diversity, the aging population – beyond 1% of the budget."[66]

The 2016–17 annual report makes this ambition clear. Diversity is highlighted in nearly every section, in what is a tacit expression both of what they know to be necessary and ethical, and what they want to achieve. Throughout the report in different ways, the museum emphasizes its "humanist and inclusive values."[67] Most indicative of the shift is the report from Thomas Bastien, director of education and wellness. His newly reconfigured position (formerly education and community programmes) highlights the museum's new emphasis on art as having beneficial health and wellness outcomes. His report describes a myriad of initiatives from free access to underserved communities to an art therapy advisory committee to partnerships with

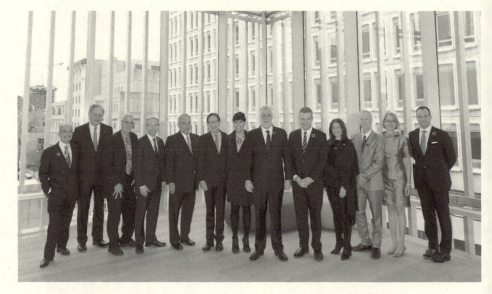

5.5 MMFA inauguration of the Michal and Renata Hornstein Pavilion for Peace, 2016. Photo Pierre Longtin.

hospitals and health researchers; he gives evidence of how programming can support girls, Indigenous women, and interculturalism, including immigrant communities, LGBTQ communities, and the African-Canadian community. A section devoted to "Interculturalism and Diversity" explains that the museum is "embarking on more collaborative projects with community organizations to make interculturalism and diversity the third pillar in the Museum's mission."[68] Bastien gives examples: for International Human Rights Day, the museum partnered with the Michaëlle Jean Foundation on a conference to combat "the social exclusion that is often at the source of violence and extremism." For the fifth year, the museum hosted Encounters with Diversity, which

> brought together more than 150 representatives from the arts, culture and education to explore the theme "Des cultures autochthones aux expressions métissées : notre culture en mouvement" [From Indigenous Cultures to Hybrid Expressions: Our Culture in Motion (my translation)]. It offered a platform for 40 artists and creators – 15 from Indigenous cultures – who have chosen to express themselves using emerging practices or whose creativity

is combined with influences from around the world. In seven multidisciplinary workshops, they discussed concrete ways to make this creative diversity one of the drivers of Quebec's evolving culture.[69]

The English version of the annual report does not translate the symposium's theme and I do so with caution. But the phrases "from Indigenous cultures" (des cultures autochthones) and "to hybrid expressions" (aux expression métissées) raise serious issues. They seem imply an inevitable loss of Indigenous culture and celebrate cultural mixing in ways that do not take into account Indigenous sovereignty and cultural autonomy. Despite how carefully the museum protects the distinct identity of Quebec, for example in the department name "Quebec and Canadian art," it does not seem that the same care is extended to protecting Indigenous nations as distinct, with sovereign rights, that might not celebrate such a shift.

The Education and Wellness department was the first place in which the more inclusive mission was highly visible. When I first wrote this chapter, the 2016–17 annual report was the latest available, so I concluded my statistical data there. Since that report, other initiatives at the MMFA have begun to signal a truly significant shift in practice. One important locus since 2015 has been through the Montreal Museum of Fine Arts Foundation, the fundraising arm of the museum. In conjunction with the important historical exhibition *1920s Modernism in Montreal: The Beaver Hall Group*, the Museum Foundation and several female board members, led by financial manager Françoise E. Lyon, launched a "Women of Influence Circle." Drawing parallels between the pioneering professional female artists of the Beaver Hall Group and the museum's new patrons, the promotional materials explain that the patronage group formed to address the gender gap. [70] The Women of Influence group "supports the presence of women at the Museum through the acquisition of works by women artists, exhibitions devoted to women artists, and access to the Museum for disadvantaged women." In the brief time of their existence, this group has already made a substantial impact on the museum's exhibitions. Their contributions have supported successive curators of contemporary Quebec and Canadian art to initiate multiple exhibitions of women artists, including a new series of exhibitions of works by contemporary Indigenous women, exhibitions that themselves are facilitated by concomitant changes to the curatorial staff.

Shortly after long-time curator of contemporary art Stéphane Aquin's 1998 arrival at the MMFA, he curated exceptional shows by female artists Pipilotti Rist (2000) and Geneviève Cadieux (2000). Since those blockbusters, however, the statistics above suggest that there has been little support for solo shows of female artists and artists of colour in the contemporary areas of the museum. His departure in 2014 to become chief curator at the Hirshhorn Museum in Washington, DC, came fast on the heels of the creation of a new curatorial position in contemporary Quebec and Canadian art from 1945.[71]

Marie-Ève Beaupré, who had strong ties to the local art scene, assumed the Quebec and Canadian position, and in no short order curated *Her Story Today: Six Painters from Quebec and Canada* (which opened October 2015). The show was supported by the Women of Influence Circle and designed to complement the Beaver Hall Group show. Museum didactics explained that this exhibition of six contemporary (all white) female Quebec and Canadian artists asked, "Nearly one hundred years after the existence of the Beaver Hall Group (1920–1923) … where do woman artists working with the paint medium stand today?"[72] Fall 2015 was thus a significant moment for women artists at the MMFA, with a historical show that looked at a famously gender-equitable Montreal painting group and a contemporary group show that addressed gender. Despite this promising start, Beaupré would not stay long; she took up a position at the MACM in less than two years. However, the museum would repeat this strategy of pairing major exhibitions with complementary, often smaller shows that are positioned as a counterbalance to the main show. While in this first iteration, the juxtaposition was enlightening, in later formulations, the result can be seen as sustaining a centre/periphery dynamic, as we will see below.

The major 2016 Mapplethorpe exhibition was an ambitious coproduction by the Los Angeles County Museum of Art, the J. Paul Getty Museum, the Robert Mapplethorpe Foundation, and the MMFA. With a beautiful catalogue and taking up significant real estate, it was widely reviewed and attracted a sizable audience. It was paired with two complementary exhibitions. The most direct pairing was *Être/Aimer – Be/Loved*, which was billed as "works from the Museum's collection with the words of members of the LGBTQ community and allies," exhibited in a perspective that is "always inclusive" and "invites visitors … to reflect on people's common need, regardless of their

origins, sexual orientation or gender identity, to love and be loved."[73] Activities for World AIDS Day were also linked to these shows; however no significant record of the second show remains.

The other linked exhibition was *She Photographs: A Feminine View of Photography – MMFA Acquisitions and Collections*, curated by Diane Charbonneau, curator of modern and contemporary decorative arts, and supported by the Women of Influence Circle. The group show included thirty female photographers highlighting a broad overview of contemporary practice. It was an impressive exhibition with some stunning pieces such as Janieta Eyre's *The Sisters Sophie and Sarah* (from the series *Motherhood*, 2001). Like the *Be/Loved* exhibition, however, little record of the exhibition survives. Neither of these smaller counterpoint exhibitions was reviewed in the major Canadian art press, indicative of some of the limits of the strategy.

The following year, 2017, would see the MMFA again position a smaller complementary show in relation to a major multidisciplinary exhibition, *Once Upon a Time ... The Western: A New Frontier in Art and Film*. This large exhibition reassessed the Western film genre by contextualizing it in relation to other kinds of visual representations of the West. The show sought to deconstruct the genre and made frequent mention of the sexism and racism inherent in myths of the cowboy and the settlement of the West. It was the first major exhibition of the new curator of international modern art, Mary-Dailey Desmarais, produced in partnership with the Denver Art Museum.[74] Like the Beaver Hall and Mapplethorpe shows, this mainstage exhibition also had a hefty catalogue and was widely reviewed. Indicative of an awareness of the necessity of Indigenous representation at the planning stages of exhibitions, the production had a scholarly advisory committee that included Indigenous scholar and curator Gerald McMaster, among others; moreover, works by Indigenous artists – both historical and contemporary – spoke to the myth of the cowboy from Indigenous perspectives. Such consultation and representation indicate sincere efforts to improve inclusivity at the museum, and have long been the practice at many institutions when more voices are needed at the table.

This principal fall show was complemented by a new series billed as "a season at the Museum, devoted to female Indigenous artists." The clunky title of the series – *Woman. Artist. Indigenous.* – makes the categories of inclusion clear. The series was again supported by the Women of Influence Circle as well as a new endowed curatorial

position, the Gail and Stephen A. Jarislowsky curator of Quebec and
Canadian contemporary art, held by Geneviève Goyer-Ouimette.
Goyer-Ouimette's track record as director of the respected artist-run
centre CIRCA Art Actuel in Montreal allowed her to hit the ground
running in this new position. Collectively, the *Woman. Artist.
Indigenous.* events were described as "a powerful and poignant bal-
ance to the museum's feature exhibit *Once Upon a Time ... The
Western.*"[75] Goyer-Ouimette clearly explained their necessity: "At the
end of the [*Once Upon a Time ... The Western*] show, you have a lot
of artwork that is a critique of the western genre, and a lot of them
are created by Indigenous people, but it's still very male ... So the
museum created another response, a critical response in a way, with
a series – *Artist. Woman. Indigenous.* – three exhibitions and two
acquisitions."[76] Two of the events were curated by Goyer-Ouimette:
the immersive installation *Kushapetshekan/Kosapitcikan: A Glimpse
into the Other World* by Atikamekw artists Eruoma Awashish and
Meky Ottawa, and Innu artist Jani Bellefleur-Kaltush; as well as the
solo exhibition of Algonquin artist Nadia Myre's show *Tout ce Qui
Reste – Scattered Remains.* The third show, *In-Between Worlds,* was
an exhibition of photographs by Meryl McMaster, a member of
the Siksika Nation and of Euro-Canadian descent, curated by
Charbonneau. It was singled out as "a relief from all the overpower-
ing masculine energy that enveloped me in the exhibit [*Once Upon
a Time ... The Western*]."[77] While I am relieved to see the institution
supporting Indigenous and female artists with solo shows, I am wary
that to date these have been on a smaller scale. Moreover, I wonder
whether juxtaposing major and minor shows reinforces a subordinate
position for the smaller exhibitions.

It is important to applaud the MMFA's attempts to redress a gen-
dered, colonialist history, late as they are; but I think we should also
call the institution to the highest standards of practice. Another recent
incident adds to my concern that the changes do not yet reflect sig-
nificant staffing or structural changes, which I see as the hallmark of
real change. In the summer preceding the fall/winter "season devoted
to Indigenous women artists," the museum displayed an exhibition
of bridal attire by Gaultier called *Love Is Love: Wedding Bliss for All
à la Jean Paul Gaultier – Haute Couture and Prêt-à-porter Creations.*
It re-exhibited works that had been shown without incident in MMFA's
massively successful 2011 Gaultier retrospective. Now, however, it
reframed them in a "celebration of marriage and love [that] brings

together heterosexual, homosexual, intercultural and interracial couples in diversity and peace ... to promote the acceptance of diversity and to continue the fight against homophobia."[78] The show's promotional materials championed Gaultier as "a defender of diversity" who challenges "stereotypes and dress codes with humour."[79] The exhibition itself is a "festive installation bearing a humanist and pacifist message."[80]

One of the ensembles included a headpiece that was a loose reinterpretation of, or reference to, an Indigenous Plains headdress. It had been exhibited in 2011 without controversy.[81] In the spring of 2017, with the increased awareness of the need for reconciliation brought about by the Truth and Reconciliation Commission (TRC), and the heightened awareness of Indigenous rights around Canada's sesquicentennial, Indigenous artists and curators felt empowered to speak up. As it was reported in the *Globe and Mail*: "'My God, it never ends,' said Métis artist Christi Belcourt, after seeing a photo of the gown. 'We may as well call #Canada150 the Year of Appropriation.' ... 'Why would any major art exhibition taking place [in Montreal] make a mockery of Indigenous rights by representing European representations of Indigenous peoples?' said Clayton Windatt, executive director of the Aboriginal Curatorial Collective."[82]

In its response, the museum asserted, as museums tend to do when their decisions are called out as insulting or inappropriate, the values of free speech and artistic freedom.[83] Bondil rejected the complaints outright, insisting that such appropriations were "a clear and well-known homage to interculturalism," that was "a visionary tribute made by the couturier to togetherness and world cultures." She rejected the idea that Gaultier's work was inappropriate because of its cultural appropriation, because his work "'is openly based on *métissage* [hybridization].' To have kept his headdress gown out of the show this time would have been 'artistic censorship,' she said."[84]

The controversy did not end there. Several months later, in September, the museum staged a mock wedding between Gaultier and artist Kent Monkman, in his persona Miss Chief Eagle Testickle, wearing the headdress in question.[85] The idea for the event was Bondil's, who explained, again citing her vision of a humanist museum: "I had this idea because I thought it was the right thing to do ... Beyond the controversy, beyond the issues, beyond divisions, great artists dialogue together, and they create kind-of artistic islands, an aesthetic union in order to fight together for the

same great values they want to defend; and this is really the sense of this performance."[86]

The problem with such "humanist values" is that they rely on an idea of individual relations that are empathetic, but they do not take account of systemic differences in power and access that make such lofty goals impossible. What about cultures that do not believe in the values of *métissage*? What about cultures that reject the idea of another culture's right to freely borrow from theirs, and make it their own? The universalizing goals of a humanist museum do not recognize that such ideas of individual artistic freedom are based on Western ideas of individual rights, including copyright, rather than a more collective sense of cultural ownership often found in Indigenous cultures. To assert as universal the value of *métissage* ignores several decades of scholarship and activism around the perils of appropriation. To add insult to injury, the museum claims to do so in the guise of tolerance, inclusivity, and universal love.

Bondil's heavy-handed response relates, I would argue, to another central issue: the museum staff is overwhelmingly white. Moreover, the institution has not created positions that are empowered to curate greater diversity. Indeed, the departments seem to be in the process of being reconfigured into a department of world cultures and Mediterranean archaeology, which groups together art of the Americas, Asian art, African art, and Islamic art. There continues to be no curatorial position in contemporary Indigenous art, and the arts of the Americas section is overseen by a curator of pre-Columbian art, with a collection that largely comes from the lands now known as Latin America (terminology the museum still uses). Together, these concerns – around the idea of *métissage* in the conference, around positioning the gallery's first solo female Indigenous shows in relation to a story about the Western film genre, and around defending cultural appropriation as a celebration of interculturalism – add up to a set of positions that make me profoundly wary of this new vision for the museum. While on the one hand I do believe that the addition of works from groups that have not been traditionally well represented in the museum is, in the end, transformative, I fear what seems to be an undercutting of the transformative potential. I do not doubt the sincerity of Bondil's vision and intentions; what I doubt is the ability of a privileged white woman to make the right calls in tough situations without a diversity of voices around the table who have been empowered to dissent.

These misgivings were amplified by the 2018 exhibition *Here We Are Here: Black Canadian Contemporary Art*. It indicated again the MMFA's desire to create programming that connected with previously underserved communities, but which once again missed the mark. The Montreal iteration of the show took place in a very different context than when the same exhibition showed at the Royal Ontario Museum (ROM).

In Toronto, the exhibition was a culmination of a series of projects undertaken since 2013 that worked at repairing relations between the ROM and Toronto's black community, strained since the *Into the Heart of Africa* debacle in 1989.[87] That exhibition displayed objects collected from Africa primarily by colonial missionaries; regardless of curatorial intentions, it was received by black communities as racist, and supporting negative stereotypes about Africans. The ROM's reparative initiatives were grouped under the name *Of Africa*, a project initiated by then-independent curators Julie Crooks and Dominique Fontaine. Working with ROM curator of African arts and cultures, Silvia Forni, they programmed an impressive series of events that promoted greater knowledge of African and diasporic art and culture.[88] Through symposia, exhibitions, guest speakers, and other initiatives, the museum did not try to suppress or deny the ROM's history. Finally, in November 2016, more than twenty-five years after the debacle, the museum officially apologized. It acknowledged that *Into the Heart of Africa* had "perpetuated an atmosphere of racism and the effect of the exhibition itself was racist."[89] The Coalition for Truth About Africa, a group that had protested the 1989 exhibition, accepted the apology.[90] Moreover, the museum recognized that the apology was only a part of a reconciliation process that must include significant action, including for example, internships for black youth and other community partnerships. Reviews of the exhibition were overwhelmingly positive; critic Kelsey Adams concluded that the exhibition critiqued "the way in which Black Canadians are constantly positioned as immigrants or newcomers; this is a commonplace assumption based on a legislated multiculturalism that maintains the perception of this population as 'other' by actively contributing to the erasure of Canada's Black history. The curators successfully expand a conversation about whose work is considered naturally 'Canadian' and whose work belongs in spaces like Canada's art and history institutions."[91]

In Montreal, the exhibition must be read differently. Here, the exhibition did not come with the years of prior community work or

from years of curatorial initiatives working with black communities in the city. The specific context of the ROM made such reparations necessary. However, the less blatant record of promoting racism in most other galleries in Canada, including the MMFA, remained unremarked on and, consequently, unrepaired. The exhibition title resonates slightly differently in French than English: I would translate *Nous sommes ici, d'ici* as *We are here, from here.* The French version more directly points to one of the frequent suppositions critiqued in the exhibition: that black Canadians are likely "new to Canada." The Montreal version supplemented the original show with three additional artists. However, this is not the most meaningful difference.

Most significant and most problematic is how this exhibition of black contemporary Canadian art was paired with *From Africa to the Americas: Face-to-Face Picasso, Past and Present,* once again reprising the blockbuster/complementary show paradigm.[92] Together, the exhibitions were described as a "prelude" to the "new wing dedicated to 'World Cultures and Togetherness,'" which opened in 2018 and promised "encounters that narrate the evolution of attitudes and of art history."[93] The Picasso exhibition purported to look

at the transformation in our view of the arts of Africa, Oceania and the Americas from the end of the 19th century to the present day. Following milestones in the life of Pablo Picasso (1881–1973) and in history, the exhibition explores the close relationship between the Spanish master and these arts, focusing on the history of attitudes. Throughout the show, works by contemporary artists of African descent provide a counterpoint, increasing the points of view on the international history of art that requires rethinking.[94]

This discursive framing of the exhibition reprises language that has been critiqued as primitivizing since the 1980s. The use of the term "our view" is unproblematized, and while possibly meant as an inclusive term, can too easily slip into one that presupposes a white, Western point of view. This nagging suspicion is strengthened as the museum website cites Bondil as explaining:

This project appealed to me since it enabled us to tell the story of the decolonization of the gaze over a century, that of Picasso: He was born in 1881, a year before the opening of the Musée

d'Ethnographie du Trocadéro and four years before Africa was divided among the European colonial powers in Berlin in 1885. He died in 1973, before the last African decolonization, Angola in 1975. This century plays out here like a book in which the emancipation of an entire continent recounts the emancipation of the gaze, of appropriation to re-appropriation.

How have ethnographic objects come to be viewed as art? How can a Picasso and an anonymous mask be exhibited in the same plane? What were the stages in this "decolonization of the gaze" from the last century to the present day? In Montreal, the exhibition tells the story of "the museum of the Other," from the legacy of a colonial world to its current redefinition as a globalized one. Taking a cross-cultural approach, we invited contemporary artists from Africa or of African descent into this narrative. Cultural Eurocentrism must be reviewed in a history of art yet to be reinvented: the borders that used to mark the accounts of modernism are now blurred.[95]

The wording merits analysis. The premise of the exhibition, the gallery tells us, is the "decolonization of the gaze over a century, that of Picasso." Describing the history of the "emancipation" of Africa in the twentieth century as the century of Picasso bizarrely frames it in personal terms that belie the history of power that is central to the colonialist project, to situate it instead within the confines of the life of the "master," who is, not coincidentally, the only named artist in the description. Next, the question "How have ethnographic objects come to be viewed as art?" does not deconstruct the terms, but leaves intact the fundamental distinction, the fundamental hierarchy, without raising any questions about the power of the categorizer or the history of the museum's complicity in colonialist projects. It goes on to suggest that the legacy of colonialism is a thing of the past in the newly globalized world. It ends by calling for a critique of Eurocentrism, as if that has not been integral to any study of Picasso and modernism since the Museum of Modern Art's widely criticized – and arguably discipline transforming – 1984 exhibition *"Primitivism" and 20th Century Art: Affinity of the Tribal and the Modern*. Although the terminology needs to be updated, Thomas McEvilley's critique of that show continues to ring true: "My real concern is that this exhibition shows Western egotism still as unbridled as in the centuries of colonialism and souvenirism. The Museum pretends to confront the

Third World while really coopting it and using it to consolidate Western notions of quality and feelings of superiority."[96]

The pairing of the Picasso show and the exhibition of contemporary black Canadian art, we are told, "invites visitors to reflect on the issues raised by the 'decolonization of the colonial gaze' and perceptions of identity, aesthetics and culture through two exhibitions."[97] For me, it re-situates the contemporary artists in a history that marks them as other, as gaining meaning through their unexplained relation to Picasso, perhaps even ahistorically absorbing them into Picasso's source material. Nevertheless, the presence of the contemporary work is significant; as Bondil says "each artist asserts their rightful place."[98] Many accounts of the exhibition note Michèle Pearson Clarke's *Suck Teeth Compositions (After Rashaad Newsome)* (see figure 5.6).[99] This video installation shows a series of black Canadians, each sharply inhaling through closed teeth in what the artist describes as a widely practiced black verbal gesture that "is used to signify a wide range of negative affects, including irritation, disapproval, disgust, disrespect, anger and frustration."[100] For me this work captures the importance of representation, even when partial and problematic. It has the power to disrupt the museum's narrative power: it talks back.

All of this leaves me slightly uncomfortable. On the one hand, it is clear that the institution is trying to improve its record of representation, and I want to acknowledge and support that. On the other hand, it also seems clear that with an unrelentingly white curatorial team, its efforts are mired in the kinds of thinking that have marked and marred museum practices for a long time. These problems are also revealed in the uncritical embrace of the "humanist endeavour." Critiques of humanism as a universalizing theory that was used to justify colonialism and France's "civilizing mission" date back to debates between Althusser and Sartre in the 1950s.[101] Nowhere have I seen Bondil or the institution give the term the required nuance, and I have come to see the term as central to the concerns of this inquiry in many ways. At its heart, the philosophy is universalizing and posits that we must each recognize our shared humanity; more than that, it suggests that recognizing our common humanity is the start of an effective solution to rectifying histories of colonialism, racism, and patriarchy. Too often that recognition of the full equality of all people has only been assumed for white men and meted out parsimoniously to women and artists of colour. My critique of humanism lies in its

5.6 Michèle Pearson Clarke, *Suck Teeth Compositions (After Rashaad Newsome)*, 2018. Digital video still. Image courtesy of the artist.

reliance on the individual and its concomitant denial of and refusal to address structural problems. To imply that we are all past those problems, without some serious redistributive justice, does not redress the issue. It entrenches it.

As one last example of the gulf between the rhetoric and reality at the MMFA, consider the Pavilion of Peace contemporary art installations in the recently opened Michal and Renata Hornstein Pavilion for Peace. Each level of the pavilion has a work by a contemporary Quebec artist. Although these may change over time, in its first iteration, it included works by Patrick Beaulieu, Mathieu Beauséjour, Patrick Coutu, Antony Gormley, Jean-Michel Othoniel, Roberto Pelegrinuzzi, Yannick Pouliot, Barbara Steinman, Martha Townsend, and the collectives EN MASSE and MU. This collection of seven male and two female white artists does not bring me peace; it brings me frustration and anger at what I see as ongoing systemic bias and partial, problematic inclusion. While the MMFA has clearly made a serious effort since 2015 towards more inclusive programming, there remains much work to be done.

CONCLUSION

This chapter begins with an epigraph from a 2017 interview in which Bondil was questioned about the Association of Art Museum Directors' (AAMD) report "The Gender Gap in Art Museum Directorships."[102] Bondil was "not all that interested in the 'woman question' ... [but was] finally induced ... to reveal her success formula – 'determination, passion, work, and not being intimidated ... I'm a workaholic. This is not a secret.'" Whatever else, the comment reveals the optimistic view that gender is no longer an issue or is one that can be overcome by hard work. This view is not borne out by the analysis of solo exhibitions at the MACM or at the MMFA, or at many other large institutions, which still exhibit far more white men than artists of colour and female artists.

6

Conclusion: Calls to Action

The "machineries" and regimes of representation in a culture play a constitutive, and not merely a reflexive, after-the-event role.

Stuart Hall[1]

Justice today requires both redistribution and recognition; neither alone is sufficient.

Nancy Fraser[2]

The histories created by our public art institutions feed the narratives that become our shared histories. What these institutions exhibit matters because it creates public culture and the historical record. While I would like it to be true that the diversity of institutions representing the breadth of communities across the country represented the diversity of our population, this is simply inaccurate. While I would like it to be true that curators and directors choose the best art, which is naturally representative of the best of our population, this is simply incorrect. While I would like it to be true that we are past mere counting because we now consider more complex issues of representation that numbers cannot get at, this is simply not the case. The numbers make clear that at many institutions, we are not even close to equity; that at some institutions, we are getting further from gender equity than in the past; and that too often our most prestigious institutions tell a story that is far too white and too male. Moreover, I want to suggest that when we accept that our institutions merely "choose the best art," yet the result is disproportionately white and male, we accept the myth of aesthetic neutrality, with all its resulting myths: that art and art museums rely on good taste, which is seen

as natural but in reality is the product of culture and capital, "[rein-forcing] for some the feeling of belonging and for others the feeling of exclusion"[3] – a myth that has long been used to deflect and mini-mize criticism about art museums as structures of power that serve the status quo, that disguise the nature of their power in the guise of taste, and that refuse to face how gendered and racialized hier-archies are built into taste, as well as their own "complicity in cen-tering whiteness."[4]

Over the course of writing this book, the cultural landscape has continued to change and there are indications of what look to be substantive positive developments. Most notable has been the struc-tural commitments to improving representation of Indigenous art at the NGC, the AGO, and the WAG. Indeed, the recommendations of the TRC, which published its *Calls to Action* in 2015, seem to be having significant effects in a wide range of sectors across the country.[5] Some of the calls to action make specific recommendations around arts and culture; for example, number 79 calls on "the federal govern-ment, in collaboration with Survivors, Aboriginal organizations, and the arts community, to develop a reconciliation framework for Canadian heritage and commemoration."[6] *Resilience*, an exhibition of 167 billboards by fifty Indigenous women artists, curated by Lee-Ann Martin and facilitated by the Winnipeg artist-run centre Mentoring Artists for Women's Art (MAWA), directly cites the TRC in its announcement. The NGC's corporate plan for 2017–18 to 2021–22 similarly cites this call in the TRC and notes various ways it is working to support the call, noting a new Indigenous education pos-ition and announcing as an ongoing series its second Indigenous quinquennial, to occur in 2019, presumably after the *Sakahàn* exhibit.[7] The AGO's ongoing changes to the ways in which it organizes Indigenous and Canadian art also seem promising. The WAG's planned Inuit Art Centre might be representative of a way forward: early in the planning process, the gallery formed an Indigenous advisory circle, headed by Julie Nagam and Heather Igloliorte and with majority Inuit representatives that will include up to twenty-four representa-tives from across the North: "Their new role in the WAG is in many ways historic – a groundbreaking effort to 'decolonize' a century-old gallery that has for decades held a special place for Indigenous and Inuit art. Now, however, the goal of the advisory circle is to shape just how that art is curated, interpreted and presented from the inside.

From the beginning."[8] The sense that these new initiatives really do represent a sea change gives me much hope; however the numbers I have found in the rest of this study make me cautious. I would not have predicted in the 1990s that the increase in female artists with solo shows at the National Gallery might be a blip that would decrease in the subsequent decades; I would not have believed it to be possible. But that has happened at some institutions. Too often, inclusion turns out to be episodic or issue-based, rather than the effects of real changes to structures and mind-sets. The hegemonic effects of patriarchy are resilient, which means we must take care to guard against backsliding.

In the previous five chapters, I have looked at data from over 5,000 exhibitions in Canada. Although I was initially motivated by the lack of serious consideration of the ongoing gender equity problem in exhibitions of contemporary art, the study became a much broader inquiry into diversity and representation issues in contemporary art more generally. It began as a record of the state of affairs; yet in revealing how far short of equitable many galleries continue to be, this study must also be a call to action. In the process of this study, I have tried to strike a balance between looking at institutions and at individuals, and I hope change will come from both. I hope the research will stimulate institutions to tackle these issues head on by making structural changes that will redress these issues. I recognize, however, that some institutions will continue to resist implementing more just structures and policies. Consequently, I hope that the professionals working within the institutions will consider where and how they could be more equitable and inclusive in their programming. Even more than this, I hope the data will also be a call to the Canadian art world – the artists, the scholars, the board members, and the audiences – to demand more of those same galleries, to call them to account, to expect better representation, and to support it when we find it. It is also a call to museum studies scholars to reconsider the value of statistical data for analyzing institutions in a multitude of ways. I see this book as a starting point, and its flaws point to where there is more work to be done: data about how sexual identity relates to other categories of exclusion have yet to be considered, consideration of how racial or ethnic diversity within institutions relates to institutional practices needs to become far more nuanced and it needs to take into account a much broader range of institutions than I have

been able to manage, and work on artists with disabilities must be done. Yet despite its many omissions and oversights, there is still much to be gleaned from this starting point:

- Despite the significant numbers of artists who are racialized or gendered female, or both, many of the most significant Canadian art institutions exhibit far fewer women and people of colour than are found in the population. Collecting institutions and larger institutions tend to have worse records on diversity than artist-run centres (ARCS).
- We cannot assume that inequities will just wither away over time:
 - At least two examples indicate to me that the common assumption that institutions will just gradually get more equitable over time is false. First, the data clearly shows that the percentage of female solo shows at the NGC went down significantly from the 1990s to the 2000s. This suggests that complacency breeds backsliding. Less definitive, but potentially more worrisome, is the fact that the percentage of female artists in an NGC touring exhibition in 1925 was higher than the gallery's NGC@ series in the 2010s. This trend of gains followed by losses for women's equity is consistent with data from other areas. It fits with the idea that feminism had achieved what it set out to do and that gender inequity was a problem we had taken care of. I encountered that explicit sentiment from many administrators: for example, one curator discussing personnel cutbacks at various institutions and their sense that all curators were spread too thinly concluded, "We have bigger problems than gender to think about." Another stated, unequivocally but off the record, that race was a much more pressing concern than gender in contemporary thinking about diversity, adding that while questions of diversity and representation played into institutional thinking at some stages, as a curator visiting artists across the country, in the end it was purely about the work.
- Hiring a woman or an Indigenous person (or someone from any other identity category) will not, in and of itself, magically fix an institution's exhibition record on diversity:
 - While the data on the identity of curators and the shows they curate has proven difficult to collect on a large scale, the preliminary data suggests that simply hiring a curator who fills a particular identity niche will not necessarily lead to more

exhibitions of that type. There is strong evidence that many female curators do not curate equitably with respect to gender for a variety of reasons. Indeed, curators who are of a specific identity but not explicitly empowered to strengthen their institution's record in that area may feel particularly unable to do so, for fear of being perceived as being biased.

- Hiring someone for their expertise and interest in a particular area, for example feminist or First Nations art, and empowering them through structural changes to curate in that area is more likely to lead to better representation in the exhibits themselves.
- Museum workers and others are wary of collecting diversity numbers, with some reason, but without them, business as usual is all too likely.
- The strong presence of female artists in the exhibits at ARCs and smaller institutions suggests that artistic quality is not the only factor in the selection processes of those institutions that fall short of equity.
- Periodic changes in what counts as "art" – for example, the accession of decorative silver to the NGC or the accession of a collection of model ships to the AGO – are often indicative of the patriarchy behind the taxonomy: if for too long the work of women and non-Europeans was excluded from art galleries on the basis of a classification system that separated "fine art" from other forms of production such as craft, the later inclusion of this type of work reveals how malleable these categories are. That other forms of production, such as quilts or beadwork, continue to be excluded is telling about the values that lurk behind the purportedly objective categorization. Craft or design by white men is acceptable, especially if it is backed by significant financial value; so-called craft by women or by racialized minorities has not yet been accepted to the same degree. If the category of art is malleable enough to include silver and model ships, surely it is also malleable enough to include quilts and beadwork.
- There is little oversight in most institutions or from funding bodies that considers the burden of representing the diversity of the communities in which galleries are located. Incentive programs to increase diversity can be problematic because they can lead to ad hoc or token commitments. One alternative is patron or donor-led initiatives, which are at least as problematic; another is an engaged, demanding audience.

Once we accept that the category of fine art has a built-in bias that is both gendered and racialized, we need to begin to combat it. One of the least radical ways of making change is by looking at best practices around reducing unconscious bias. Many studies have shown that people, including women and feminists, exhibit significant gender and racial bias in selecting job applications.[9] A much-cited study showed that, when given fictional applications that were identical other than an altered name and gender, university science professors held a significant bias in favour of a male student's CV compared to an identical female student's CV. The male student was "more likely to be hired and offered mentoring, was rated as more competent, and was offered a higher salary than the female student with the identical credentials. This bias was independent of the faculty member's gender, scientific discipline, age, and tenure status."[10] This is only one of literally hundreds of studies confirming such a bias towards the dominant gender in a given occupational field. Similar studies with respect to "black-sounding names" suggest that race remains a formidable category by which people unconsciously discriminate: one key study found that "White names receive 50 percent more callbacks for interviews."[11] We may want to believe that in the art world we are less biased than the general population, but there is evidence that gender bias affects how we perceive works of art as well. A well-studied example takes place in the more closely related area of symphony orchestras. Plagued by a lack of female artists, many orchestras moved to "blind" auditions, and, as Claudia Goldin and Cecilia Rouse have detailed, this shift accounted for much of the increase in female hires in the 1990s.[12] Indeed, there is strong evidence that fields such as art that rely less on quantifiable factors may be more biased: one large-scale study "found that women and African Americans are significantly underrepresented in academic fields that are culturally understood to require 'brilliance' or 'raw talent.'"[13] Compound this with the bias that leads to fewer quantifiable outputs (for example, articles by female academics tend to receive fewer citations, and female academics tend to cite themselves less) and the disadvantage to female and visible minority artists is clear. The scientific evidence is unambiguous: unconscious bias permeates our decision making and it favours the dominant group, which in the case of art is white men; moreover, the perception of genius as male combined with a lack of quantifiable markers for it, multiply to disadvantage non-dominant identities in the art world.

Even more alarming, Eric Luis Uhlmann and Geoffrey L. Cohen have studied peoples' belief in their ability to be objective, and found that the more someone believes that they are objective and free of bias, the more biased their selections may be.[14] They have also examined how hiring criteria can be altered to favour the dominant group. They give the example of job interviews for the position of police chief, where if a male candidate has no formal education, the value of formal education is downplayed, but no such adjustments are made to favour female candidates. This example really struck home for me when I heard a female commercial art dealer praising the self-confidence of a young male artist as something that made her feel he was worthy of her support; in the pool of artists, which was mostly female, it seemed clear that although he was the most confident, he was not the most productive. From my perspective, he seemed the least serious and hard working, and the dealer seemed to be valuing a criterion unrelated to the strength of the art that is also highly gendered. There are many other such factors at play. Uhlmann and Cohen report, however, that such bias can be reduced by a variety of strategies.

In the art world, and especially in the curatorial field, the discussion around combatting unconscious bias remains at a preliminary stage. Yet certain professions, such as those in law and education, have been working at combatting implicit bias for more than a decade now. Research from these areas makes it clear that there are things we can do to reduce our implicit bias. The first thing is to recognize its existence, and to educate those in decision-making roles about its manifestations and the means of combatting it. This requires a two-pronged approach, both institutional and individual. Given that people are generally unaware of their own unconscious and discriminatory biases, institutions need to develop policies and structures that correct for it and seek to combat it. Although institutions can create policies to minimize bias, one of the most important things institutions can do is ensure that people are made aware of the research on unconscious bias. On a personal level, this means that we need to recognize that our stated beliefs often do not mirror our subconscious beliefs. *Project Implicit* is a large-scale ongoing study based out of Harvard University that allows people to test their implicit biases in a variety of ways (age, race, gender, sexuality).[15] We also need to become aware of the compounding effects of such biases. If women and minority candidates face an initial bias against them, their level of success cannot be judged as equivalent to that of other groups.

One of the best ways to combat various forms of discrimination is through an awareness of the hard numbers. I believe that equity numbers are something that people at every level of the art world need to remain aware of, through an ongoing process, otherwise we risk the backsliding we saw in the 2000s, when the assumption that we had reached gender equity led to a regression in that domain. As I conducted this research, I became increasingly aware of the lack of representation of virtually all visible minorities in Canadian galleries. Yet most institutions do not collect or analyze these numbers, and they are often quite unaware of their own records.

One of the reasons people are often resistant to statistics such as those collected in this book is that they fear mandated quota systems, but of course those are not the only possible outcome. The case for any kind of oversight around diversity is controversial in every field, but to many I spoke to, this seems unimaginable in the case of art. The example of combatting implicit bias in music auditions by making them truly blind does not have an obvious parallel in the art world. It just does not work that way. Curators know the artists they are exhibiting, so it can never be blind; moreover, they are often selecting work that has not been made yet, based on a record of experience.

Governmental funding bodies may influence collections and exhibitions by supporting diverse programs, which is not the same as mandated quota systems. As Andrea Fatona has shown, the work of the Canada Council for the Arts to increase the participation of visible minorities in arts groups in the 1990s made positive gains but was subject to the vagaries of changing personnel, and over the course of the 1990s the anti-racist work of the advisory committees was watered down in order to embrace a folksy cultural pluralism.[16] Yet late in 2016, Simon Brault, the director of the Canada Council, announced changes to the funding model meant to address systemic racism within the arts. This brought the promise of increased funds allocated to non-core programs, theoretically more accessible to first-time applicants, targeting programs for increased Indigenous arts. I wonder though if it is worth considering how this is playing out in a similar approach in the academic field: the Canada Research Chair (CRC) program. The CRC program, which runs across the institutional divides of the sciences and humanities, is a federal government program instituted in 2000 to promote research excellence at Canada's postsecondary institutions. Despite a commitment to diversity and the

recognition that "achieving a more equitable, diverse and inclusive Canadian research enterprise is essential to creating the excellent, innovative and impactful research necessary to seize opportunities and for responding to global challenges," the program continues to fail to reach equity targets. In 2017, Minister of Science Kirsty Duncan announced that changes to the CRC program may require institutions to submit diversity and equity plans.[17] While such government-mandated support is important, and sends a clear message, as Fatona has shown, it does not necessarily continue past the date of the specific funding; to last, change must be more fundamental. Nevertheless, the CRC funding offers a kind of cautionary tale: if institutions do not make the changes internally, they may be pushed into it.

Institutions in other countries have taken different paths. In the United States, specialized institutions have developed to tell the histories of groups that have been marginalized in older, more "traditional" institutions. The National Museum of Women in the Arts, the National Museum of the American Indian, and, the most recent arrival, the National Museum of African American History and Culture, provide examples of different routes through this difficult terrain. There are many advantages to specialized institutions – not least that they can do sustained rigorous work that is not being done by other museums. There are also drawbacks, such as ongoing exclusion from what too often is viewed as "regular – not specialized – history." Regardless of the pros and cons, this does not at all seem likely to develop in Canadian art institutions.

Other methods to improve gender and other kinds of diversity have been more common elsewhere. In Sweden, the Moderna Museet has led an amazingly successful campaign to improve gender equity in their gallery, and this in turn seems to have made them more aware of other kinds of diversity within Swedish art. The first "Museum of Our Wishes" was a plea made in 1963 for funds and donations to improve their collection overall. In 2006, director Lars Nittve issued a new call, a "Second Museum of Our Wishes," that specifically targeted better gender representation, which had been exacerbated by the purchases made through the original Museum of Our Wishes. The institution made gender equity a priority. It seems to have paid off: they became the first major institution to have equal gender representation. In a 2015 interview, director Daniel Birnbaum and co-director and chief curator Ann-Sofi Noring were asked if there were anything they were especially proud of:

ANN-SOFI: We're the only major art museum in the world with
a gender-equal exhibition programme. Considering the male
dominance historically and in the collection, this may seem only
natural, but no other large museum has worked in this way. It
makes you wonder why?
DANIEL: Perhaps they're afraid that only male classic artists will
attract enough visitors, although we're delighted to have dis-
proved that. Our contemporary art is not a problem. But when it
comes to earlier periods we need to think harder so we don't just
carry on in the same old rut. Hannah Ryggen is currently getting
a lot of attention, not just in Skåne – where she was born – but
all over Europe. And our Hilma af Klint exhibition, which has
toured to many other places, is actually the most successful
exhibition created by the museum ever, in visitor numbers.[18]

Other curators and directors do not think it is possible, but Moderna
Museet has shown that not only is it possible, it can also be good for
attendance.

British institutions have also started to commit to better gender
representation. Under Frances Morris, the first female director of the
Tate Modern, the gallery has promised to hold more shows of women
artists and Morris has been frank in many interviews about the ongo-
ing bias against women artists and curators. She has made a career
of championing female and non-European artists, and is reported to
regularly point to the need for diversity.[19] She has discussed publicly
the importance of work:

> I realised what a deficit [of work by women] there was. And then
> I was in a position to do something about it. I encourage col-
> leagues to dig a little more when they see interesting work by
> a woman artist they haven't heard of before, or to be aware of
> where women have been overlooked. Sonia Delaunay ... is a case
> in point. For years people had been saying, "Let's do a Sonia
> Delaunay show," but the feeling would be, "Oh no, the work
> isn't strong enough." Well, what on earth did that mean? The
> work was unbelievably strong and diverse – but nobody actually
> knew its full extent.[20]

Morris's views are backed up by research from the Freelands
Foundation, which has quantified the paucity of female artists in

British institutions.[21] Initiated by Tate trustee Elisabeth Murdoch, the Freelands Foundation established a £100,000 prize to enable a regional arts organization to support an exhibition by a mid-career female artist.[22]

Although I have focused on the diversity of exhibited artists, diversity within museum personnel remains a significant issue as well. Nevertheless, when I read recently about a museum worker in charge of a major curatorial studies program warning that our graduate programs "are so disproportionately female that they resemble finishing schools. We have to make an effort to bring men into museum work,"[23] I was concerned. The opinion that when men are not adequately represented, action must be taken to equalize the numbers, without a commensurate sense that the reverse must happen first, is frustratingly common. The relative silence on equity in exhibitions in comparison to the outcry about equity in graduate programs is revealing. Elizabeth Easton complicates this picture by citing research showing that while women make up 35 per cent of the museum directorship of the AAMD, by annual budget, institutions headed by female directors make up only 15 percent of the total museum budget; that is to say, the budgets of institutions run by women tend to be smaller than those headed by men.[24] In Canada, Michael Maranda's recent study of gender and ethnicity in museum staff makes it clear that diversity in gallery management lags behind both the relative population of Canada's artists and that of the general population, and that while there are more women working in curatorial and directorial positions, they are less represented in the higher echelons. Moreover, "the less money a gallery receives, the more likely that the director or curator is Indigenous."[25] Although it is not his point, one key conclusion for me from Maranda's important research on diversity in museum management is that more diverse staff in and of itself does not necessarily lead to more diverse exhibitions.

One of my concerns in the writing of this project is the continuing gap between theory and practice. In recent decades, much important theoretical work has been done around the necessity of reframing how institutions consider art by Indigenous peoples, women, and all those who are not positioned at the top of museums' traditional hierarchies. The critique of institutions as creating, reinforcing, and sustaining power relations within and between cultures is now more than three decades old. And yet, things have not changed as much as many would have hoped. Indeed, I sometimes fear that the very

sophistication of the theoretical discourse sustains the inequities in practice: I suspect that many curators have essentially thrown up their hands, and effectively cried, "If every position is critiqued, why don't I just show what I know will most likely be popular?" – which remains, overwhelmingly, the art of the status quo. Consequently, in the body of this text, I have minimized the theoretical content and focused instead upon the data. However, I believe the theoretical implications of the data are significant.

From the early days of feminist art history, the additive model – in which newly found female artists are merely added to the canon – has been critiqued as inherently flawed. Merely adding the oppressed to the canon, without overturning the terms of the canon, so the argument goes, does not actually change the terms of debate; worse than that, such additions only serve to uphold the outsiders' status as lesser, since the terms by which they are judged are not theirs, and so the work is always seen as not quite measuring up. Moreover, it can easily function to reinforce stereotypes and generalizations about cultures and thus exacerbate the problems. This critique has been and remains crucial, and certainly I can recall installations that seemed to emphasize cultures as "exotic" and "other," rather than deconstruct those terms. But I fear that such critiques have also been used to justify not exhibiting such groups. Indeed, much of the museum studies discourse of the 1990s and 2000s worked on the assumption that exhibitions of non-dominant groups were commonplace and that we had to move beyond mere inclusivity to a more radical restructuring. For example, Irit Rogoff's important critique of museums and cultural institutions states, "In relation to cultural difference within western cultural institutions, we seem to have made a smooth transition from exclusion to inclusion, from xenophobia to xenophilia in one fell swoop and without unravelling ourselves or our institutional practices in the process."[26] She goes on to critique the terms of inclusion of the additive model, which, she argues, "leaves intact the concept of plenitude at the heart of the museum project. Therefore it assumes a possibility of change without loss, without alteration, without remapping the navigational principles that allow us to make judgments about quality, appropriateness, inclusion, and revision."[27] Similarly, criticisms of the act of collecting and exhibiting as using the power of the gaze and the distancing effects of time in order to "other" people have become essential to how museums situate non-Western cultures.

More recently, at the symposium "Who Counts? A Feminist Art Throwdown" hosted by MAWA in Winnipeg, a debate over the question "Is Art Gendered?" generated an animated response to many of these same questions. While the yay side argued that there was still a place for gender-based analysis, the attendants raucously supported the nay side, which argued we were long past gender binaries and thus should refuse gendered positions. I admit to being surprised that a symposium hosted by MAWA would attract a crowd that supported the position that the art world had moved beyond gender concerns. But I see it as part of the strength of hegemony: the critique of gender binaries leads to the assumption and wishful thinking that we are past them, and this allows them to continue to go un-analyzed. Like the critiques of so-called additive histories, critiques of gender or race-focused work are too often based on a sense that we are "post-gender" or "post-race."

This book and the research it relies on arose out of a sense that the dense theoretical texts that have animated museum studies have sometimes actually contributed to decreased representation. Indeed, I fear that the theory that often motivated critical exhibition reviews and nuanced critiques of *how* shows included works by artists of colour inhibited (or was used as an excuse by) white curators from including them at all. It must be a disincentive when an institution mounts an exhibition about a non-dominant cultural practice and receives significant (even if justified) criticism but receives no criticism when it mounts an exhibition of all-white men. No curators I spoke with said this directly, but many referred to the "complexity" of including works from cultures they were not familiar with. This is not to say such criticism should not be made – indeed, I have made some myself in this very book. Concerns over institutions displaying art from a colonialist-settler perspective, for example, are important and significant; however, we do not hold the institutions to the same standard with respect to exhibitions where such identities are not included. If a single exhibition includes no women or no Indigenous artists – that is, if it falls below the relatively low bar we typically accept as adequate representation – it may be called out; yet when show after show does not include significant representation, there is little outcry. The result of our focus on specific exhibitions and even installations is that sometimes it can seem safer for institutions to continue with the status quo than to change their exhibition standards.

In some sense, this book questions the critique of the additive model. Or, if it does not question the premise of that critique, it questions how that critique has actually played out on the ground. My data suggests that, contrary to the institutions Rogoff considers, art institutions in Canada have not shifted to xenophilia: there has been no state of inclusion. Non-dominant peoples – women, visible minorities, Indigenous peoples – are, in many institutions, still significantly underrepresented. I do not believe that we can move beyond the additive model without at least first moving towards it; I would like to get past it, but I know that we will not be able to do so if we continue to not exhibit and collect art by women, visible minorities, and Indigenous people.

Many years ago, Christopher Steiner asked, "Can the canon burst?" He envisioned the canon as being like a bag

> into which objects are stuffed until there exists such tremendous diversity and quantity that the receptacle threatens to dissolve or tear. No participant in the art world would want to destroy the imaginary bag (since, after all, the canon is meaningful only if it can be juxtaposed to whatever is noncanonical); yet because the canon takes on greater significance and value the more limited it is in scope, all the participants in the art world want their class of objects to be the last one dropped into the bag – after which it would be sealed shut forever ... Such attempts to reconfigure the canon in order to include previously marginalized categories of art seem, however, to have largely missed the point. It is not, I would argue, what is in or out of the canon that ought to be of concern to us, but rather the social structure of the canon itself that must be reconsidered. Those who squabble at the gated entrance to this exclusive "club" fail, in my opinion, to ask the really difficult question of how and why the canon was constructed in the first place. Seeking piecemeal admittance for one type of putatively undervalued art or another does little to challenge the fundamental structures of inequity and hierarchy which are inherent in the canonical order. If anything, in fact, such practices function merely to validate the canon system.[28]

For many years, I agreed with Steiner and others who argued that museums needed a far more radical restructuring than the additive model would allow. However, some two decades after first reading

Steiner's blistering critique, I am no longer so certain. Over those decades, our social world has been transformed by the radically flat, uncurated content of the internet. We have also seen the additive model at play, for example in *Art of this Land* at the NGC. Given those very different realms, I would like to suggest that, in my experience, the additive model is not "merely" additive; if we added truly representative numbers, it would necessarily be transformative. I do not believe that anyone could have visited *Art of this Land*, for example, and not been struck by how visually interesting the Indigenous arts were; that additive installation fundamentally altered the way one saw Canadian history and art history. Nor, I would suggest, could someone regularly attend one of the more inclusive art galleries noted here and not feel alienated by the stories being told by the big boys. That is to say, in my experience – if not in theory – when institutions really take on the "merely additive model" in a serious way, it actually is transformative, whether they wish it to be or not.

If we envision a gallery that exhibits works from 50 per cent male and 50 per cent female artists, a gallery representative of the diverse population of Canada's ethnicities and identities, it would be so fundamentally different than what we typically see in Canadian galleries that it would indeed constitute a radical revision. Moreover, we can catch glimpses of this brave new world if we look at artist-run centres and some of our smaller galleries, which let the art of this land speak to and from all its people.

List of institutions in data set and their solo contemporary exhibitions by gender

Probability is calculated using the binomial test, which assesses difference from an assumed outcome. We assumed two genders were equally represented. A probability of less than 0.05 tells us that our assumption, that each gender is equally likely to be represented at a gallery, is extremely unlikely to be true; that is to say, that this result is significantly different from equitable. Probability values below this threshold are highlighted.

Gallery	Solo shows male artists	Solo shows female artists	Total shows	% of shows to female artists	Probability
A Space Gallery	16	19	35	54%	0.750
aceartinc.	35	42	77	55%	0.819
Action Art Actuel	26	18	44	41%	0.146
A G York U	19	12	31	39%	0.141
A G Alberta	34	17	51	33%	**0.012**
A G Calgary	21	12	33	36%	0.081
A G Hamilton	27	12	39	31%	**0.012**
Agnes Etherington Art Centre	13	10	23	43%	0.339
A G Nova Scotia	21	20	41	49%	0.500
A G O	46	22	68	32%	**0.002**
A G Prince Albert	10	18	28	64%	0.956
A G Regina	15	19	34	56%	0.804
A G Southwestern Manitoba	29	24	53	45%	0.292
A G Victoria	39	32	71	45%	0.238
Artcite Inc.	38	36	74	49%	0.454
Articule	27	43	70	61%	0.979

Gallery	Solo shows male artists	Solo shows female artists	Total shows	% of shows to female artists	Probability
Art Metropole	9	7	16	44%	0.402
Artspeak Gallery	22	37	59	63%	0.982
Artsplace Gallery	1	18	19	95%	1.000
AxeNéo7	18	19	37	51%	0.629
Beaverbrook AG	32	14	46	30%	**0.006**
Belkin Satellite Gallery	12	5	17	29%	0.072
Belkin AG UBC	15	7	22	32%	0.067
Blackwood Gallery UofT	11	7	18	39%	0.240
Cambridge Centre for the Arts	45	50	95	53%	0.731
Carleton U AG	30	25	55	45%	0.295
Canadian Clay & Glass G	33	36	69	52%	0.685
Centre A Vancouver	17	18	35	51%	0.632
CMCP	15	9	24	38%	0.154
Contemporary AG Vancouver	38	22	60	37%	**0.026**
Dalhousie AG	29	14	43	33%	**0.016**
Doris McCarthy G UTSC	8	7	15	47%	0.500
Dunlop AG	35	40	75	53%	0.756
Ellen AG Concordia University	8	4	12	33%	0.194
Esplanade Arts & Heritage Centre	12	16	28	57%	0.828
Expression Centre d'expo St-Hyacinthe	28	21	49	43%	0.196
FAB Gallery UofA	21	31	52	60%	0.937
Foreman AG Bishop's University	7	15	22	68%	0.974
Gallery 1C03 U Wpg	15	14	29	48%	0.500
Gallery 101 AC Ottawa	29	32	61	52%	0.696
Gallery One One One U MB	14	13	27	48%	0.500
Galerie Sagamie	20	19	39	49%	0.500
Gallery TPW	25	21	46	46%	0.329
Glenbow	6	9	15	60%	0.849
Harcourt House ARC	32	56	88	64%	0.996
Helen Pitt Gallery ARC	35	30	65	46%	0.310
Joliette Museum of Art	25	18	43	42%	0.180
Kamloops AG	48	57	105	54%	0.835

Gallery	Solo shows male artists	Solo shows female artists	Total shows	% of shows to female artists	Probability
Kelowna AG	40	35	75	47%	0.322
Kenderdine AG U Sask	22	10	32	31%	**0.025**
Kitchener Waterloo AG	44	22	66	33%	**0.005**
La Centrale Galerie Powerhouse	0	40	40	100%	1.000
Latitude 53	26	26	52	50%	0.555
MAC Montreal	44	23	67	34%	**0.007**
MacDonald Stewart AC U Guelph	36	30	66	45%	0.269
MacKenzie AG	9	6	15	40%	0.304
McMaster U AG	22	17	39	44%	0.261
Mendel AG	16	12	28	43%	0.286
Mercer Union	48	44	92	48%	0.377
MMFA	13	3	16	19%	**0.011**
MOCCA	26	10	36	28%	**0.006**
Mt St Vincent U AG	26	39	65	60%	0.959
Neutral Ground	28	26	54	48%	0.446
New Gallery	69	90	159	57%	0.960
NGC	41	10	51	20%	**0.000**
Nickle Arts Museum U Calgary	33	14	47	30%	**0.004**
Oakville Galleries	33	21	54	39%	0.067
Odd Gallery Klondike	35	35	70	50%	0.548
Or Gallery	24	31	55	56%	0.860
Ottawa AG	17	17	34	50%	0.568
Platform	25	22	47	47%	0.385
Plug In Gallery	40	20	60	33%	**0.007**
Power Plant	40	27	67	40%	0.071
Presentation House	24	17	41	41%	0.174
Richmond AG	26	58	84	69%	1.000
Robert Langen AG Wilred Laurier U	31	29	60	48%	0.449
Rodman Hall AC Brock U	15	12	27	44%	0.351
Rooms NL	20	13	33	39%	0.148
Ryerson AG	18	20	38	53%	0.686
Southern Alberta AG	41	49	90	54%	0.829

Gallery	Solo shows male artists	Solo shows female artists	Total shows	% of shows to female artists	Probability
Sir Wilfred Grenfell College AG	15	20	35	57%	0.845
St Mary's U AG	21	21	42	50%	0.561
Stratford Gallery	12	8	20	40%	0.252
Stride Gallery	75	86	161	53%	0.828
Surrey AG	15	24	39	62%	0.946
Triangle AG	9	3	12	25%	0.073
Truck Contemporary Art	55	74	129	57%	0.961
Two Rivers Gallery	20	12	32	38%	0.108
UBC Museum of Anthropology	18	1	19	5%	0.000
U Lethbridge AG	7	5	12	42%	0.387
UoT Art Centre	12	4	16	25%	0.038
UQAM Gallery	34	25	59	42%	0.149
Vancouver AG	39	12	51	24%	0.000
Varley AG	8	6	14	43%	0.395
Winnipeg AG	44	21	65	32%	0.003
Walter Phillips Gallery	15	11	26	42%	0.279
Western Front	21	13	34	38%	0.115
Total	2,463	2,221	4,684	47%	0.000

Notes

PREFACE

1 Levin, *Gender, Sexuality, and Museums,* is an example of where gender is discussed in more complex and nuanced ways.

2 Bannerji, *Dark Side of the Nation,* 37; and Fatona, "Where Outreach Meets Outrage," 175.

3 D'Souza, *Whitewalling,* 9. Whitewalling is "a neologism that expands in many directions: the literal site of contention, i.e., the white walls of the gallery; the idea of 'blackballing' or excluding someone; the notion of 'whitewashing,' or covering over that which we prefer to ignore or suppress; the idea of putting a wall around whiteness, of fencing it off, of defending it against incursions."

4 The chapter on the National Gallery does not therefore include significant analysis of the rehang of the Canadian and Indigenous galleries that opened in the summer of 2017, after the chapter was completed.

CHAPTER ONE

1 Nochlin, "Why Have There Been No Great Women Artists?," 22; and Rose, "Rachel Whiteread Interviewed," 33.

2 See https://brooklynrail.org/2014/09/criticspage/gallery-tally-poster-project.

3 Online survey response, summer 2013.

4 On the presence of feminist art online, see Greenberg, "Feminist Curation and Exhibition Online."

5 On the difficulty of defining "contemporary" in an art context, see Smith, *Thinking Contemporary Curating,* 33–5.

6 I am grateful for the assistance of University of Lethbridge librarian Rhys Stevens who garnered this data for me from Statistics Canada's Labour Force Survey.

7 For an excellent analysis of the complexities analyzing contemporary artists, see Maranda, *Waging Culture*, 1–4, which also shows that professional female artists have significantly more education, although fewer career success, benchmarks: 11, and 49. His ongoing project estimates the percentage of female artists to have increased to 62 per cent by 2012 (see Maranda, "Waging Culture: The Sex Gap (!)"). Bellavance, *The Visual Arts in Canada*, 85, states that the population of artists was mostly male (66 per cent) in the 1970s, but "by the mid-2000s it was mostly female (56%)"; the report provides a useful overview of analyses of research to date on the visual arts in Canada. Although it does not directly address the issue, it inadvertently points out the paucity of work on gender.

8 Canadian Association of University Teachers, "Women's University Enrolments," 4, lists the percentage of enrolled female university students in the category "Visual and Performing Arts and Communications Technologies" as increasing from 62.8 per cent in 1992 to 67.7 per cent in 2003. For more on the gender of students enrolled in post-secondary art programs, see Zemans and Wallace, "Where Are the Women?," 10–12.

9 Maranda, *Waging Culture*, 49.

10 See Maranda, *Waging Culture*, 15, for a discussion of the career benchmarks used in their study.

11 We did not include in this category artistic duos that produce artwork as a single entity.

12 See M. Schor, "Backlash and Appropriation," who dismantled the idea that assessing difference was in effect contributing to essentialism. As well, the strong reaction against any kind of discussion of how the female gender is situated differently (whether we want it to be or not) within the culture brings us to the bind of being unable to discuss the category into which "artists gendered female" are put. See also de Lauretis, "The Essence of the Triangle," 1–39, and N. Schor, Introduction to *The Essential Difference*, vii–xix.

13 Using a binomial test with 0.5 expected outcome, the two-tailed p-value = 0.000432, which is considered extremely significant. The results become even more unlikely to be based on chance if you consider the percentage of female artists or of women in the population, which are both higher than 50 per cent. If we used 55 per cent as the

expected number of shows of female artists, many more galleries would be considered inequitable. See the discussion below.

14 A binomial square test of the Western Front, which had nineteen solo shows by male artists and twelve solo shows by female artists, shows it to be not statistically significant from expected equity.

15 "According to the 1971 Census, 68% of 25 to 29-year-old university graduates were male. Ten years later, women had more or less caught up to men, as only 54% of graduates were male. By 1991, women had become the slight majority, comprising 51% of graduates. In the 2001 Census, universities had clearly become the domain of women, as they made up 58% of all graduates," https://www150.statcan.gc.ca/n1/pub/81-004-x/2008001/article/10561-eng.htm. In BFA and MFA programs, the percentage of female students may be even higher; see Statistics Canada's 2010–11 numbers in the category "Visual and Performing Arts and Communications Technologies," which notes 63 per cent female students; both sexes, 84,024; male, 31,065; and female, 52,482; which leaves 477 without an identified gender. Of those whose gender is identified, a total of 83,547, 62.8 per cent are female, http://www.statcan.gc.ca/tables-tableaux/sum-som/l01/cst01/educ72a-eng.htm.

16 Having access to the percentage of applications that are from male and female applicants would help further contextualize the numbers from ARCS. However, I have not yet had much access to this detailed information.

17 http://www.aceart.org/mandate (accessed 23 January 2013). This wording has since been revised, with less strongly worded support: "we work with contemporary artists, curators, and art writers, including emerging artists and those from queer, Indigenous, and underrepresented communities" (accessed 24 March 2017).

18 Pourtavaf, Introduction to Féminismes Électriques, 12.

19 The Triangle has since undergone significant changes. In 2011, it was rebranded as the Museum of Contemporary Art, and has since merged with the Institute of Modern and Contemporary Art (IMCA) and the Art Gallery of Calgary (AGC) to become Contemporary Calgary.

CHAPTER TWO

1 Government of Canada, Museums Act.

2 National Gallery of Canada, Annual Report, 2010–11, 3.

3 The most comprehensive overview of the National Gallery's history can be found in Ord, The National Gallery of Canada.

4 Whitelaw, "Statistical Imperatives," 22–41.

5 There are other inconsistencies in the data that do not affect our count. For example, there are exhibitions listed in one year's annual report as having happened in one set of galleries, and in the next year's annual report as having taken place in another gallery. For example, *No Man's Land: The Photographs of Lynne Cohen* (1 February to 12 May 2002) is listed in the 2001–02 annual report as being held in the Prints, Drawings and Photographs galleries, but in the 2002–03 annual report as having been in the Special Exhibitions galleries. The latter seems to be incorrect; regardless, the point remains that sometimes the available data varies between the annual reports, the general website exhibition listings and the exhibition listings in the Library database.

6 See the NGC's refusal to pay the CARFAC scale for artists and of the eventual agreement, which excludes works from the permanent collection, https://scc-csc.lexum.com/scc-csc/scc-csc/en/item/14232/index.do (accessed 6 June 2017).

7 Using the binomial pair test, and assuming shows of male and female artists are equally likely, the probability of this result is extremely unlikely. The two-tail p-value is less than 0.0001.

8 Universities Art Association of Canada annual conference, 2011, hosted by Carleton University.

9 Using binomial test and 0.5 expected probability, the two-tail p-value is 0.016.

10 See Gagnon, "Work in Progress," 114.

11 I thank the researchers at Statistics Canada and my university librarian, Rhys Stevens, for obtaining this data for me. See also Maranda, "Waging Culture: The Sex Gap."

12 Cooley, Luo and Morgan-Feir, "Canada's Galleries Fall Short."

13 Morgan-Feir, email to the author, 9 February 2017.

14 The website changes with surprising frequency, and since this chapter was written, the method to access past exhibitions on the gallery website has changed: https://www.gallery.ca/research/past-exhibitions; the numbers used in these counts were verified 9 February 2017 from the gallery's main website. After email inquiries in September 2016 to the Library and Archives about discrepancies, I was referred to the main gallery website.

15 Zemans and Wallace, "Where Are the Women?," 19.

16 See Lowndes, "Vera Frenkel," 130. In 1971, Frenkel received a prize at the Segunda Bienal Americana de Artes Gráficas, in Colombia, and in 1972 she would have success at the Venice Biennale.

17 In 1969, Nancy Graves was one of only five female artists and the youngest artist to have had a solo show at the Whitney. Brydon Smith's concerted interest in her work forms part of the recent shift in the gallery's practice towards the collection of contemporary American art since 1967.

18 Angel, "Joyce Wieland."

19 For a nuanced discussion of her international reputation, see Holmes, "Negotiating the Nation," 61–5.

20 Their 1971–72 annual report included a short essay on the topic to the Year of the Woman. See also Boggs, "The National Gallery and Women," 8–9.

21 See Kritzwiser, "At the Galleries," for example.

22 Angel, "Joyce Wieland."

23 *Diane Arbus*, 14 March to 21 April 1974; and *Bernd and Hilla Becher*, 20 September to 17 November 1974.

24 On these and other exhibitions in 1975, as well as for a history of Canadian feminist art more generally, see Gagnon, "Work in Progress," 103–8.

25 Graham, "In Celebration: Some Canadian Women Artists," 12.

26 Purdie, "Sense of Wonderment from Women Painters."

27 On these and other exhibitions in 1975, as well as for a history of Canadian feminist art more generally, see Gagnon, "Work in Progress," 100–27; and Zack, Kantaroff and Corne, *Woman as Viewer*.

28 Graham, Introduction to *Some Canadian Women Artists*, 9.

29 Ibid., 12.

30 Ibid., 13.

31 Ibid., 19.

32 Sleigh, Review of *Some Canadian Women Artists*, 168.

33 Boggs, "No Disavowal." I thank Jessica Stewart for her research help.

34 Perry, "Gathie Falk," 9. Bogardi and Nixon both refer to artists' refusals to be included, without naming the artists.

35 Fulford, "There Is a Distinct 'Female Art.'"

36 Bogardi, "Women's Art Lost in Issues."

37 With the exception of David Burnett, "Some Canadian Women Artists," 54, who states that every word of the title "cries out for definition."

38 See Conley, "Hot Tramp, I Love You So!," 53–4.

39 See Klein, "Bad Girls Video," in which she positions the exhibition as a necessary corrective to early histories of video that neglected female artists: "Concerned that an important corpus of early feminist work would simply be forgotten, curator JoAnn Hanley organized a

traveling exhibition of this early feminist work in conjunction with Independent Curators Incorporated of New York City."

40 It was coordinated by Jessica Bradley, which is interesting because her stable was gender equitable, which is unusual among commercial galleries. Unfortunately, she closed her gallery in 2015.

41 Nixon, "'Pluralities' Has Variety, Surprise," 84.

42 McInnes-Hayman, *Contemporary Canadian Women Artists*, 3.

43 Ibid., 3.

44 Ibid., 1–2.

45 Ibid., 16.

46 See entry in NGC Library and Archives online catalogue, http://bibcat. gallery.ca/search~S3 (call number: EX 1701; collection: Archives Only).

47 Conley, "Curatorial Conundrums," 5.

48 Pollock, "The Missing Future," 42, points to this phenomenon at the Museum of Modern Art.

49 Dagg, *The Fifty Percent Solution*.

50 Dagg, "What Happens to Women's Art?," 6.

51 C. Hill, "Committed to Art."

52 It is notable that this exhibition was curated by Diana Nemiroff and Jessica Bradley, both of whom have very positive records of curating shows of women artists.

53 McInness-Hayman was gallery director of a Womanspirit, an ARC in London, Ontario. See also Broadhurst, "Strategic Spaces," 76–9.

54 On *Songs of Experience* see Whitelaw, "Statistical Imperatives," 22–41, and in particular page 26, which states that ten of fifteen artists in this exhibition were women (which is not statistically significant from expected equity). In the 1989 biennial, fourteen of twenty-five artists were women, which is 56 per cent and also not statistically significant from expected equity.

55 On *Land, Spirit, Power*" see Whitelaw, "Land Spirit Power"; and Phillips, "Artists, Museums and the Columbus Quincentennial," 162–7.

56 http://laws-lois.justice.gc.ca/eng/acts/m-13.4/page-1.html#docCont

57 Bradley left in 1987; Nemiroff arrived in 1984, became acting curator of contemporary art in 1988, and curator of contemporary art in 1990.

58 Lamoureux, "La Statistique canadienne," 49.

59 Now known as Panya Clark Espinal.

60 Now known as Lynn Hershman Leeson.

61 I thank Panya Clark Espinal for clarifying the history of her exhibition.

62 Interestingly, the NGC archives have no textual material related to the Whittome exhibition. See entry in NGC Library and Archives online

catalogue, http://bibcat.gallery.ca/search~S3 (call number: EX 1899A; collection: Archives Only).

63 McRobbie, *The Aftermath of Feminism*, 12.

64 Conley, "Curatorial Conundrums," 4–5.

65 For my terminology here and any assessment of Indigenous arts and Canadian institutions I am indebted to the scholarship of Phillips, *Museum Pieces*, particularly her chapter "Modes of Inclusion," 252–68. I also use the terminology used by the NGC website, verified in February 2017.

66 However, under what is seemingly a subcategory, Aboriginal Art, they also include Inuit art again.

67 Rogoff, "Hit and Run," 63–73.

68 Hooper-Greenhill, *Museums and the Shaping of Knowledge*, 10–11.

69 G. Hill, "Carl Beam," 19.

70 On the early history of First Nations and the NGC, see Nemiroff, "Modernism, Nationalism and Beyond," 18–35; and Dawn, *National Visions*, particularly 238–54. On Markle and Letendre's entry into the NGC, see Soulliere, "The Stone That Cracked the Wall," 31; and G. Hill, untitled presentation.

71 Boggs, "The National Gallery and Our Two Cultures," 16.

72 Ord, *National Gallery of Canada*, 273.

73 Freedman, "Silver Saga Continues." The relation between the National Museums Corporation and the NGC was particularly fraught in these years, and Shih would resign the following year. See Ord, *National Gallery of Canada*, 269–77.

74 Ord, *National Gallery of Canada*, 261–77.

75 Freedman, "Birks' Silver."

76 Soulliere, "Stone that Cracked," 31.

77 Soulliere, "Stone that Cracked," 31 and 94. Greg Hill, University of Lethbridge presentation.

78 Soulliere, "Stone that Cracked," 24–5; and Blodgett, "Report," 6.

79 See G. Hill, "Carl Beam," 19.

80 The department's name and mandate changes over time, however for simplicity's sake, I will refer to it as DIAND. The collection was divided into the Northern Affairs collection and the Indian and Northern Affairs of Canada collection.

81 Mullick, "Transfer of the Northern Affairs," iii.

82 Ibid., 16–22; Ipellie, "The Colonization of the Arctic," 50; Goetz, "Inuit Art," 357–82; and Igloliorte, "Arctic Culture/Global Indigeneity," 155–60.

83 Igloliorte, "Arctic Culture/Global Indigeneity," 158.

84 Ibid., 159.

85 For a view of someone on the council, see Watt, "The Role of the Canadian Eskimo Arts Council," 67–71. For a more disinterested account that includes the ongoing challenges that were coming to a head in the CEAC by the 1980s see Gustavison, *Arctic Expressions*.

86 Routledge, "Development of an Inuit Art Collection," 75, citing Indian and Northern Affairs, *Report on the Conference for Curators and Specialists who work with Inuit Art held at the Canadian Government Conference Centre in Ottawa, on September 15 and 16, 1982*, Ottawa: Indian and Northern Affairs, 1983.

87 Ibid., 75.

88 Gustavison, *Arctic Expressions*, 72, reports that the meeting included representatives from the Inuit Art Section; CEAC chairperson Virginia Watt; and from the NGC, Tovell, Brydon Smith (curator of contemporary and modern art), and Gyde V. Shepherd (public programs).

89 Soulliere, "Stone that Cracked," 25; Blodgett, "Report," 6; Gustavison, *Arctic Visions*, 73; and Nemiroff, "Modernism, Nationalism and Beyond."

90 Applebaum, *Report*; and Blodgett, "Report."

91 Tovell's mother, Rosita Tovell, had been a founding member of the National Gallery Association, which became Friends of the National Gallery, and she was a noted collector of Canadian modernism and First Nations art, and would later found a fund at the NGC to support the collection on First Nations art. See http://www.timescolonist.com/news/local/art-gallery-receives-1-1-million-from-art-collector-philanthropist-1.2176714.

92 The role of Budd (Melville Francis) Feheley in the development and legitimization of Inuit art is fascinating: he ran a commercial art studio, worked as a corporate art consultant promoting Inuit art, became a commercial dealer for Inuit art, was cofounder of the Park Gallery, and later founded Feheley Fine Arts, now run by his daughter Patricia Feheley, as well as being a founding member of CEAC.

93 Speak, "It's Inuit," 5.

94 Maria von Finckenstein, as quoted in Mullick, "Transfer of the Northern Affairs," 29, which has the most in-depth account of the role of DIAND and the CEAC. DIAND oversaw two collections of Inuit art: one was the Northern Affairs collection and the other was the Indian and Northern Affairs of Canada collection.

95 Mullick, "Transfer," 25.

96 Ibid., 29.

97 Ibid., 28.

98 On this process, including the changes to the agreement from its initi-
ation in the mid-1980s through to 1989 – when eventually Inuit art
centres were included and the collection was broken up, see Mullick,
"Transfer."

99 Mullick, "Transfer," 108.

100 Speak, "It's Inuit," 4.

101 Blodgett, "After Essay," 206–7, discusses the different ways Inuit and
art by other Indigenous nations are treated in galleries.

102 Speak, "It's Inuit," 6.

103 See Crandall, *Inuit Art*, for a very detailed exhibition history of Inuit
art; as well as many of the essays in *On Aboriginal Representation in
the Gallery*, including Bagg, "The Anthropology of Inuit Art," 183–
94; Christine Lalonde, "Status 2000: Presenting Contemporary Inuit
Art in the Gallery Setting," 195–204; and Blodgett, "After Essay,"
205–14; as well as Crandell and Crandell, *An Annotated Bibliography*.

104 Bagg, "Anthropology of Inuit Art," 186.

105 Massie, quoted in Blodgett, "After Essay," 207.

106 Fabian, *Time and the Other*.

107 Rogoff, "Hit and Run," 66.

108 Nemiroff, "Modernism, Nationalism, and Beyond," 41.

109 Why the non-Inuit components of the DIAND collection were not
seen as appropriate for the NGC remains an open question.

110 On PNIAI, see Sanchez, "The Formation of Professional Native
Artists Inc.," 20–5.

111 Martin, "The Politics of Inclusion and Exclusion," 38; and Task
Force on Museums and First Peoples, "Turning the Page," 4.

112 The artist Jimmie Durham was included in the 1998 exhibition
Crossings; he identifies as Cherokee; however, recently this identifica-
tion has been disputed. See Boucher, "Cherokee Artists and Curators
Denounce Artist."

113 See Hines, "*Art of this Land*," 102–3; and Whitelaw, "Placing," 205.

114 Please see the extended discussion of the data variability above; using
the binomial pair test, and assuming shows by men and women are
equally likely, the probability of this result is extremely unlikely.
The two-tail p-value is less than 0.0001.

115 Marion Tuu'luq's 2002 retrospective was excluded from this list
because of her death two weeks prior to the opening. The inclusion
of Tuu'luq's show does not affect the data significantly.

116 "It's one of the most popular works of art of the past decade or so, globetrotting with such regularity that its owners can hardly keep it in house," Whyte, "Janet Cardiff's 40 Part Motet."
117 Stauble, "Remembering Lynne Cohen."
118 Zemans, "Where Are the Women?," 17–18.
119 Routledge, "Development," 73–8; Routledge, "Carving an Identity," 32–6; and Speak, "It's Inuit," 4–7.
120 Lockyer, "Charting the Development"; and Whitelaw, "Placing Aboriginal Art." In the summer of 2017, after this manuscript was sent to the publisher, these galleries were renamed and rehung as the Canadian and Indigenous Galleries, with a permanent installation titled *Canadian and Indigenous Art: From Time Immemorial to 1967*. It promises a renewed relation with Indigenous artists and better visibility of women artists.
121 Whitelaw, "Placing Aboriginal Art."
122 McMaster, "Our (Inter) Related History," 6.
123 Whitelaw, "Placing Aboriginal," 205.
124 The history of the NGC's so-called biennials is fraught; after three relatively successful shows in 2010, 2012, and 2014, the NGC took a year hiatus, attributed to Canada's sesquicentennial exhibitions, and the biennial returned in 2017.
125 Shier, "It Is What It Is."
126 Zemans, "Where Are the Women?," 17, has a slightly different count because she includes individuals in groups as a fraction of an individual, and I have excluded them. The difference is small.
127 Ibid.
128 Mousseau, "Exposition pancanadienne," 20. Translation mine. The original text was: "'C'est une exposition censée être un miroir de ce qui fait au Canada, donc nous sommes un peu scandalisés du fait que certains de nos grands artistes ne sont pas là. Je trouve ça complètement inacceptable qu'on n'ait pas fait un travail rigoureux pour découvrir nos artistes,' a-t-elle déclare."
129 Ibid. Translation mine. The original text was: "'Nous avons le devoir d'aller chercher partout au Canada pour des œuvres qui sont extraordinaires dans un contexte national et même international puisque nous avons un mandat international. Et jusqu'à présent, nous en avons trouvé très peu au Nouveau-Brunswick et nous en sommes désolés,' a déclaré M. Mayer. Il précise que les commissaires recherchent avant tout l'originalité, des pratiques novatrices, des choses qu'ils n'ont jamais vues et des carrieres vraiment uniques. 'Nous cherchons

aussi la pertinence, c'est-à-dire que les œuvres nous parlent d'aujourd'hui … J'ai rencontré des gens vraiment géniaux, sympathiques, de grand talent, mais malheureusement, ce n'est pas par sentimentalité qu'on organise notre collection. On essaie d'être le plus scientifique possible.'"

130 Gessell, "Not in This Place."

131 McLaughlin, "It Is What It Is."

132 Transcription is the author's; the original piece was formerly online but is no longer available.

133 It is archived at http://excellenceatthenationalgallery.blogspot.ca.

134 Gessell, "The Trouble with 'Excellence.'"

135 Lowndes, "Maltreating Mayer."

136 Laidlaw, "Pop Life."

137 https://www.gallery.ca/whats-on/exhibitions-and-galleries/builders-canadian-biennial-2012.

138 Zemans, "Where Are the Women?," 17.

139 Shaughnessy, "Intro to Builders," 12–17.

140 On racism in Canadian hockey as it affects Indigenous peoples, see Valentine, "New Racism and Old Stereotypes in the National Hockey League," 112-114.

141 Shaughnessy, "Intro," 12.

142 See, for example, Sandals, "Canadian Biennial."

143 Falvey, "Canadian Biennial Both Dazzles and Disappoints."

144 Note that the lists from the websites are not entirely clear about which artists showed in both exhibitions, or which were only shown in one location. The catalogue also does not make it perfectly clear, unless one goes through the acquisitions list (289–325) entry by entry to determine whether the work was exhibited and, if so, in which location.

145 Singhal, "State of the Art."

146 Counting Daniel Young and Christian Giroux, an artist duo, as 0.5 each.

147 Whyte, "From Ottawa, with Love and Muscle"; and Whyte, "Failure's Not an Option for Canada at Art Event."

148 Whyte, "From Ottawa."

149 Ibid.

150 Goddard, "Dude Culture Near the Doge's Palace"; Dixon, "Head Bangers at the Biennale"; and Milroy, "Steven Shearer: Boy Trouble."

151 Taylor, "For the Artist Representing Canada, the Biennale Is a Mixed Blessing."

152 The NGC's mandate is "to develop, maintain, and make known, throughout Canada and internationally, a collection of works of art, both historic and contemporary, with special, but not exclusive, reference to Canada, and to further knowledge, understanding, and enjoyment of art in general among all Canadians." Government of Canada Museums Act, http://laws-lois.justice.gc.ca/eng/acts/m-13.4/page-1.html#h-5.

153 Interview with Kitty Scott, 24 June 2013.

154 National Gallery of Canada, *Annual Report, 2010–11*, 4.

155 As Griselda Pollock has argued, it is a myth supported by major art institutions that women were not significant contributors to the development of modernism: "how can we account for the counterintuitive fact that despite every form of evidence to the contrary, and despite everything that made the *modernization of gender roles* fundamental to modernity itself, the dominant vision of modern art created by the most influential American museum systematically failed to register the intensely visible artistic participation of women in making modernism modern?" in "The Missing Future," 34.

156 The artists are David Altmejd, Lee Bul, Bharti Kher, Yinka Shonibare, Sarah Sze, and Tricia Middleton. See http://www.youraga.ca/media-releases/enter-a-world-of-material-excess-accumulation-bravado-and-theatricality-in-misled-by-nature-contemporary-art-and-the-baroque-opening-at-your-aga.

157 The solo shows of living artists in the NGC@MOCCA collaboration were Artur Żmijewski (2011), Fred Herzog (2011), Guy Ben-Ner (2012), Louise Bourgeois (2013), Michael Snow (2013), Phil Collins (2013), and David Cronenberg (2013).

158 Whitelaw, *Spaces and Places for Art*, 88, lists eighteen artists included in the 1925 NGC extension exhibition at the Moose Jaw Public Library, of which three are women.

CHAPTER THREE

1 O'Brian, Preface to *Vancouver Art and Economies*, 7. See also Douglas, *Vancouver Anthology*; Watson and Roelstraete, *Intertidal*; and Wallace, *Whispered Art History*.

2 Using a binomial test with expected equal representation, the two-tailed p-value equals 0.001. By conventional criteria, this difference is considered to be very statistically significant.

3 Using a binomial test with expected equal representation, the two-tailed p-value equals 0.134, which is not statistically significantly different than expected equality.

4 This is changing. For example, see the Facebook page "Women in the History of Art," which consistently names the ethnicity of all artists.

5 Ip, "Ethnicity and Visible Minority." See also Ming Wai Jim, "Dealing with Chiastic Perspectives," 72, on the history of term "visible minority" in Canada.

6 See http://www12.statcan.ca/census-recensement/2006/dp-pd/prof/ 92-591 (search "Vancouver" [Census metropolitan area]) (accessed 22 February 2016). The Employment Equity Act (section 3) defines visible minorities as "persons, other than Aboriginal peoples, who are non-Caucasian in race or non-white in colour." https://laws-lois.justice. gc.ca/eng/acts/e-5.401.

7 Because there are more than two variables, we have to use a different test than the binomial test. Here statisticians use a chi-square test. Chi squared equals 7.513 with two degrees of freedom. The two-tailed p-value equals 0.0234.

8 VAG website, https://www.vanartgallery.bc.ca/about-us/about-us.html. On the other hand, Bartels has not yet been successful with her ambitious expansion plans, although that is outside the scope of this project.

9 Laurence, "Board Walk," 16; and Gill, "Bartels: Facing a House Divided."

10 Ditmars, "The Master Builder."

11 Ibid.

12 Ibid.

13 Using population of the city as the comparator, chi squared equals 11.045 with two degrees of freedom; the two-tailed p-value equals 0.0040. By conventional criteria, this difference is considered to be very statistically significant. Using the population of the province, chi squared equals 0.681 with one degree of freedom; the two-tailed p-value equals 0.4094. By conventional criteria, this difference is considered to be not statistically significant.

14 See the VAG's annual reports from 2000 (page 2) and 2001 (page 1).

15 VAG, 2003 Annual Report, http://www.vanartgallery.bc.ca/pdfs/ AnnualReport2003.pdf (accessed 16 January 2015).

16 See Government of British Columbia, "Key Markets," https://www. britishcolumbia.ca/export/key-markets.

17 http://www.vanartgallery.bc.ca/about-us/institute_of_asian_art.html.

18 On the construct, see Palumbo-Liu, "Modernisms, Pacific and Otherwise," 36.

19 http://www.vanartgallery.bc.ca/media_room/pdf/100902.pdf (accessed 3 June 2014).

20 http://www.vanartgallery.bc.ca/the_exhibitions/exhibit_next_jeff_ladouceur.html (accessed 4 June 2014).

21 Thom and Arnold, *Forest, Shore and Beyond*, 145, 147.

22 For the group shows, we used the available website data from 2002 to 2010; the determination of when a show was substantially contemporary was somewhat more subjective than our definition of contemporary art, where we used the definite qualification that the artist was alive on the date of the opening. In this case, if the majority of artists were still living, we included it.

23 See the account of the MoA in Phillips, "APEC at the Museum," particularly 73–5.

24 http://www.sfu.ca/people/anniegrace/about-annie.html (accessed 25 April 2017).

25 https://www.shadboltfoundation.org/viva-awards (accessed 28 April 2017). I thank Scott Watson for alerting me to the equitability of this award.

CHAPTER FOUR

1 http://www.blogto.com/city/2016/05/toronto_named_most_diverse_city_in_the_world; http://www1.toronto.ca/city_of_toronto/social_development_finance__administration/files/pdf/nhs_backgrounder.pdf (accessed 9 July 2014); and Ballingall, "A Majority of Torontonians."

2 Philip Monk, "Toronto the Good," notes how removed the city's major galleries have been from documenting their history in his review of two recent exhibitions that attempt to rectify this lacuna.

3 The Ryerson Art Centre has had major changes since the opening of the Ryerson Image Centre, and is now known as the Ryerson Artspace, and MOCCA has become the Museum of Contemporary Art Toronto Canada. I use the names that were in use during the period.

4 For all Toronto galleries included, using a binomial test with expected equal representation, the two-tailed p-value equals 0.0005. By conventional criteria, this difference is considered to be extremely statistically significant.

5 For Toronto ARCs, using a binomial test with expected equal representation, the two-tailed p-value equals 0.6, which is not significant.

6 With Toronto university affiliated galleries, using a binomial test with expected equal representation, the two-tailed p-value equals 0.12 which is not statistically significant.

7 For Toronto public galleries, using a binomial test with expected equal representation, the two-tailed p-value is less than 0.001, which is considered extremely statistically significant.

8 On the AGO transformation and reinstall, see, Gewurtz, "Transformation AGO"; and Phillips, "Modes of Inclusion."

9 Using a binomial test with expected equal representation, the two-tailed p-value equals 0.009, which is very statistically significant.

10 R. Hill, "Meeting Ground," 51.

11 Ibid., 56.

12 Bordo, "The Terra Nullius of Wilderness"; and Bordo, "Jack Pine-Wilderness Sublime."

13 R. Hill, "Meeting Ground," 58.

14 See Gewurtz, "Transformation AGO," 112–13.

15 Phillips, "Modes of Inclusion," 271, is less favourable.

16 Phillips, "Modes of Inclusion," 274.

17 AGO didactic panel, July 2013.

18 Phillips, "Modes of Inclusion," 272–4.

19 See the AGO website, https://ago.ca/collection/canadian (accessed February 2017).

20 Currently, galleries are being reinstalled in a project the AGO calls "Look: Forward, an exciting reinstallation of the AGO collection."

21 As quoted in Phillips, "Modes of Inclusion," 269.

22 I have been unable to confirm this.

23 Czajkowski and Hill, "Transformation," 258.

24 Ibid., 257.

25 A former employee of the AGO in conversation, 26 June 2013.

26 As a sample of the controversy, see Mortimer, "Frida's Unibrow"; Cross, "AGO's Frida Kahlo Unibrow"; and Krishtalka, "A Critic's Open Letter Responds to the AGO Frida Kahlo Unibrow Controversy"; as well as the official AGO response: http://artmatters.ca/wp/2012/11/our-director-of-marketing-weighs-in-on-the-frida-unibrow-debate.

27 https://www.huffingtonpost.ca/sarah-mortimer/frida-kahlo-ago-unibrow_b_2100916.html.

28 http://artmatters.ca/wp/2012/11/our-director-of-marketing-weighs-in-on-the-frida-unibrow-debate.

29 Rice, *Becoming Women*, 44.

30 Teitelbaum interview, 16 September 2013. Lethbridge, Alberta.

31 https://www.ago.net/assets/files/pdf/AGOyearReview2006-7.pdf, 6.

32 Whyte, "AGO Facing Big Choice."

33 https://ago.ca/exhibitions/idea-north-paintings-lawren-harris.

34 Hunter, "Why I Quit."

35 http://www.ago.net/art-gallery-of-ontario-launches-department-of-canadian-and-indigenous-art-appoints-two-new-positions.

36 https://www.cbc.ca/news/entertainment/ago-inclusivity-jost-hunter-1.4340638.

37 Stone, "Hanging on."

38 David Liss, public lecture. Lethbridge, Alberta.

39 http://www.mocca.ca/about-mocca (accessed 8 July 2014).

40 Garnet, "Synthetic Psychosis," 136.

41 David Liss, public lecture. Lethbridge, Alberta.

42 Using a binomial test with expected equal representation, the two-tailed p-value equals 0.01, which is statistically significantly different than expected equity.

43 See https://www150.statcan.gc.ca/n1/pub/11-402-x/2007/30000/.ceb30000_000-eng.htm; and Ballingall, "A Majority of Torontonians."

44 Using a binomial test with expected equal representation, the two-tailed p-value is less than 0.0001, which is extremely statistically significant.

45 On MOCCA's uncertain location, see Sutton, "Facing Eviction"; and J. Adams, "Toronto's Museum of Contemporary Canadian Art."

46 J. Adams, "Toronto's Museum of Contemporary Canadian Art."

47 http://museumofcontemporaryart.ca/about (accessed 16 May 2017).

48 Gooden, "Chantal Pontbriand."

49 Whyte, "New Name."

50 Ibid.

51 Gooden, "Chantal Pontbriand."

52 Whyte, "MOCA CEO Chantal Pontbriand," 1.

53 Whyte, "Terry Nicholson Takes Helm at MOCA."

54 J. Adams, "The Perpetual Crisis at Toronto's Power Plant Gallery."

55 Using a binomial test with expected equal representation, the two-tailed p-value equals 0.14, which is not statistically significant.

56 http://www.thepowerplant.org/AboutUs/Mandate---Vision.aspx (accessed 18 May 2017).

57 Some artists included in the general tally are excluded when their ethnicity is attributable. For city data, see https://www12.statcan.gc.ca/census-recensement/2006/dp-pd/hlt/97-562/pages/page.cfm?Lang=E&Geo=CSD&Code=35&Table=1&Data=Dist&StartRec=201&Sort=2&Display=Page&CSDFilter=5000.

CHAPTER FIVE

1 Rosenbaum, "Bonding with Bondil."
2 Twerdy, "6 New Montreal Art Spaces."
3 See the MACM's "About" page, https://macm.org/en/the-musee.
4 Chassé and LaPierre, *Marcel Brisebois*, 71.
5 Lacroix, "Borduas et la Fondation," 143.
6 See the MACM's "About the Collection" page, https://macm.org/en/the-musee/about-the-collection.
7 Dubreuil, "Les Acquisitions du MACM," 255.
8 Mays, "I Am Still the Boss," 44–8.
9 Ibid.
10 Dubreuil, "Les Acquisitions du MACM," 105.
11 Chassé and LaPierre, *Marcel Brisebois*, 71–2.
12 Lamarre was chair of the board of directors of the MMFA from 1982 to 1991 and 1997 to 2008 (discussed below).
13 Conlogue, "Lavalin Purchase a Mixed Blessing?"; Gagnon, "La collection Lavalin," 12–15; and Lacroix, "*À cheval donné*," 15–18.
14 Mays, "Right Artists, Wrong Works."
15 Connolly, "Le MACM," 50. Dubreuil, "Les Acquisitions du musée d'Art Contemporain de Montréal," 87–98, discusses the acquisition procedure, and breaks down acquisitions by media, province of artist, periods, and whether artists are Canadian, International, or from Quebec, but does not consider artists' gender or race.
16 Dubreuil, "Les Acquisitions," 244, 255–6.
17 Mays, "I Am Still the Boss."
18 In 2009, Monique Gauthier was interim director between Mayer and Gagnon, and in 2013 Richard Bellerose was interim director between Gagnon and Zeppetelli.
19 Using a binomial pair test assuming two genders of equal probability, from 2000 to 2017, the two-tailed p-value is 0.00154, which is considered a statistically significant deviation from expected equity. In table 1, for consistency with other institutions, we were using data

collected in 2011 and so considered a shorter time frame, from 2000 to 2010, which is why the numbers are not the same.

20 This also excludes seven exhibitions that opened under interim directors.

21 Mays, "I Am Still the Boss."

22 Milroy, "Is Montreal the Real Art Capital?"

23 The curatorial team was chief curator Gagnon, and curators Josée Bélisle, Pierre Landry, and Mark Lanctôt, with Lesley Johnstone as project coordinator. Tousignant, "The Quebec Triennial."

24 Tousignant, "The Quebec Triennial."

25 See the summary by Tousignant, "MACM Debate."

26 The letter is reproduced here: https://www.ledevoir.com/opinion/idees/257765/musee-d-art-contemporain-de-montreal-une-nomination-revoltante. Translation is mine. The original text was: "Notre surprise est d'abord venue du fait qu'une large partie de la communauté culturelle espérait à cette occasion un changement en profondeur pour l'institution."

27 Ibid. Translation is mine. The original was: "le MACM se contente généralement d'accueillir des valeurs sûres de l'extérieur sans y porter un regard précis, ignore sans raison apparente des acteurs essentiels de son milieu (artistes, commissaires, chercheurs, designers, etc.), ne sesert pas de l'exposition comme d'un mode de réflexion, privilégie leplus souvent des pratiques artistiques qui ne posent aucun défi aux règles de la muséologie (au détriment de tout un pan de la création actuelle), voit rétrécir d'année en année son cycle de colloques et de conférences, et ne fait qu'exceptionnellement circuler un artiste québécois vivant sur la scène internationale où le Musée demeure méconnu, voire invisible."

28 Baillargeon, "Fronde contre le Musée."

29 Doyon, "Paulette Gagnon." Translation is mine. The original was: "les prix du récent Gala des arts visuels … prix de la meilleure manifestation publique pour la Triennale québécoise signée Marie Fraser et prix de la meilleure exposition dans un établissement muséal pour la rétrospective consacrée à Valérie Blass."

30 Ibid.

31 Given the lack of diversity under Brisebois's leadership, and the lack of Indigenous representation generally before 1984, it very likely means they had never had a solo show by an Indigenous woman.

32 The province as a whole is much less diverse than the city and more in line with what they gallery exhibits: 1.4 percent Indigenous and 11 per

cent visible minority. https://www12.statcan.gc.ca/census-recensement/
2016/dp-pd/prof/details/page.cfm?Lang=E&Geo1=PR&Code1=24&
Geo2=PR&Code2=01&Data=Count&SearchText=quebec&
SearchType=Begins&SearchPR=01&B1=All.

33 Delgado, "Exposition."

34 Paré, "Le MAC abandonne."

35 Media reports about personal collections tend to focus on works by
 white male artists, and this is certainly true of descriptions of Taillefer's
 collection, although it may not represent the collection proportionally;
 see Sandals, "MAC Montreal Rocked."

36 Ibid.

37 See the MACM's press release, "The MAC Renews Its Strategic Vision,"
 https://macm.org/en/press-release/the-mac-renews-its-strategic-vision.

38 Twerdy, "Zeppetelli Construction Ahead."

39 Everett-Green, "Montreal's Art Biennale"; and Sandals, "Quebec
 Triennial Out."

40 On biennale history, see Everett-Green, "Montreal's Art Biennale."
 On more recent bankruptcy declaration, see Sandals, "Biennale de
 Montréal Files for Bankruptcy"; and Schneider, "Unable to Pay."

41 Sandals, "Biennale de Montréal files for Bankruptcy."

42 Everett-Green, "Finding Quebec's Joie de Vivre."

43 See "Nathalie Bondil Awarded Order of Canada," which notes,
 "Through her efforts, the museum also became Canada's leading
 exporter of exhibitions to museums in other countries."

44 Kerr, "Nathalie Bondil: Executive Director and Chief Curator," which
 quotes Bondil: "We grew from 600,000 visitors in 2007 to 1,000,000
 and then 1,200,000 last year. We were the #1 art museum in Canada
 in 2015, and we slipped a bit to #2 behind Toronto's Art Gallery of
 Ontario (AGO) in 2016 – but we're on track to be #1 in Canada again
 in 2017." What makes this ranking even more impressive is that
 Toronto's population is approximately 50 per cent larger than
 Montreal's.

45 Germain, *A City's Museum*, 18.

46 Baillargeon, "Musées: L'héritage Cogeval."

47 Montreal Museum of Fine Arts, "Appointment of Nathalie Bondil."

48 Bondil, quoted here: https://www.mbam.qc.ca/en/exhibitions/past/
 focus-perfection.

49 Germain, *A City's Museum*, 230.

50 https://www.mbam.qc.ca/en/museum-district/jean-noel-desmarais-
 pavilion/#toggle-id-3.

51 Ming Wai Jim, "Dealing with Chiastic Perspectives," 80.

52 Everett-Green, "Marion Wagschal Retrospective."

53 Ming Wai Jim, "Dealing with Chiastic Perspectives," 72.

54 The data use in the discussion of contemporary shows uses the last available annual report at the time of rewriting in spring 2018, the annual report for 2016 to 2017. The annual report for 2017 to 2018 has not yet been posted at the time of writing. Consequently, the discussion of solo exhibitions above excludes some solo shows discussed below, including those by Nadia Myre and Meryl McMaster. While the addition of these artists' solo shows from fall 2017 will change the MMFA's gender and ethnicity distribution, the exhibition record that precedes them is important to consider.

55 Montreal Museum of Fine Arts, "An Exceptional Donation."

56 In 2018 the provincial government announced a return to funding levels of 2010 to 2011; "Quebec Government Ensures."

57 See Whitelaw, "A New Pavilion."

58 Ibid., 170, 176.

59 Ibid., 181.

60 https://www.mbam.qc.ca/en/collections.

61 Whitelaw, "A New Pavilion," 175.

62 Ibid., 182.

63 Ibid., 182.

64 Montreal Museum of Fine Arts, "An Exceptional Donation."

65 https://www.mbam.qc.ca/en/about-the-museum/a-bold-innovative-and-caring-museum.

66 Ibid.

67 Annual Report, 2016–17, 6.

68 Ibid., 28.

69 Ibid., 28.

70 https://www.mbam.qc.ca/en/exhibitions/past/the-beaver-hall-group/exhibition.

71 "Stéphane Aquin to be Hirshhorn's Chief Curator."

72 https://www.mbam.qc.ca/en/exhibitions/past/her-story-today.

73 https://www.mbam.qc.ca/en/exhibitions/past/focus-perfection.

74 After Aquin's departure, the position of curator of contemporary international art was reconfigured and Desmarais was hired. American-born, with a Yale dissertation on Monet and whose most significant publication is a 2016 exhibition catalogue on Monet's early years, she may seem a surprising choice for curator of international modern art,

and to fill what was a contemporary position. Given the Montreal art community's outrage at the hiring of the very qualified Paulette Gagnon, the silence around this appointment – of a full curator with no significant curatorial record – is striking. However, her marriage into the powerful Desmarais family, her role as a board member at the MACM, and her significant personal art collection all speak to the skills she brings to the position.

75 Rowe, "Spotlight on Indigenous Artists at Beaux Arts."

76 Ibid.

77 Grechko, "Why the Montreal Museum Is One to Watch."

78 https://www.mbam.qc.ca/en/exhibitions/past/love-is-love.

79 Ibid.

80 Ibid.

81 Everett-Green, "Times Have Changed around Cultural Appropriation."

82 Ibid.

83 D'Souza, *Whitewalling*, 9.

84 Everett-Green, "Times Have Changed around Cultural Appropriation."

85 Kilkenny, "Jean Paul Gaultier and Kent Monkman Unite."

86 Ibid.

87 There is a wealth of literature on this important exhibition. See Butler, *Contested Representations*, 8–9; for a recalcitrant position see Fulford, "Into the Heart of Political Correctness."

88 See Forni, "Engaging Dialogues," 197–210; as well as ROM press releases and the *Of Africa* website: https://www.rom.on.ca/en/of-africa.

89 "Royal Ontario Museum Apologizes."

90 Royal Ontario Museum, "Royal Ontario Museum and the Coalition for the Truth"; and Thompson, "Royal Ontario Museum Apologizes."

91 K. Adams, "Black Is Canadian."

92 This major summer blockbuster began as a co-production of the Musée du quai Branly - Jacques Chirac and the Musée national Picasso-Paris, curated by Yves Le Fur. In Montreal, the show was "adapted" by Bondil with additional works by Picasso, additional African works, and the juxtaposition of the black contemporary show from the ROM.

93 Montreal Museum of Fine Arts, "From Africa to the Americas."

94 https://www.mbam.qc.ca/en/exhibitions/on-view/picasso.

95 Ibid.

96 McEvilley, "Doctor, Lawyer, Indian Chief," 60.

97 https://www.mbam.qc.ca/en/exhibitions/on-view/picasso.

98 Montreal Museum of Fine Arts, "Here We Are Here."
99 Whyte, "New Show Returns ROM to African-Canadian Issues."
100 http://www.michelepearsonclarke.com/suck-teeth.
101 Power, "Reading Transdisciplinarily: Sartre and Althusser," 109–10.
102 Rosenbaum, "Bonding with Bondil"; and Treviño, et al., "Gender Gap."

CHAPTER SIX

1 Hall, "New Ethnicities," 443.
2 Fraser, "Recognition without Ethics?," 22.
3 Bourdieu and Darbel, *The Love of Art*, 112.
4 D'Souza, *Whitewalling*, 35; see also 80–2.
5 See http://nctr.ca/reports.php.
6 *Truth and Reconciliation Commission of Canada: Calls to Action*, 9.
7 *Summary of the Corporate Plan for 2017–18 to 2021–22*, 21.
8 Turner, "Newly Formed Indigenous Advisory Circle."
9 For an excellent overview of recent literature, see Savonick and Davidson, "Gender Bias in Academe."
10 Moss-Racusin, et al., "Science Faculty's Subtle Gender Biases."
11 Bertrand and Mullainathan, "Are Emily and Greg More Employable."
12 Goldin and Rouse, "Orchestrating Impartiality."
13 Savonick and Davidson, "Gender Bias."
14 Uhlmann and Cohen, "I Think It, Therefore It's True."
15 https://implicit.harvard.edu/implicit (accessed 16 March 2017).
16 Fatona, "Where Outreach Meets Outrage," especially 187–8.
17 Usher, "Diversity in Canada Research Chairs," provides a useful summary and critique of the government's failure to date to significantly improve diversity.
18 http://www.modernamuseet.se/stockholm/en/2015/11/02/5-ar-med-daniel-birnbaum-och-ann-sofi-noring.
19 https://www.theguardian.com/artanddesign/2016/jan/22/frances-morris-takes-tate-modern-helm.
20 https://www.theguardian.com/artanddesign/2016/apr/16/tate-modern-director-frances-morris-interview.
21 http://freelandsfoundation.co.uk/research/representation-of-female-artists-in-britain.
22 https://news.artnet.com/art-world/elisabeth-murdoch-artist-award-463094.
23 Easton, "Museums in Crisis?," 331.

24 Ibid.
25 Maranda, "Hard Numbers."
26 Rogoff, "Hit and Run," 66.
27 Ibid., 66.
28 Steiner, "Can the Canon Burst?," 213–14.

Bibliography

Adams, James. "The Perpetual Crisis at Toronto's Power Plant Gallery."
 Globe and Mail, 14 September 2012.
– "Toronto's Museum of Contemporary Canadian Art Is on the Move."
 Globe and Mail, 2 October 2012.
Adams, Kelsey. "Black Is Canadian." *Canadian Art*, 10 April 2018.
 https://canadianart.ca/reviews/black-is-canadian.
Angel, Sara. "Joyce Wieland: True Patriot Love." *Canadian Art*,
 15 September 2011. https://canadianart.ca/features/joyce_wieland.
Applebaum, Louis, and Jacques Hébert. *Report of the Federal Cultural
 Policy Review Committee*. Ottawa: Government of Canada, 1982.
Bagg, Shannon. "The Anthropology of Inuit Art." In *On Aboriginal
 Representation in the Gallery*, edited by Lynda Jessup and Shannon
 Bagg, 183–94. Hull: Canadian Museum of Civilization, 2002.
Baillargeon, Stéphane. "Fronde contre le Musée d'art contemporain:
 80 personnalités réclament 'une importante réforme' de l'institution."
 Le Devoir, 9 July 2009.
– "Musées: L'héritage Cogeval." *Le Devoir*, 20 January 2007.
Ballingall, Alex. "A Majority of Torontonians Now Identify Themselves
 as Visible Minorities." *Toronto Star*, 25 October 2017.
Bannerji, Himani. *The Dark Side of the Nation: Essays on Multiculturalism,
 Nationalism and Gender*. Toronto: Canadian Scholars' Press, 2000.
Bellavance, Guy. *The Visual Arts in Canada: A Synthesis and Critical
 Analysis of Recent Research*. Montreal: Institut national de la recherche
 scientifique, 2011.
Bertrand, Marianne, and Sendhil Mullainathan. "Are Emily and Greg
 More Employable Than Lakisha and Jamal? A Field Experiment on

Labor Market Discrimination." *American Economic Review* 94, no. 4 (2004): 991–1013. DOI: 10.1257/0002828042002561.

Blodgett, Jean. "After Essay: And What About Inuit Art?" In *On Aboriginal Representation in the Gallery*, edited by Lynda Jessup and Shannon Bagg, 205–14. Hull: Canadian Museum of Civilization, 2002.

– "Report on Indian and Inuit Art at the National Gallery of Canada." Ottawa: National Gallery of Canada, 1983.

Bogardi, Georges. "Women's Art Lost in Issues." *Montreal Star*, 29 November 1975, D6.

Boggs, Jean Sutherland. "The National Gallery and Our Two Cultures." *Vie des Arts*, no. 58 (1970): 16–21.

– "The National Gallery and Women." In *Third Annual Review of the National Gallery of Canada*, 8–10. Ottawa: National Gallery of Canada, 1972.

– "No Disavowal," letter to the editor. *Ottawa Citizen*, 19 December 1975, B362.

Bordo, Jonathon. "Jack Pine: Wilderness Sublime or the Erasure of the Aboriginal Presence from the Landscape." *Journal of Canadian Studies* 27 (winter 1992–93): 98–128.

– "The Terra Nullius of Wilderness: Colonialist Landscape Art (Canada and Australia) and the So-Called Claim to American Exception." *International Journal of Canadian Studies* 15 (spring 1997): 13–36.

Boucher, Brian. "Cherokee Artists and Curators Denounce Artist Jimmie Durham as a Fraud, Saying He 'Is Not a Cherokee.'" *Artnet*, 27 June 2017. https://news.artnet.com/art-world/cherokee-curators-artists-jimmie-durham-cherokee-1007336.

Bourdieu, Pierre, and Alain Darbel, with Dominique Schnapper. *The Love of Art: European Art Museums and Their Public*. Translated by Caroline Beattie and Nick Merriman. Malden, MA: Polity Press, 1991.

Broadhurst, Maura Lesley. "Strategic Spaces: Towards a Genealogy of Women Artists' Groups in Canada." Master's thesis, Concordia University, 1997.

Burnett, David. "Some Canadian Women Artists: The National Gallery of Canada." *Artscanada* 32, no. 4 (winter 1975–76): 54–8.

Butler, Shelley Ruth. *Contested Representations: Revisiting Into the Heart of Africa*. Toronto: University of Toronto Press, 2011.

Canadian Association of University Teachers. "The Persistent Gap: Understanding Male-Female Salary Differentials amongst Canadian Academic Staff." *CAUT Equity Review* 5 (March 2011): 1–8.

– "Women's University Enrolments: Trends by Level of Study and Discipline, 1992–2003." *CAUT Equity Review* 3 (March 2008): 1–8.

Chassé, Bernard, and Laurent LaPierre. *Marcel Brisebois et le Musée d'art contemporain de Montréal (1985-2004)*. Quebec: Presses de l'Université du Québec, 2011.

Conley, Christine. "Curatorial Conundrums: Feminism and Practices of Collection and Display." Paper presented at Art Institutions and the Feminist Dialectic, Ontario College of Art and Design University, Toronto, Ontario, 2008. https://www2.ocadu.ca/event/art-institutions-and-the-feminist-dialectic.

– "Hot Tramp, I Love You So!" *Fuse* 13 no. 1–2 (fall 1989): 53–4.

Conlogue, Ray. "Lavalin Purchase a Mixed Blessing?" *Globe and Mail*, 25 June 1992, C1.

Connolly, Jocelyne. "Le Musée d'art contemporain de Montréal: Décideurs et tendances socio-esthétiques de la collection." *Journal of Canadian Art History/Annales d'histoire de l'art Canadien* 16, no. 1 (1994): 30–63.

Cooley, Alison, Amy Luo and Caoimhe Morgan-Feir. "Canada's Galleries Fall Short: The Not-So Great White North." *Canadian Art*, 21 April 2015. http://canadianart.ca/features/canadas-galleries-fall-short-the-not-so-great-white-north.

Crandell, Richard C. *Inuit Art: A History*. Jefferson, NC: McFarland, 2000.

Crandell, Richard C., and Susan M. Crandell. *An Annotated Bibliography of Inuit Art*. Jefferson, NC: McFarland, 2001.

Cross, Jessica Smith. "AGO's Frida Kahlo Unibrow Irks Some Visitors." *MetroNews*, 22 October 2012.

Czajkowski, Jennifer Wild, and Shiralee Hudson Hill. "Transformation and Interpretation: What Is the Museums Educator's Role?" *Journal of Museum Education* 33, no. 3 (fall 2008): 255–63.

Dagg, Anne Innis. *The Fifty Percent Solution: Why Should Women Pay for Men's Culture?* Waterloo: Otter Press, 1986.

– "What Happens to Women's Art?" *Globe and Mail*, 4 August 1984.

Dawn, Leslie. *National Visions, National Blindness: Canadian Art and Identities in the 1920s*. Vancouver: UBC Press, 2006.

de Lauretis, Teresa. "The Essence of the Triangle; or Taking the Risk of Essentialism Seriously: Feminist Theory in Italy, the US, and Britain." In *The Essential Difference*, edited by Naomi Schor and Elizabeth Weed, 1–39. Bloomington: Indiana University Press, 1994.

Delgado, Jérôme. "Exposition: L'Abstraction en 118 points au Musée d'art contemporain." *Le Devoir*, 12 April 2012.

Ditmars, Hadani. "The Master Builder: Kathleen Bartels Brings the Vancouver Art Gallery to the Global Stage." *Canadian Art* (summer 2011): 68–71. https://canadianart.ca/features/kathleen_bartels.

Dixon, Guy. "Head Bangers at the Biennale." *Globe and Mail*, 4 August 2010.

Douglas, Stan, ed. *Vancouver Anthology: The Institutional Politics of Art*. Vancouver: Talonbooks, 1991.

Doyon, Frédérique. "Paulette Gagnon voit son mandat renouvelé au MACM." *Le Devoir*, 9 January 2013.

D'Souza, Aruna. *Whitewalling: Art, Race and Protest in 3 Acts*. New York: Badlands, 2018.

Dubreuil, Martine. "Les Acquisitions du musée d'Art Contemporain de Montréal, 1992–2012." PhD diss., Université de Montréal, 2011.

Easton, Elizabeth. "Museums in Crisis?" *Visual Resources: An International Journal of Documentation* 27, no. 4 (2011): 329–36.

Everett-Green, Rupert. "Finding Quebec's Joie de Vivre." *Globe and Mail*. 1 December 2017.

– "Marion Wagschal Retrospective Shows Paintings Saturated with Time." *Globe and Mail*, 29 May 2015.

– "Montreal's Art Biennale, Unable to Pay Its Debts, Takes a Hard Fall." *Globe and Mail*, 3 August 2017.

– "Times Have Changed around Cultural Appropriation, but Has the MMFA?" *Globe and Mail*, 26 May 2017.

Fatona, Andrea. "'Where Outreach Meets Outrage': Racial Equity at the Canada Council for the Arts (1989–1999)." PhD diss., University of Toronto, 2011.

Falvey, Emily. "Canadian Biennial Both Dazzles and Disappoints." *Canadian Art*, 17 December 2014. http://canadianart.ca/reviews/canadian-biennial-dazzles-disappoints.

Forni, Silvia. "Engaging Dialogues." *Museum Worlds* 5, no. 1 (2017): 197–210. https://doi.org/10.3167/armw.2017.050116.

Fraser, Nancy. "Recognition without Ethics?" *Theory, Culture & Society* 18, no. 2–3 (2001): 21–42.

Freedman, Adele. "Birks' Silver: National Scandal or Tempest in a Porringer?" *Globe and Mail*. 19 January 1980, C9.

Freedman, Adele. "Silver Saga Continues: The Birks Collection Is Still a Hot Potato." *Globe and Mail*, 6 March 1980, E17.

Fulford, Robert. "Into the Heart of Political Correctness." *National Post*, 24 November 2007.

- "There Is a Distinct 'Female Art' Insists Organizer of Women's Show." *Toronto Star*, 6 December 1975, B72. National Gallery of Canada Archives exhibition file.

Gagnon, François-Marc. "La collection Lavalin au Musée d'art contemporain: Reflet de l'histoire de l'art moderne et contemporain au Québec." *Vie des arts* 39, no. 155 (1994): 12–15.

Gagnon, Monika Kin. "Work in Progress: Canadian Women in the Visual Arts, 1975–1987." In *Work in Progress: Building Feminist Culture*, edited by Rhea Tregebov, 100–27. Toronto: The Women's Press, 1987.

Garnet, Carla. "Synthetic Psychosis." *Canadian Art* 19, no. 4 (fall 2002): 136.

Germain, Georges-Hébert. *A City's Museum: A History of the Montreal Museum of Fine Arts*. Montreal: MMFA, 2007.

Gessell, Paul. "Not in This Place," *Telegraph-Journal* (Saint John, NB), 22 January 2011, S4.

- "The Trouble with 'Excellence.'" *Ottawa Citizen*, 5 March 2010, A3.

Gewurtz, Michelle. "Transformation AGO: Fulfilling Feminisms' Promise?" *Crossroads* 30, no. 2 (summer 2013): 111–24.

Gill, Alexandra. "Bartels: Facing a House Divided." *Globe and Mail*, 20 December 2000.

Gillis, Wendy. "30-Year AGO Employee Forced into Retirement." *Toronto Star*, 22 July 2010.

Goddard, Peter. "Dude Culture Near the Doge's Palace." *Toronto Star*, 3 June 2011.

Goetz, Helga. "Inuit Art: A History of Government Involvement." In *In the Shadow of the Sun: Perspectives on Contemporary Native Art*, 357–82. Hull: Canadian Museum of Civilization, 1993.

Goldin, Claudia, and Cecilia Rouse. "Orchestrating Impartiality: The Impact of 'Blind' Auditions on Female Musicians." *American Economic Review* 90, no. 4 (2000): 715–41. DOI: 10.1257/aer.90.4.715.

Gooden, Sky. "Chantal Pontbriand Will Not Curate Your Biennial: On 'Demo-Graphics,' and Its Potential to Reignite Toronto." *Momus*, 13 July 2015. http://momus.ca/interview-chantal-pontbriand-will-not-curate-your-biennial-on-demo-graphics-and-its-potential-to-reignite-toronto.

Government of Canada. "Purposes, Capacity and Powers of the National Gallery of Canada," Museums Act, S.C. 1990, c. 3. http://laws-lois.justice.gc.ca/eng/acts/m-13.4/page-1.html#h-5.

Graham, Mayo. Introduction to *Some Canadian Women Artists*, 9–24. Ottawa: NGC and Apex Press, 1975.

– "In Celebration: Some Canadian Women Artists." *Art Magazine* (January–December 1976): 12–17.

Grechko, Irina. "Why the Montreal Museum Is One to Watch." *Nylon*, 23 November 2017. https://nylon.com/articles/montreal-museum-fine-arts.

Greenberg, Reesa. "Feminist Curation and Exhibition Online." Talk presented at Connecting the Dots: Virtuality, Technology and Feminism in the Museum, Smithsonian, Washington, DC, 23 September 2011. http://feminismandcurating.pbworks.com/w/page/45715825/Reesa% 20Greenberg.

Gustavison, Susan J. *Arctic Expressions: Inuit Art and the Canadian Eskimo Arts Council, 1961–1989*. Kleinburg, ON: McMichael Canadian Art Collection, 1994.

Hall, Stuart. "New Ethnicities." In *Stuart Hall: Critical Dialogues in Cultural Studies*, edited by David Morley and Kuan-Hsing Chen, 441–9. London and New York: Routledge, 1994.

Hill, Charles C. "Committed to Art." *Globe and Mail*, 17 September 1984.

Hill, Greg A. "Carl Beam: The Artist and Some of His Concerns." In *Carl Beam: The Poetics of Being*, edited by Greg A. Hill, 12–33. Ottawa: ABC Art Books and National Gallery of Canada, 2010.

– Untitled presentation at the University of Lethbridge, Art Now Speaker's Series, 2 April 2014.

Hill, Richard William. "Meeting Ground: The Reinstallation of the Art Gallery of Ontario's McLaughlin Gallery." In *Making a Noise!: Aboriginal Perspectives on Art, Art History, Critical Writing and Community*, edited by Lee-Ann Martin, 50–70. Banff: Banff Centre, 2004.

Hines, Jessica. "*Art of this Land* and the Exhibition of Aboriginal Art at the National Gallery of Canada." Master's thesis, Carleton University, 2004.

Holmes, Kristy A. "Negotiating the Nation: The Work of Joyce Wieland, 1968–1976." PhD diss., Queen's University, 2007.

Hooper-Greenhill, Eilean. *Museums and the Shaping of Knowledge*. London and New York: Routledge, 1992.

Hunter, Andrew. "Why I Quit the Art Gallery of Ontario: Former Canadian-Art Curator Andrew Hunter Explains." *Toronto Star*, 3 October 2017.

Igloliorte, Heather. "Arctic Culture/Global Indigeneity." In *Negotiations in a Vacant Lot: Studying the Visual in Canada*, edited by Erin Morton,

Kirsty Robertson and Lynda Jessup, 150–70. Montreal and Kingston: McGill-Queen's University Press, 2014.

Ip, Frank. "Ethnicity and Visible Minority Characteristics of B.C.'s Population." Government of British Columbia, BC Stats, 2006. http://www.bcstats.gov.bc.ca/StatisticsBySubject/Census/2006Census.aspx.

Ipellie, Alootook. "The Colonization of the Arctic." In *Indigena: Contemporary Native Perspectives*, edited by Gerald McMaster and Lee-Ann Martin, 38–57. Vancouver: Douglas and McIntyre, 1992.

Jessup, Lynda, and Shannon Bagg, eds. *On Aboriginal Representation in the Gallery*. Hull: Canadian Museum of Civilization, 2002.

Kerr, Peter. "Nathalie Bondil: Executive Director and Chief Curator." *Montrealer Online*, 4 January 2018. https://themontrealeronline.com/2018/01/nathalie-bondil-executive-director-and-chief-curator-at-the-montreal-museum-of-fine-arts.

Kilkenny, Carmel. "Jean Paul Gaultier and Kent Monkman Unite at MMFA." Radio Canada International, 11 September 2017. http://www.rcinet.ca/en/2017/09/11/jean-paul-gauthier-and-kent-monkman-unite-at-mmfa.

Klein, Jennie. "Bad Girls Video." *Afterimage* (January 1995): 12.

Krishtalka, Sholem. "A Critic's Open Letter Responds to the AGO Frida Kahlo Unibrow Controversy." Blouin Artinfo, 13 November 2012. http://ca.blouinartinfo.com/news/story/840573/a-critics-open-letter-responds-to-the-ago-frida-kahlo-unibrow. Accessed 5 May 2017.

Kritzwiser, Kay. "At the Galleries." *Globe and Mail*, 3 July 1971.

Lacroix, Laurier. "À cheval donné... ou la collection Lavalin au Musée d'art contemporain de Montréal." *ETC* 20 (1992): 15–18.

– "Paul-Émile Borduas et la fondation du Musée d'art contemporain de Montréal." *Journal of Canadian Art History/Annales D'histoire De L'art Canadien* 33, no. 1 (2012): 142–65.

Laidlaw, Katherine. "Pop Life: Hirst and Koons Pieces Land in Ottawa for Exhibit." *National Post*, 10 June 2010.

Lalonde, Christine. "Status 2000: Presenting Contemporary Inuit Art in the Gallery Setting." In *On Aboriginal Representation in the Gallery*, edited by Lynda Jessup and Shannon Bagg, 195–204. Hull: Canadian Museum of Civilization, 2002.

Lamoureux, Johanne. "La Statistique canadienne: A State Ethics." *Parachute* 60 (October–December 1990): 49–52.

Laurence, Robin. "Board Walk." *Border Crossings* 20, no. 1 (February 2001): 16.

Levin, Amy, ed. *Gender, Sexuality, and Museums: A Routledge Reader*.
 London: Routledge, 2010.

Lockyer, Jonathan A. "Charting the Development of Indigenous Curatorial
 Practice." Master's thesis, Ontario College of Art and Design University,
 2014.

Lowndes, Joan. "Maltreating Mayer," editorial. *Ottawa Citizen*, 6 March
 2010, B6.

– "Vera Frenkel: Printmaking Plus The National Gallery of Canada
 Extension Services May 1971–June 1972." *artscanada* 28, no. 6
 (December/January 1972): 130–32.

Maranda, Michael. "Hard Numbers: A Study on Diversity in Canada's
 Galleries." *Canadian Art*, 5 April 2017. http://canadianart.ca/features/
 art-leadership-diversity. Accessed 8 April 2017.

– *Waging Culture: A Report on the Socio-economic Status of Canadian
 Visual Artists*. Toronto: Art Gallery of York University, 2009.

– "Waging Culture: The Sex Gap (!)" Art Gallery of York University,
 2012. http://theagyuisoutthere.org/everywhere/?p=4472. Accessed
 14 June 2017.

Martin, Lee-Ann. "The Politics of Inclusion and Exclusion: Contemporary
 Native Art and Public Art Museums in Canada: A Report." Ottawa:
 Canada Council for the Arts, 1991.

Mays, John Bentley. "I Am Still the Boss Here: Marcel Brisebois Has Given
 Canada a Secure Foothold on the International Exhibition Scene."
 Canadian Art, 20 no. 4 (winter 2003): 44–8.

– "Right Artists, Wrong Works Add Up to Bad Deal." *Globe and Mail*,
 4 June 1994, C21.

McEvilley, Thomas. "Doctor Lawyer Indian Chief: 'Primitivism' in 20th
 Century Art at the Museum of Modern Art in 1984." *Artforum* 23,
 no. 3 (1984): 54–61.

McInnes-Hayman, Sasha. *Contemporary Canadian Women Artists:
 A Survey*. London, ON: Womanspirit Art Research, 1981.

McLaughlin, Bryne. "It Is What It Is: The Canadian Biennial in Question."
 Canadian Art, 25 November 2010. https://canadianart.ca/features/it_is_
 what_it_is. Accessed 12 November 2016.

McMaster, Gerald. "Our (Inter) Related History." In *On Aboriginal
 Representation in the Gallery*, edited by Lynda Jessup and Shannon
 Bagg, 3–8. Hull: Canadian Museum of Civilization, 2002.

McRobbie, Angela. *The Aftermath of Feminism: Gender, Culture and
 Social Change*. London: Sage, 2009.

Milroy, Sarah. "Is Montreal the Real Art Capital of Canada?" *Globe and Mail*, 30 May 2008.

– "Steven Shearer: Boy Trouble." *Canadian Art*, 16 June 2011. http://canadianart.ca/features/steven_shearer. Accessed 4 November 2016.

Ming Wai Jim, Alice. "Dealing with Chiastic Perspectives: Global Art Histories in Canada." In *Negotiations in a Vacant Lot: Studying the Visual in Canada*, edited by Lynda Jessup, Erin Morton and Kirsty Robertson, 66–90. Montreal and Kingston: McGill-Queen's University Press, 2014.

Monk, Philip. "Toronto the Good, in Two Histories." *Momus*, 26 October 2016. http://momus.ca/toronto-the-good. Accessed 14 December 2016.

Montreal Museum of Fine Arts. "Appointment of Nathalie Bondil as Director of the Montreal Museum of Fine Arts." *Cision*, 27 September 2007. https://www.newswire.ca/news-releases/appointment-of-nathalie-bondil-as-director-of-the-montreal-museum-of-fine-arts-534391991.html.

– "An Exceptional Donation From Stéphan Crétier and Stéphany Maillery," press release. 10 May 2018. https://www.mbam.qc.ca/wp-content/uploads/2018/05/MMFA-Press-release-Cretier-Maillery_Final.pdf.

– "From Africa to the Americas: Face-to-Face Picasso, Past and Present," press kit. 9 May 2018. https://www.mbam.qc.ca/wp-content/uploads/2018/05/MMFA-Face-to-Face-Picasso-PRESS-KIT_Final-web.pdf.

– "Here We Are Here: Black Canadian Contemporary Art," press kit. 9 May 2018. https://www.mbam.qc.ca/wp-content/uploads/2018/05/MMFA-HWAH-M_PRESS-KIT_Final-web.pdf.

Morgan-Feir, Caoimhe, email to the author, 9 February 2017.

Mortimer, Sarah. "Frida's Unibrow Was a Statement, Not a Gimmick." *Huffington Post*, 9 November 2012.

Morton, Erin, Kirsty Robertson and Lynda Jessup. *Negotiations in a Vacant Lot: Studying the Visual in Canada*. Montreal and Kingston: McGill-Queen's University Press, 2014.

Moss-Racusin, Corinne A., John F. Dovidio, Victoria L. Brescoll, Mark J. Graham and Jo Handelsman. "Science Faculty's Subtle Gender Biases Favor Male Students." *PNAS: Proceedings of the National Academy of Sciences* 109, no. 41 (2012): 16,474–16,479. DOI: 10.1073/pnas.1211286109.

Mousseau, Sylvie. "Exposition pancanadienne: aucun artists du N-B. sélectionné." *L'Acadie Nouvelle* (Caraquet, NB). 7 February 2011. National Gallery of Canada Archives, *It Is What It Is* exhibition clippings file.

Mullick, Nancy S. "The Transfer of the Northern Affairs (NA) and Indian and Northern Affairs of Canada (INAC) Collections of Inuit Art: 1985–1992." Master's thesis, Concordia University, 1998.

"Nathalie Bondil Awarded Order of Canada." *Montrealer Online*, 23 May 2016. https://themontrealeronline.com/2016/05/nathalie-bondil-awarded-the-order-of-canada.

National Gallery of Canada, Annual Reports, 1999–2000 to 2016–17.

Nemiroff, Diana. "Modernism, Nationalism and Beyond: A Critical History of Exhibitions of First Nations Art." In *Land, Spirit, Power: First Nations at The National Gallery of Canada*, 15–41. Ottawa: National Gallery of Canada, 1992.

Nixon, Virginia. "'Pluralities' Has Variety, Surprise." *Montreal Gazette*, 19 July 1980.

Nochlin, Linda. "Why Have There Been No Great Women Artists?" *ARTnews* 69, no. 9 (January 1971): 22–39, 67–71.

O'Brian, Melanie. Preface to *Vancouver Art and Economies*, edited by Melanie O'Brian, 7–9. Vancouver: Arsenal Pulp Press, 2007.

Ord, Douglas. *The National Gallery of Canada: Ideas, Art, Architecture*. Montreal and Kingston: McGill-Queen's University Press, 2003.

Palumbo-Liu, David. "Modernisms, Pacific and Otherwise." In *Pacific Rim Modernisms*, edited by Mary Ann Gillies, Helen Sword and Steven Yao, 34–50. Toronto: University of Toronto Press, 2009.

Paré, Isabelle. "Le MAC abandonne son projet d'agrandissement." *Le Devoir*, 21 June 2012.

Perry, Art. "Gathie Falk." *Pacific Time* (spring 1976): 8–11. National Gallery of Canada Archives clippings file.

"Quebec Government Ensures MMFA's Financial Sustainability." *Montreal Times*, 28 March 2018. http://mtltimes.ca/Montreal/entertainment/art/quebec-government-ensures-mmfas-financial-sustainability.

Phillips, Ruth B. "APEC at the Museum of Anthropology." In *Museum Pieces*, 71–89.

– "Artists, Museums, and the Columbus Quincentennial." In *Museum Pieces*, 161–7.

– "Modes of Inclusion: Indigenous Art at the National Gallery of Canada and the Art Gallery of Toronto." In *Museum Pieces*, 252–68.

– *Museum Pieces: Toward the Indigenization of Canadian Museums*. Montreal and Kingston: McGill-Queen's University Press, 2011.

Pollock, Griselda. "The Missing Future: MoMA and Modern Women." In *Modern Women: Women Artists at the Museum of Modern Art*, edited

by Cornelia Butler and Alexandra Schwartz, 28–55. New York: Museum of Modern Art, 2010.

Pourtavaf, Leila. Introduction to *Féminismes Électriques*, edited by Leila Pourtavaf, 9–17. Montreal: La Centrale Galerie Powerhouse, 2012.

Power, Nina. "Reading Transdisciplinarily: Sartre and Althusser." *Theory, Culture & Society* 32, no. 5–6 (2015): 109–24. DOI: 10.1177/0263276415592038.

Purdie, James. "Sense of Wonderment from Women Painters." *Globe and Mail*, 24 November 1975. National Gallery of Canada Archives, *Some Canadian Women* exhibition clippings file.

Rayment, Steve. "Our Director of Marketing Weighs In on the Frida Unibrow Debate." Art Gallery of Ontario, 20 November 2012. https://artmatters.ca/wp/2012/11/our-director-of-marketing-weighs-in-on-the-frida-unibrow-debate.

Rice, Carla. *Becoming Women: The Embodied Self in Image Culture*. Toronto: University of Toronto Press, 2014.

Rogoff, Irit. "Hit and Run: Museums and Cultural Difference." *Art Journal* 61, no. 3 (2002): 63–73.

Rose, Andrea. "Rachel Whiteread Interviewed by Andrea Rose, March 1997." In *Rachel Whiteread: British Pavilion, XLVII Venice Biennale, 1997*, 33. London: British Council, 1997.

Rosenbaum, Lee. "Bonding with Bondil: Montreal MFA's Head on Succeeding as a (Female) Museum Director." *artsJournal*, 30 March 2017. https://www.artsjournal.com/culturegrrl/2017/03/bonding-with-bondil-montreal-mfas-head-on-succeeding-as-a-female-museum-director.html.

Rowe, Daniel J. "Spotlight on Indigenous Artists at Beaux Arts." *Eastern Door*, 21 November 2017. https://www.easterndoor.com/2017/11/21/spotlight-on-indigenous-artists-at-beaux-arts.

Routledge, Marie. "Carving an Identity: Inuit Sculpture from the Permanent Collection." *Inuit Art Quarterly* 15, no. 2 (summer 2000): 32–36.

– "The Development of an Inuit Art Collection at the National Gallery of Canada." *American Review of Canadian Studies* 17, no. 1 (1987): 73–8.

"Royal Ontario Museum Apologizes for 'Racist' Africa Exhibit It Held Nearly 30 Years Ago." *National Post*, 10 November 2016.

Royal Ontario Museum. "Royal Ontario Museum and the Coalition for the Truth about Africa Release Reconciliation Statement and Engagement strategy," Royal Ontario Museum press release. 9 November 2016.

https://www.rom.on.ca/en/about-us/newsroom/press-releases/
 royal-ontario-museum-and-the-coalition-for-the-truth-about-africa.
Sanchez, Joseph. "The Formation of Professional Native Artists Inc., the
 Indian Group of Seven." In *Witness*, edited by Bonnie Devine, 20–35.
 Sudbury: Aboriginal Curatorial Collective, 2009.
Sandals, Leah. "Biennale de Montréal Files for Bankruptcy." *Canadian Art*,
 29 March 2018. https://canadianart.ca/news/biennale-de-montreal-
 files-bankruptcy.
– "Canadian Biennial Aims to Build Different Vision of National Art."
 Canadian Art, 1 November 2012. https://canadianart.ca/reviews/
 builders-biennial.
– "MAC Montreal Rocked by Staff Departures & Plans to Cut More."
 Canadian Art, 5 April 2013. https://canadianart.ca/news/three-depart-
 macm-with-staff-cuts-en-route.
– "Quebec Triennial Out, Biennial de Montreal in at the MAC." *Canadian
 Art*, 18 April 2013. https://canadianart.ca/news/quebec-triennial-
 biennale-de-montreal-macm.
Savonick, Danica, and Cathy N. Davidson. "Gender Bias in Academe:
 An Annotated Bibliography of Important Recent Studies." HASTAC,
 26 January 2015. https://www.hastac.org/blogs/superadmin/2015/01/26/
 gender-bias-academe-annotated-bibliography-important-recent-studies.
 Accessed 12 October 2017.
Schneider, Tim. "Unable to Pay Its Mounting Debts, the Montreal Biennial
 Has Filed for Bankruptcy." artnetnews, 29 March 2018. https://news.
 artnet.com/art-world/montreal-biennial-bankruptcy-1256984.
Schor, Mira. "Backlash and Appropriation." In *The Power of Feminist Art:
 The American Movement of the 1970s, History and Impact*, edited by
 Norma Broude and Mary Garrard. New York: Harry N. Abrams, 1994.
Schor, Naomi. Introduction to *The Essential Difference*, edited by Naomi
 Schor and Elizabeth Weed, vii–xix. Bloomington: Indiana University
 Press, 1994.
Sethi, Meera. "The Mainstreaming of Dissent: Women Artists of Colour
 and Canadian Arts Institutions." *Resources for Feminist Research* 29,
 no. 3 (fall 2002): 85–103.
Shaughnessy, Jonathan. "Intro to Builders: Canadian Biennial 2012." In
 Builders: Canadian Biennial 2012, edited by Jonathan Shaughnessy,
 Heather Anderson, Andrea Kunard, Christopher Lalonde and Ann
 Thomas, 12–17. Ottawa: National Gallery of Canada, 2012.
Shier, Reid. "It Is What It Is: Or Is It?" *Canadian Art*, 6 January 2011.
 http://canadianart.ca/reviews/biennial. Accessed 17 September 2016.

Singhal, Sheila. "State of the Art: The 2016 Sobey Art Award Long List." *NGC Magazine*, 26 April 2016. https://www.gallery.ca/magazine/artists/state-of-the-art-the-2016-sobey-art-award-longlist. Accessed 14 November 2016.

Sleigh, Sylvia. Review of *Some Canadian Women Artists*, curated by Mayo Graham. *Art Journal* 36, no. 2 (winter 1976–77): 168–70.

Smith, Terry. *Thinking Contemporary Curating*. Perspectives in Curating, no. 1. New York: Independent Curators International, 2012.

Soulliere, Jacinthe. "The Stone That Cracked the Wall between the Institution and the First Nation Artist: The National Gallery of Canada, 1980–2008." Master's thesis, Concordia University, 2008.

Speak, Dorothy. "It's Inuit. Where Do You Put It?" *Inuit Art Quarterly* (summer 1988): 4–7.

Stauble, Katherine. "Remembering Lynne Cohen." *NGC Magazine*, 2 June 2014. www.gallery.ca/magazine/in-the-spotlight/remembering-lynne-cohen. Accessed 15 January 2017.

Steiner, Christopher. "Can the Canon Burst?" *Art Bulletin* 78, no. 2 (June 1996): 213–17.

"Stéphane Aquin to Be Hirshhorn's Chief Curator." *Canadian Art*, 16 December 2014. https://canadianart.ca/news/stephane-aquin hirshhorns-chief-curator.

Stone, Kyle. "Hanging On: The Best Little Modern Museum in Toronto May Be the Final Victim of the Livent Bankruptcy." *Eye Weekly*, 1 July 1999.

Summary of the Corporate Plan for 2017–18 to 2021–22 and Operating and Capital Budgets for 2017–18. National Gallery of Canada, 21. https://www.gallery.ca/about-the-gallery/governance/corporate-reports.

Sutton, Benjamin. "Facing Eviction, Museum of Contemporary Canadian Art Searching for New Toronto Home." *Blouin Art Info*, 9 October 2012.

Task Force on Museums and First Peoples. *Turning the Page: Forging New Partnerships between Museums and First Peoples*. Ottawa: Canadian Museums Association and Assembly of First Nations, 1992.

Taylor, Kate. "For the Artist Representing Canada, the Biennale Is a Mixed Blessing." *Globe and Mail*, 23 June 2012, R1.

Thom, Ian, and Grant Arnold. *Forest, Shore and Beyond: Art from the Audain Collection*. Toronto: Douglas and McIntyre, 2012.

Thompson, Nicole. "Royal Ontario Museum Apologizes for 1989 'Into the Heart of Africa' Exhibit." Global News, 10 November 2016. https://globalnews.ca/news/3058929/royal-ontario-museum-apologizes-for-1989-into-the-heart-of-africa-exhibit.

Tousignant, Isa. "MACM Debate." Akimblog, 19 November 2009. http://www.akimbo.ca/akimblog/?id=338.

– "The Quebec Triennial in Review: Provincial Powerhouse." *Canadian Art*, 19 June 2008. https://canadianart.ca/reviews/quebec-triennial-4.

Treviño, Veronica, Zannie Giraud Voss, Christine Anagnos and Alison D. Wade. "The Ongoing Gender Gap in Art Museum Directorships." Association of Art Museum Directors, 2017. https://aamd.org/our-members/from-the-field/gender-gap-report-2017.

Truth and Reconciliation Commission of Canada: Calls to Action. Winnipeg: Truth and Reconciliation Commission of Canada, 2015. http://www.trc.ca/websites/trcinstitution/File/2015/Findings/Calls_to_Action_English2.pdf.

Turner, Randy. "Newly Formed Indigenous Advisory Circle Aims to 'Decolonize' Winnipeg Art Gallery." *Winnipeg Free Press*, 25 July 2017.

Twerdy, Saelen. "John Zeppetelli: Construction Ahead." *Canadian Art*, 16 December 2013. https://canadianart.ca/features/john-zeppetelli-construction-ahead.

– "6 New Montreal Art Spaces to Watch." *Canadian Art*, 29 November 2016. https://canadianart.ca/features/6-new-montreal-art-spaces-to-watch.

Uhlmann, Eric Luis, and Geoffrey L. Cohen. "'I Think It, Therefore It's True': Effects of Self-Perceived Objectivity on Hiring Discrimination." *Organizational Behavior and Human Decision Processes* 104, no. 2 (November 2007): 207–23.

Usher, Alex. "Diversity in Canada Research Chairs." Higher Education Strategy Associates, 17 May 2016. http://higheredstrategy.com/diversity-in-canada-research-chairs. Accessed 26 May 2017.

Valentine, John. "New Racism and Old Stereotypes in the National Hockey League: The 'Stacking' of Aboriginal Players into the Role of Enforcer." In *Race and Sport in Canada: Intersecting Inequalities*, edited by Janelle Joseph, Simon Darnell, and Yuka Nakamura, 107–35. Toronto: Canadian Scholars' Press, 2012.

Wallace, Ian, ed. *Whispered Art History: Twenty Years at the Western Front*. Vancouver: Arsenal Pulp Press, 1993.

Watson, Scott, and Dieter Roelstraete, eds. *Intertidal: Vancouver Art and Artists*. Vancouver: Morris and Helen Belkin Art Gallery, 2005.

Watt, Virginia J. "The Role of the Canadian Eskimo Arts Council." *American Review of Canadian Studies* 17, no. 1 (1987): 67–71.

Whitelaw, Anne. "Land Spirit Power: First Nations Cultural Production and Canadian Nationhood." *International Journal of Canadian Studies* 12 (1995): 31–49.

– "A New Pavilion for Quebec and Canadian Art at the Montreal Museum of Fine Arts." *Journal of Canadian Art History/Annales d'histoire de l'art Canadien* 34, no. 1 (2013): 166–86.

– "Placing Aboriginal Art at the National Gallery of Canada." *Canadian Journal of Communication* 31, no. 1 (March 2006): 197–214.

– *Spaces and Places for Art: Making Art Institutions in Western Canada, 1912–1990.* Montreal and Kingston: McGill-Queen's University Press, 2017.

– "Statistical Imperatives: Representing the Nation in Exhibitions of Contemporary Art." *Topia* 1, no. 1 (spring 1997): 22–41.

Whyte, Murray. "AGO Facing Big Choices as Top Curator." *Toronto Star*, 7 September 2017.

– "Chicago Curator Stephanie Smith Named Chief Curator of Art Gallery of Ontario." *Toronto Star*, 30 April 2014.

– "Failure's Not an Option for Canada at Art Event." *Toronto Star*, 28 May 2013.

– "From Ottawa, with Love and Muscle." *Toronto Star*, 16 June 2011, E1.

– "Janet Cardiff's 40 Part Motet on Offer at AGO." *Toronto Star*, 5 April 2013.

– "MOCA CEO Chantal Pontbriand Severs Ties with Museum." *Toronto Star*, 23 June 2016.

– "New Name New Ambition for MOCA." *Toronto Star*, 29 March 2016.

– "New Show Returns ROM to African-Canadian Issues – and Scores a Provocative Success." *Toronto Star*, 28 January 2018.

– "Terry Nicholson Takes Helm at MOCA." *Toronto Star*, 6 July 2016.

Zack, Badanna, Maryon Kantaroff and Sharron Corne. *Woman as Viewer: An International Women's Year Project.* Winnipeg: Winnipeg Art Gallery, 1975.

Zemans, Joyce. "A Tale of Three Women: The Visual Arts in Canada/A Current Account/ing." *RACAR: revue d'art canadienne/Canadian Art Review* 25, no. 1–2 (1998): 103–22.

Zemans, Joyce, and Amy C. Wallace. "Where Are the Women? Updating the Account!" *RACAR: revue d'art canadienne/Canadian Art Review* 38, no. 1 (spring 2013): 1–29.

Index

Page numbers in italics refer to figures and tables.